HISTORIC PHOTOS OF
TOLEDO

TEXT AND CAPTIONS BY GREGORY M. MILLER

TURNER
PUBLISHING COMPANY
NASHVILLE, TENNESSEE PADUCAH, KENTUCKY

The passengers on this train rolling across the New York Central Bridge about 1896 would have an excellent view of the developing skyline of Toledo. Church spires still predominated before the turn of the century, but the era of the skyscraper would emerge during the next decade. The structure near the center of the bridge that looks like a ship is actually the mechanism that pivoted the bridge to allow ships to pass through.

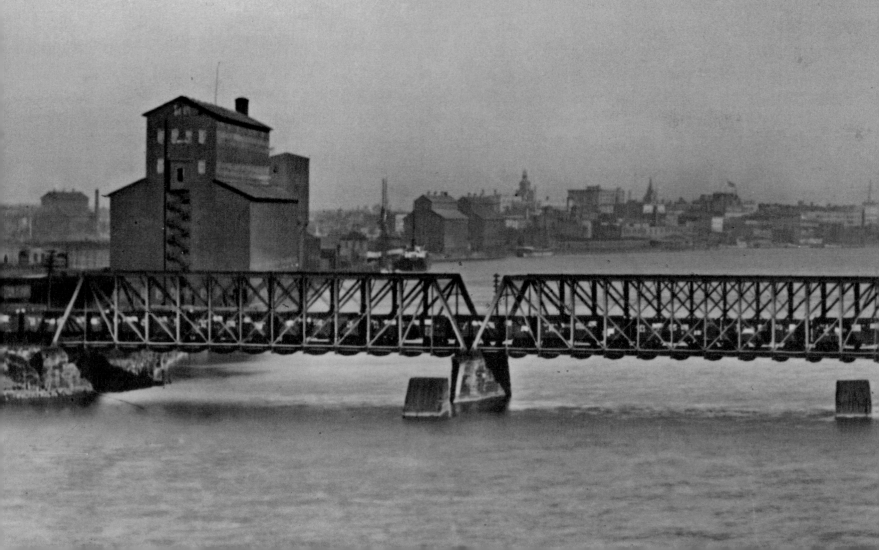

HISTORIC PHOTOS OF
TOLEDO

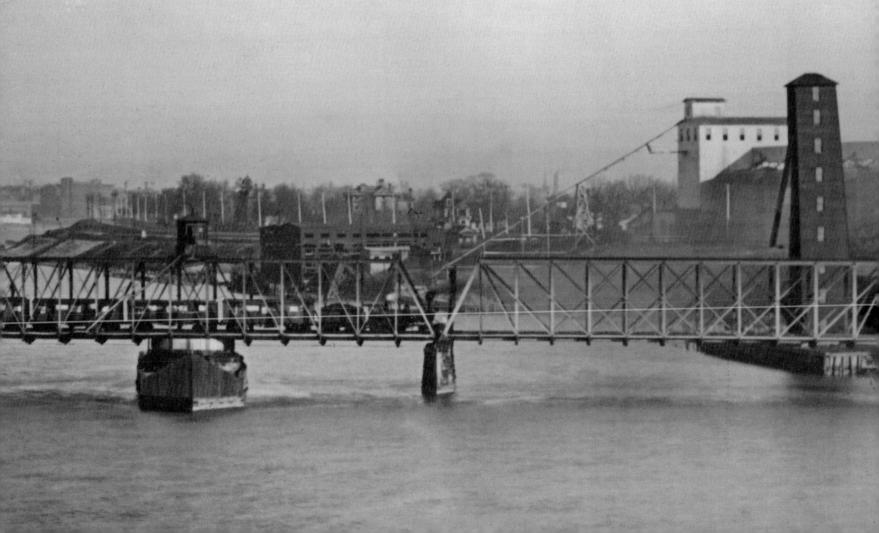

Turner Publishing Company

200 4th Avenue North • Suite 950 412 Broadway • P.O. Box 3101
Nashville, Tennessee 37219 Paducah, Kentucky 42002-3101
(615) 255-2665 (270) 443-0121

www.turnerpublishing.com

Historic Photos of Toledo

Copyright © 2007 Turner Publishing Company

Library of Congress Control Number: 2007923672

ISBN-10: 1-59652-343-3
ISBN-13: 978-1-59652-343-2

Printed in the United States of America

07 08 09 10 11 12 13 14—0 9 8 7 6 5 4 3 2 1

CONTENTS

This aerial view features both sides of the river, with a busy Toledo Marine Terminal at center-left. The opening of the St. Lawrence Seaway in 1959 provided a short boom in Great Lakes shipping, but by the mid 1970s the Marine Terminal had closed (it has since been reborn as the Docks).

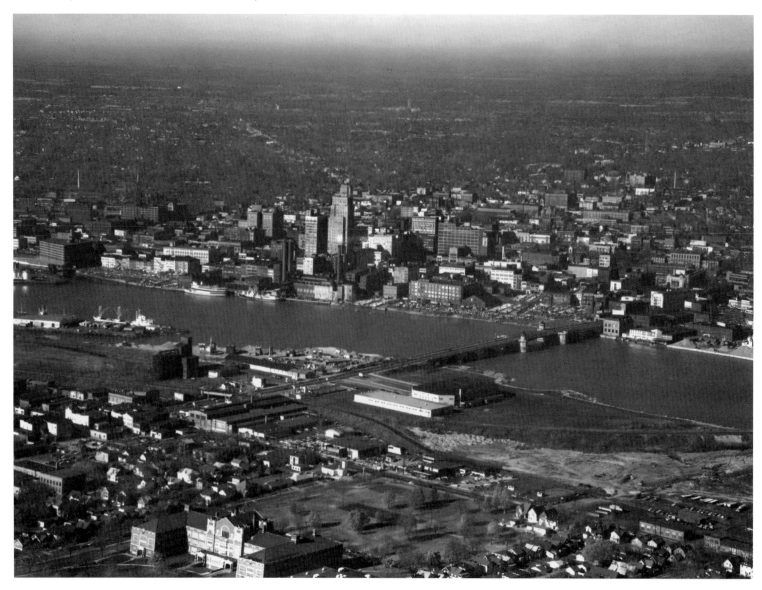

ACKNOWLEDGMENTS

The photograph collection of the Local History Department of the Toledo-Lucas County Public Library first came to the attention of the kind folks at Turner Publishing through its presence on the internet. Monies to digitize this collection were provided by the DaimlerChrysler Foundation, the City of Toledo, and the Library Legacy Foundation of the Toledo-Lucas County Public Library.

I would like to acknowledge the other staff members in the Local History Department—Michael Lora (manager), Donna Christian, Ann Hurley, Irene Martin, and Laura Voelz—for their assistance in completing this book.

———————

For my three children, Katie, Martha, and Daniel
and most of all, for my wife, Glenda, without whom my life would not be complete

PREFACE

Toledo has thousands of historic photographs that reside in archives, both locally and nationally. This book began with the observation that, while those photographs are of great interest to many, they are not easily accessible. During a time when Toledo is looking ahead and evaluating its future course, many people are asking, How do we treat the past? These decisions affect every aspect of the city—architecture, public spaces, commerce, infrastructure—and these, in turn, affect the way that people live their lives. This book seeks to provide easy access to a valuable, objective look into the history of Toledo.

The power of photographs is that they are less subjective than words in their treatment of history. Although the photographer can make decisions regarding subject matter and how to capture and present it, photographs do not provide the breadth of interpretation that text does. For this reason, they offer an original, untainted perspective that allows the viewer to interpret and observe.

This project represents countless hours of review and research. The researchers and writer have reviewed thousands of photographs in numerous archives. We greatly appreciate the generous assistance of the individuals and organizations listed in the acknowledgments of this work, without whom this project could not have been completed.

The goal in publishing this work is to provide broader access to this set of extraordinary photographs that seek to inspire, provide perspective, and evoke insight that might assist people who are responsible for determining Toledo's future. In addition, the book seeks to preserve the past with adequate respect and reverence.

With the exception of touching up imperfections caused by the damage of time and cropping where necessary, no other changes have been made. The focus and clarity of many images is limited to the technology and the ability of the photographer at the time they were taken.

The work is divided into eras. Beginning with some of the earliest known photographs of Toledo, the first section records photographs through the end of the nineteenth century. The second section spans the beginning of the twentieth

century up to the eve of the Great Depression. Section Three moves from the depression to World War II and the years immediately following. The last section covers the postwar decades to 1975.

In each of these sections we have made an effort to capture various aspects of life through our selection of photographs. People, commerce, transportation, infrastructure, religious institutions, and educational institutions have been included to provide a broad perspective.

We encourage readers to reflect as they go walking in Toledo, strolling through the city, its parks, and its neighborhoods. It is the publisher's hope that in utilizing this work, longtime residents will learn something new and that new residents will gain a perspective on where Toledo has been, so that each can contribute to its future.

Todd Bottorff, Publisher

By 1872, the Western Manufacturing Company produced sashes, doors, and blinds for use in the houses that were being built in the Midwest. The standardization of these building components, combined with the new "balloon frame" method of construction, made possible the lower prices for housing that followed, which enabled working families to acquire their own home.

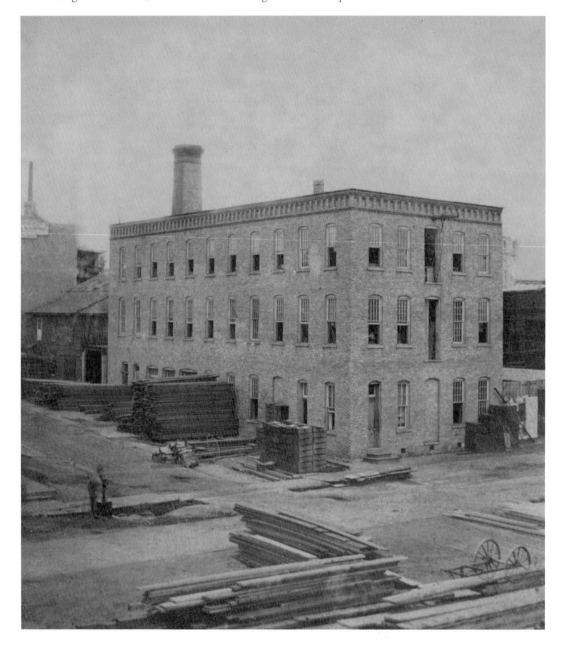

THE FUTURE GREAT CITY OF THE WORLD

(1870–1899)

Toledo, like many cities in the Midwest, was populated with a number of settlers known as "boomers." These men tried to persuade others to invest and settle in their city, because its geographic location, in their view, would guarantee its success. The most prominent of these men in Toledo was named Jesup (or Jessup—he spelled it both ways) Wakeman Scott.

Scott produced a slim volume while he worked as editor and publisher of the *Toledo Blade* called "A presentation of causes tending to fix the position of the future great city of the world in the central plain of North America." The crux of Scott's argument was that Toledo's location at the western end of one of the Great Lakes meant that it was bound to become a trading center for much of mid America. Scott had been making this argument since arriving in Toledo about thirty years earlier.

Others were making similar arguments about a settlement in a marsh at the southwestern edge of Lake Michigan that reeked of rotting wild onions each fall. Chicago's location at the western end of the Great Lakes system, rather than at the western end of a Great Lake, proved to be too much of an advantage. Although Toledo may not have become the Future Great City of the World, as prophesied by Jesup Scott, it did become an important regional trade center after the Civil War, and an important industrial city in the years before the opening of the twentieth century.

The photographs that follow illustrate Toledo's rise to prominence, and the struggles that were sometimes necessary to turn a former swamp into a modern city.

Toledo's location near the mouth of the Maumee River made it an attractive shipping hub, both to ship raw goods east and to distribute manufactured goods in its trading area. This location on the Maumee also made it an attractive terminus for canal builders.

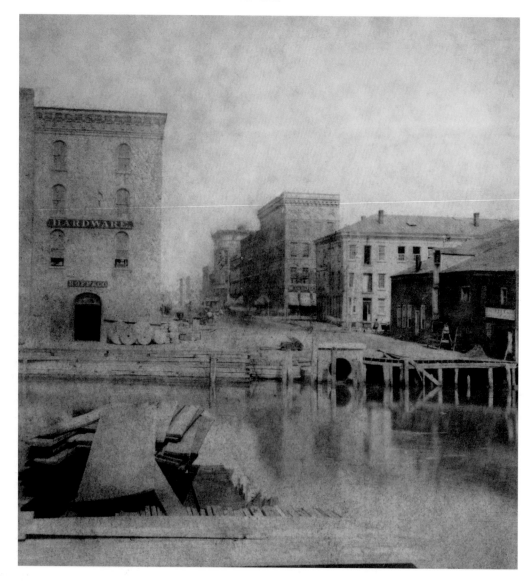

This is Superior Street near the corner of Adams Street, around 1877. The congregation of St. Paul Methodist-Episcopal, shown at center, later built a church on Madison Avenue. Superior and Adams streets are today at the heart of downtown, which has not seen single family dwellings for upwards of a hundred years. In 1877, however, Toledo was a walking city—most destinations could be reached by foot.

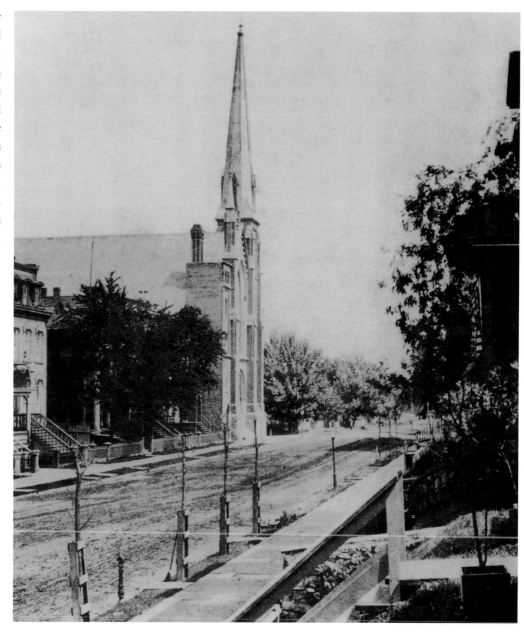

3

The Maumee River was vital to the economic health of the city, but it could also be a destructive force. Shown here is an 1883 ice gorge. After a hard winter, sudden thaws can cause ice on the Maumee River to break up; these ice floes then become jammed against bridges across the river. In earlier times, the combined force of the ice and water could damage or even destroy a bridge.

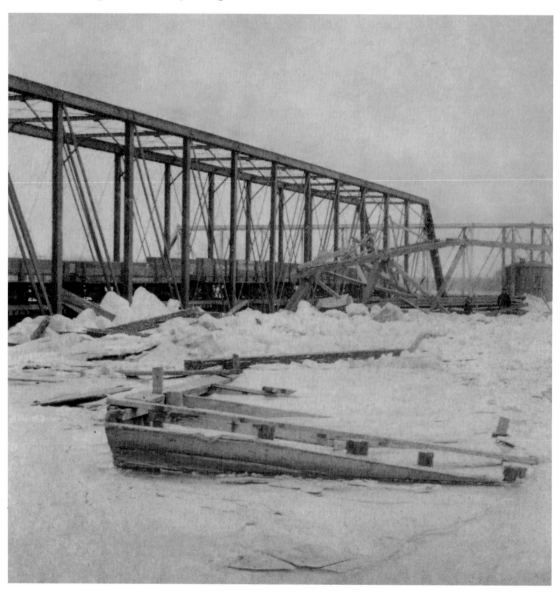

Like much of the rest of the nation, after the Civil War Toledo attempted to attract manufacturing concerns. In 1878, the city succeeded in attracting the Milburn Wagon Works to Auburndale, a newly established suburb, partly financing the construction of a factory. By the mid 1880s, Milburn claimed to be the largest wagon manufacturer in the world. This success, and the discovery of natural gas near Findlay, encouraged a second manufacturing company, the New England Glass Company, to relocate to Toledo in 1888.

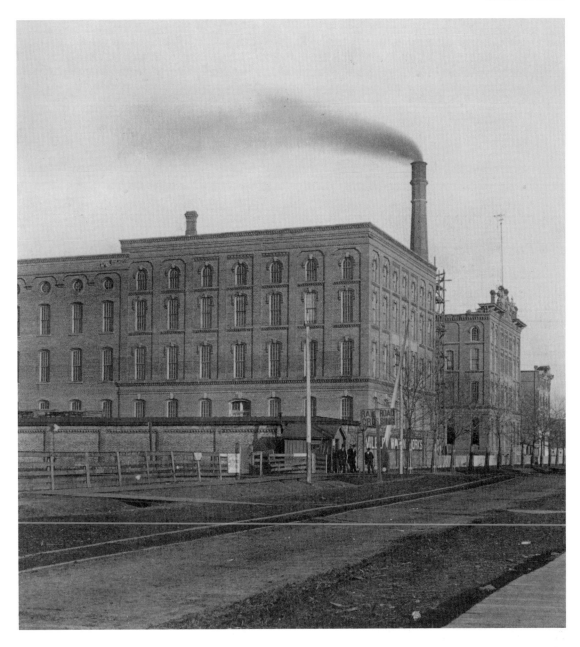

Ice gorges not only damaged bridges in 1883, they also backed up water in sufficient quantity to flood downtown—especially along Water Street. The number of bridges crossing the Maumee during this earlier time created more places for ice floes to jam against, causing the river to back up. Today, because of the flatness of the landscape in Toledo and Northwest Ohio, the Maumee rarely floods in Toledo proper—flooding takes place farther upriver.

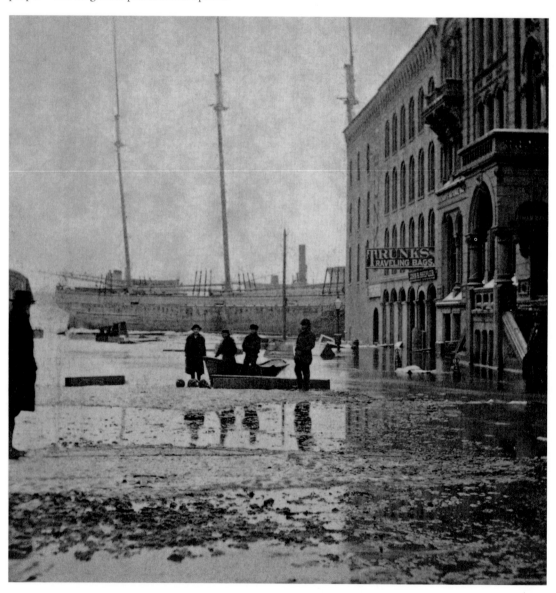

The sixth-grade class at Franklin School in 1887 poses for the photographer. Franklin was located in East Toledo, on Elm between 3rd and 4th streets. By 1887 Toledo had a number of grammar schools, as well as a high school, constructed in 1853. Besides the public school system, Toledo's growing Roman Catholic population also supported grammar schools at many of the parishes that had been established.

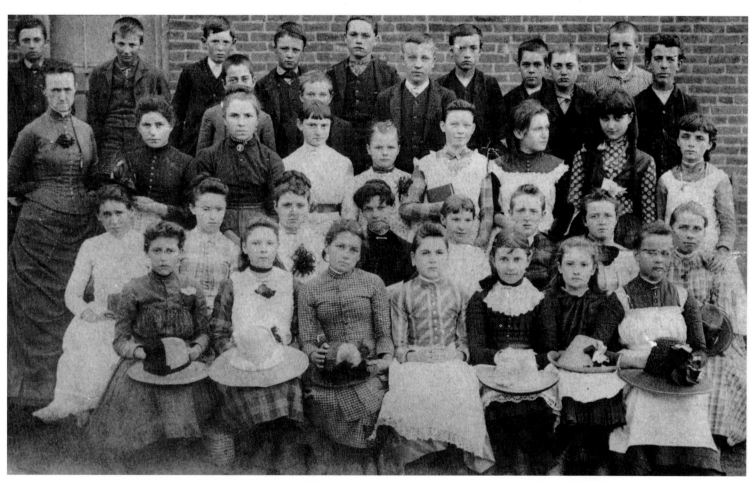

In the 1880s, Toledo was still a "walking city"—making this brownstone an attractive Madison Avenue address.

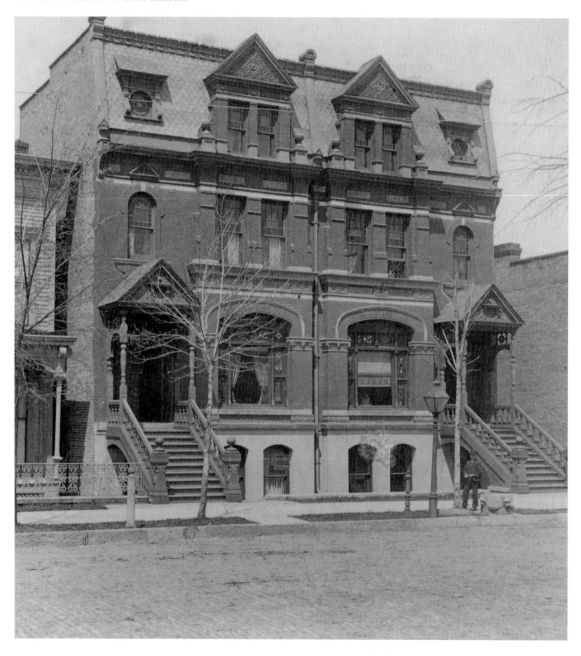

Summit Street near Jefferson Avenue (ca. 1890). While this street cleaner is taking a cigarette break, others are busy shopping in the heart of the commercial district. Given the difficulty of preserving food before the advent of the refrigerator, food shopping was often a daily errand.

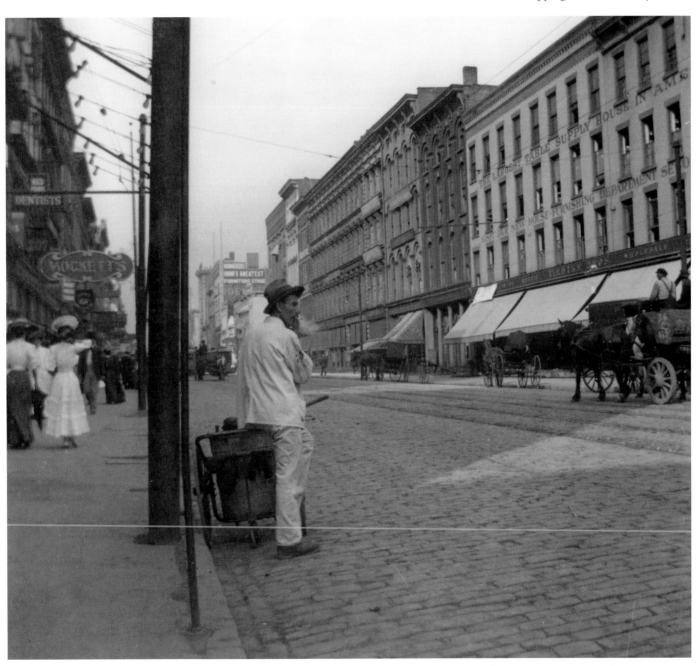

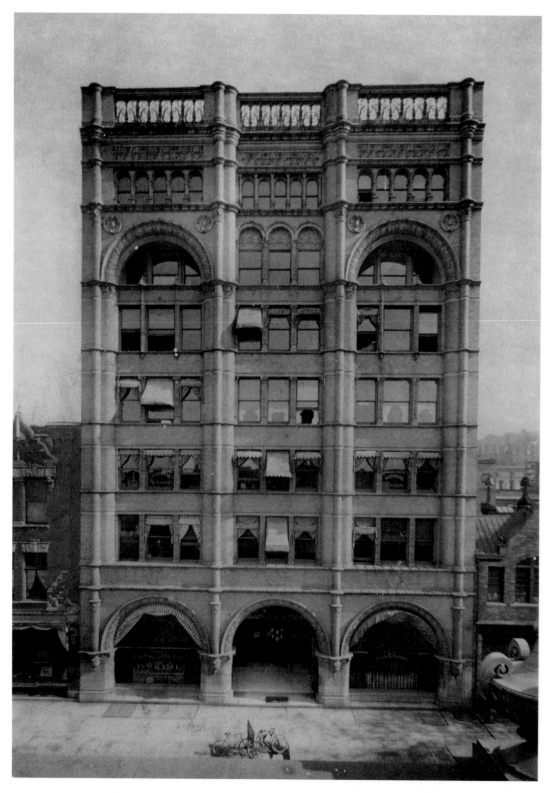

The National Union Building housed a fraternal society that provided low-cost insurance for its members. This was an important financial fallback for many working families in the era before Social Security and company pensions, when the burial of a family member could create a financial burden. This photograph was made around 1890.

Rush hour, ca. 1890, at the intersection of Cherry, Summit, and St. Clair streets. In the distance is the Cherry Street Bridge, gateway to East Toledo.

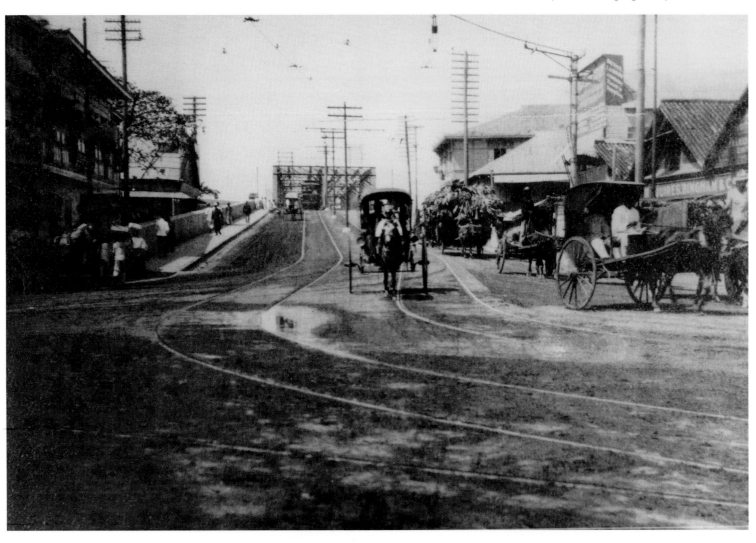

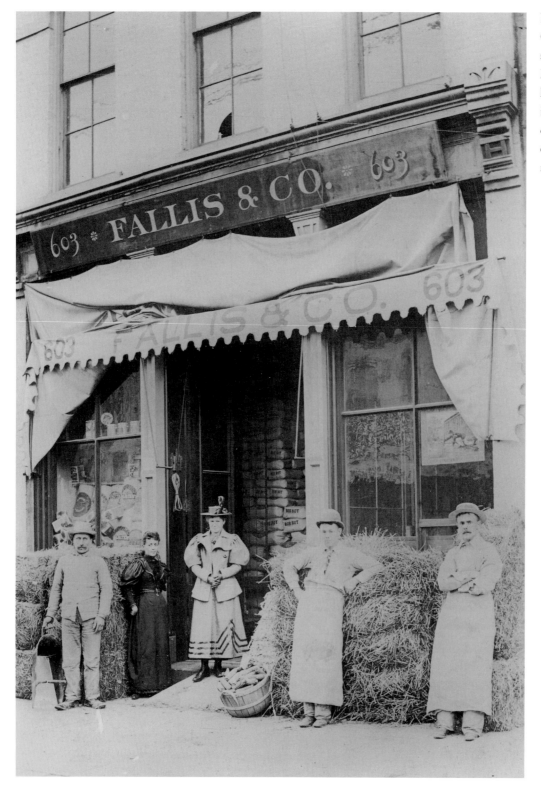

In the 1890s, Fallis and Company provided bakery supplies from their store at 603 Monroe Street. Bakeries were located in most neighborhoods in Toledo before the turn of the century, since fresh bread and other foods had to be purchased regularly.

These men are members of the baseball team sponsored by the Toledo State Hospital. The team was city champion in 1894. Team sports like baseball and football were seen as a way to promote camaraderie among workers.

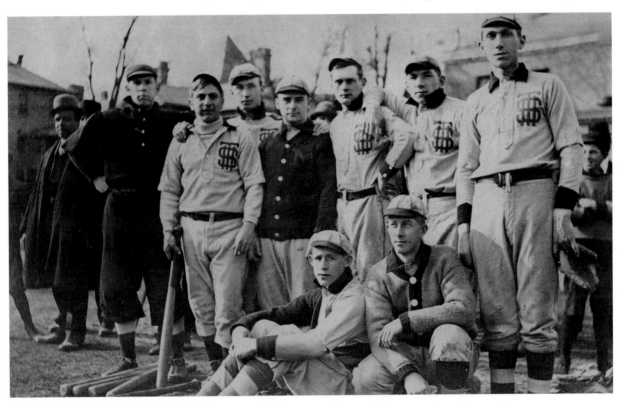

The Gardner Building was erected by Charles Gardner on the site of his boyhood home in 1893. Not tall enough to be considered a skyscraper, the Gardner provided office space for professionals like doctors and lawyers.

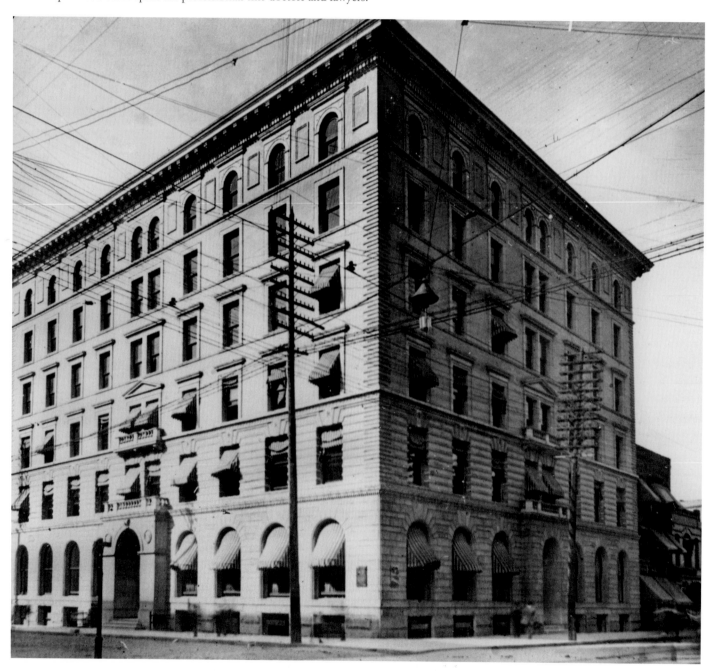

The Fort Industry Block, at the corner of Summit and Monroe streets (ca. 1890). The building was so named because it was thought to occupy the site of an earlier-day fort when it was first built in 1843.

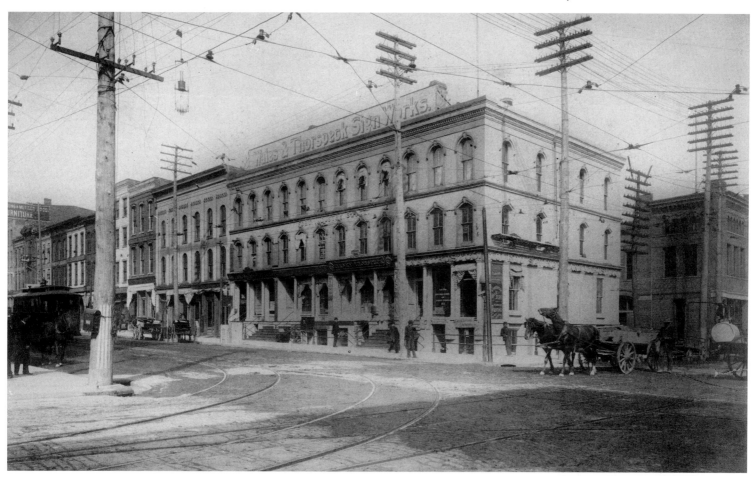

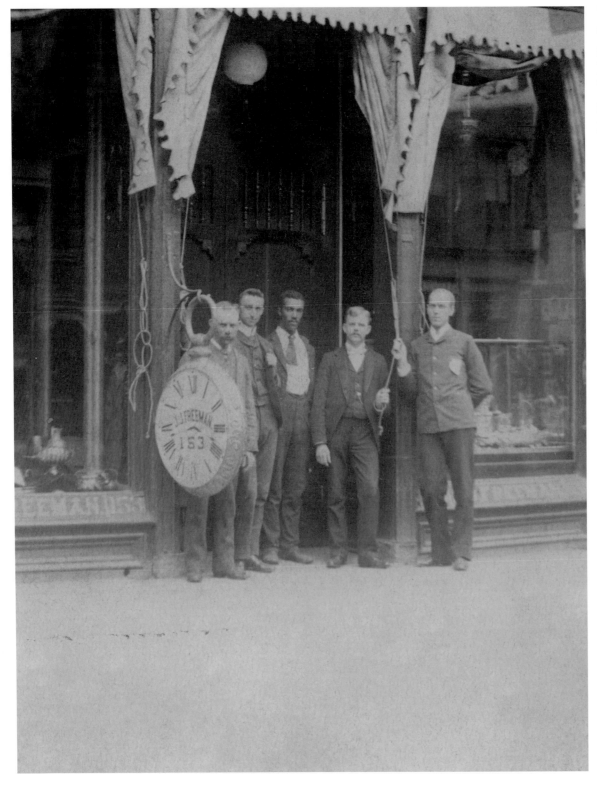

The J. J. Freeman Jeweler Company was the predecessor of Broer-Freeman Jewelers—in business in Toledo to this day. Employees gather in the doorway for this photograph ca. 1890.

Shown here ca. 1895, People's Theatre presented a variety of theatrical productions from its opening in 1889 to its close in 1899. For much of the rest of its life, it was the location of Toledo's best-known burlesque theater.

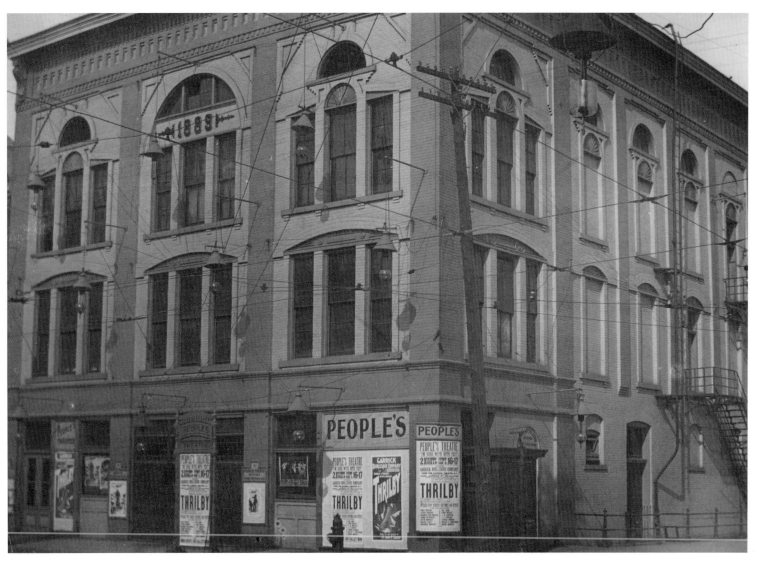

The Wild West show became a staple of circuses during the 1890s, as this parade down
Summit Street demonstrates. As the Western frontier shrank into oblivion, Indians
became a part of the "exotic" that circus customers expected to see.

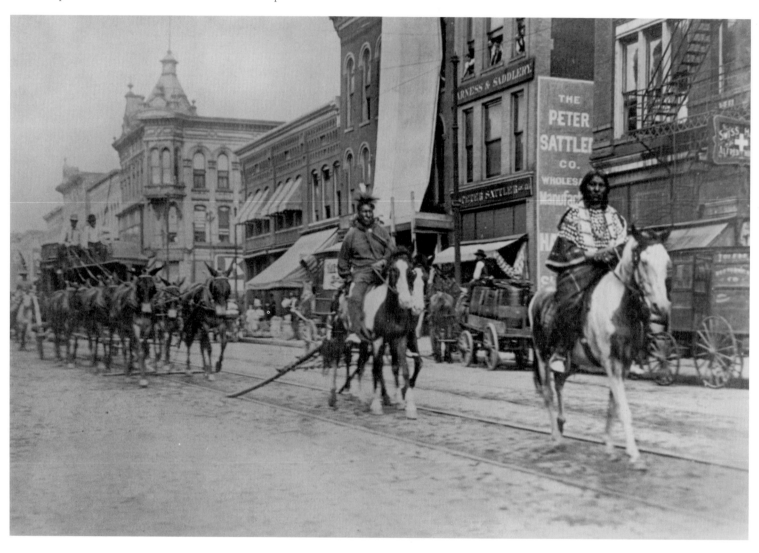

These women are taking care of the paperwork in the family business, the Lamson and Skinner Bending Company, in 1892. Lamson and Skinner specialized in bending wood for making wagon wheels.

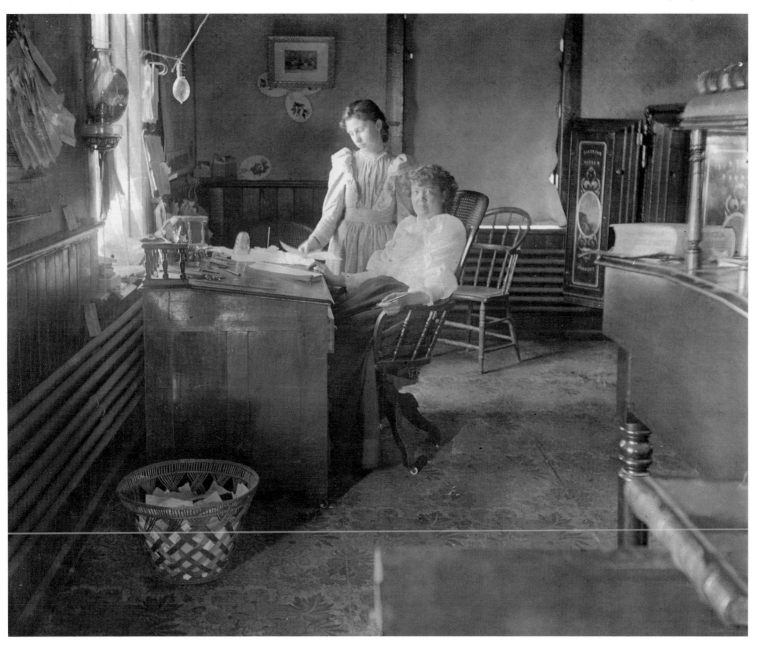

The Toledo Club was located at the corner of Madison Avenue and Superior Street from 1890 to 1915, when the building the club has used ever since opened on 14th Street. The club provided a space where the well-to-do of the city could meet and socialize, much as it does today.

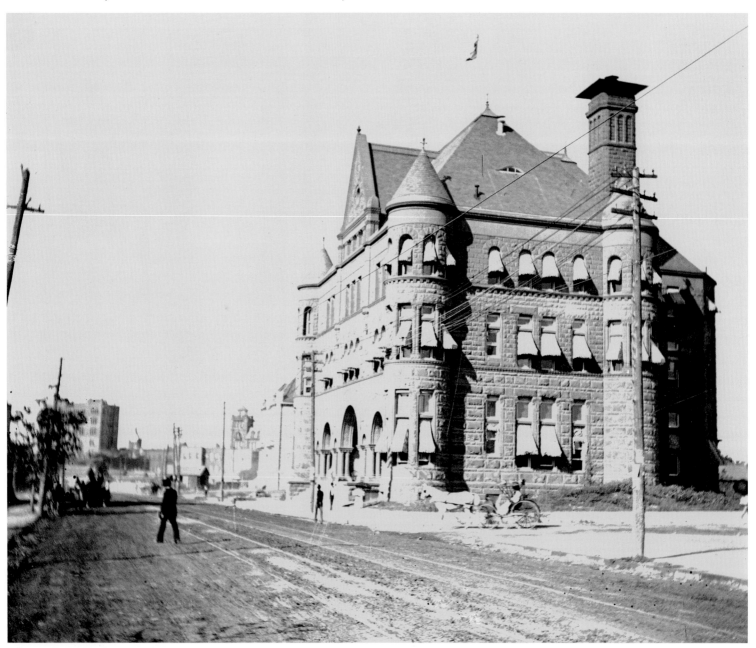

Construction of the new Sheriff's Residence, County Jail, and Powerhouse was accompanied by the construction of a new county courthouse as well. Numerous building projects under way at the same time suggests that residents of Toledo were confident of continuing prosperity in these years.

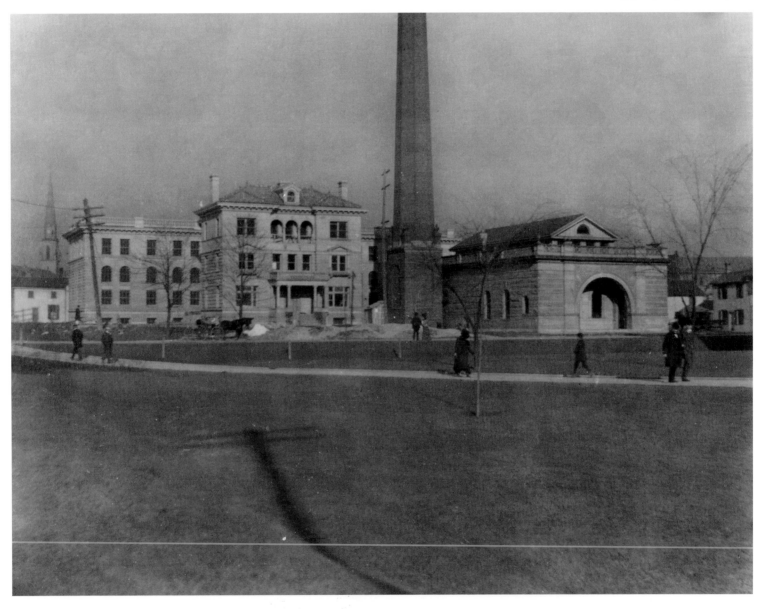

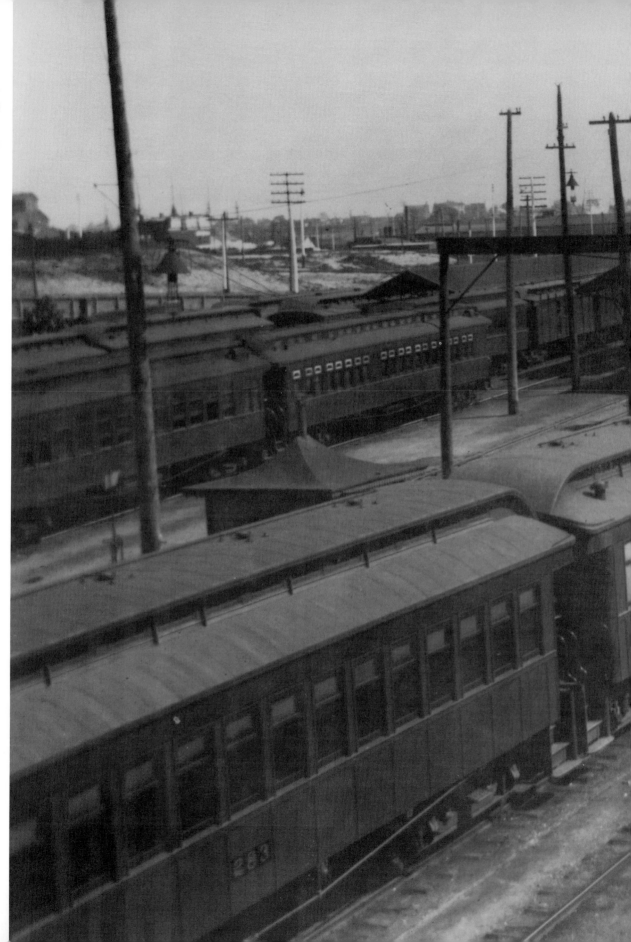

The Lake Shore and Michigan locomotive at right is pulling through Union Station, probably on its way to the Airline Junction (ca. 1896). Toledo has long been an important rail center.

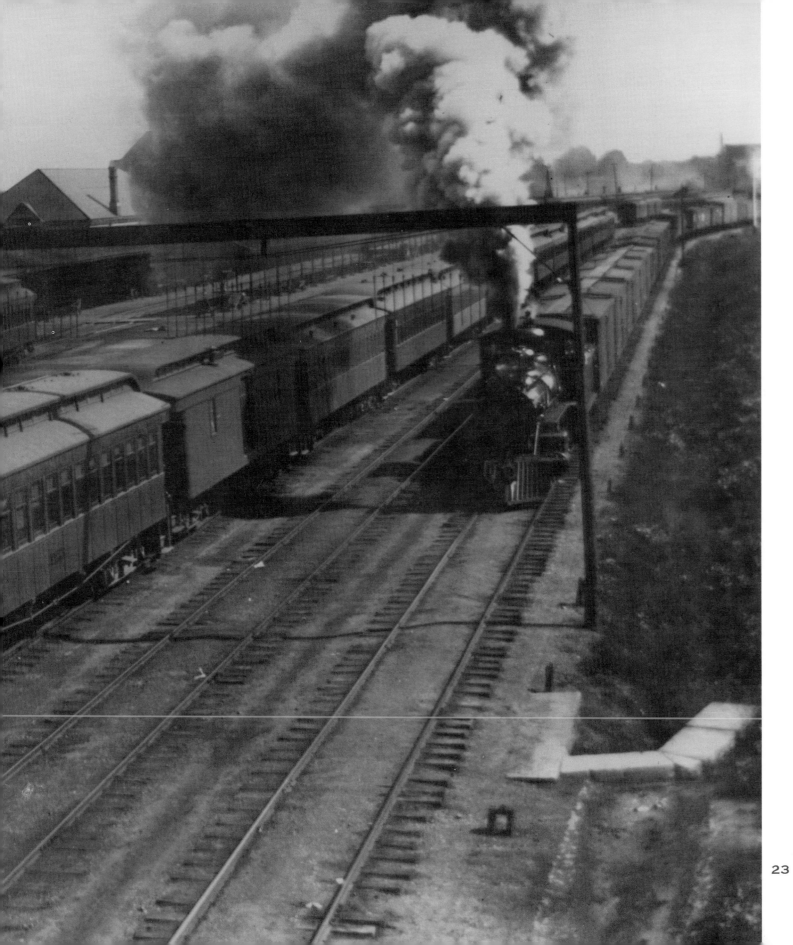

23

The Masonic Temple was located at the corner of Superior and Adams streets when this image was recorded ca. 1890. This building was destroyed by fire. A new temple was constructed at the corner of Adams and Michigan.

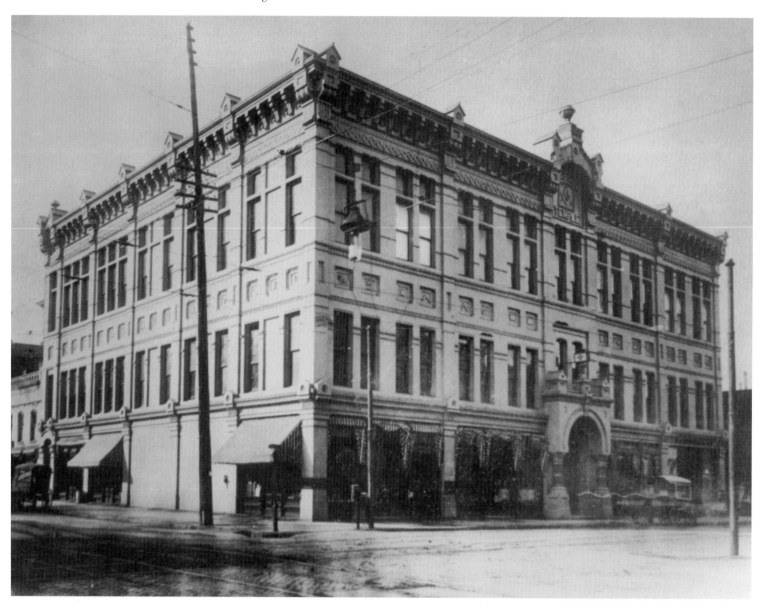

The Hartford Block was located on the southwest corner of Madison Avenue and Summit Street in 1890. The limited technology of early photography often left numerous "ghosts" in the image, as seen here.

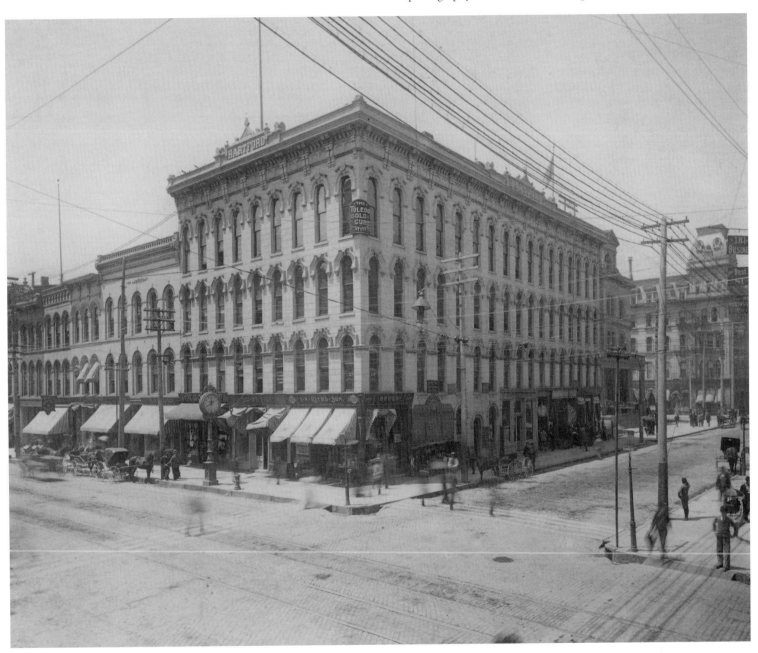

Out with the old, in with the new. This photograph from late 1897 shows the building that served as the county courthouse from 1853 to 1897 (in the foreground) and its replacement (in the background). The larger structure was erected to accommodate the number of courtrooms needed for a growing county.

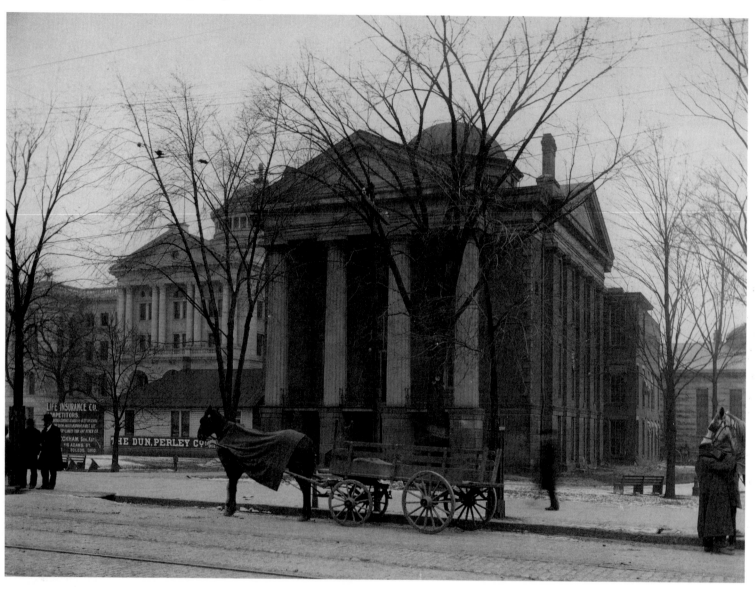

The Elk's Carnival in 1898 was a fundraiser for the organization, with proceeds going toward the purchase of property on Michigan Street that became known as "Fraternity Row."

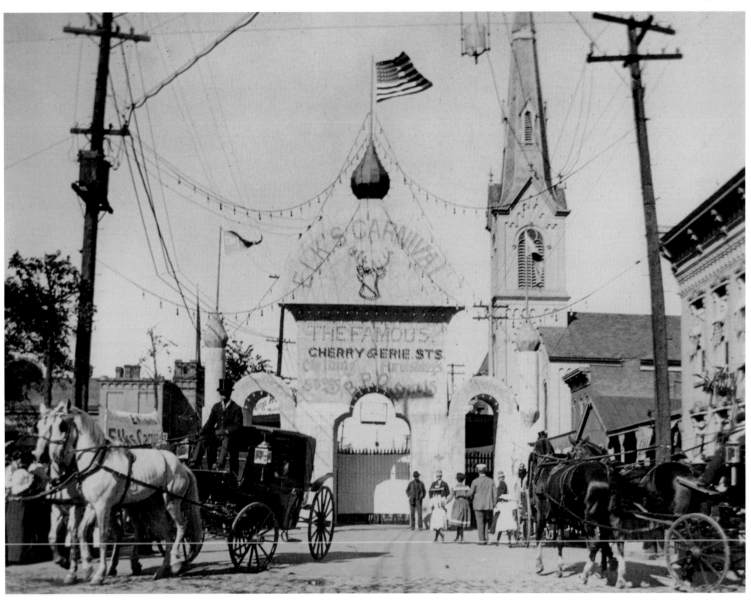

This photograph depicts the Ohio National Guard mobilizing in 1898 to travel to Cuba as part of the War with Spain. Industrial unrest in the years between 1877 and 1894 spurred the construction of fortresses like this one around the nation. The Lucas County Armory was built in 1894 and was destroyed by fire in 1934—after housing Ohio National Guard troops brought in to quell the Auto-Lite strike that year.

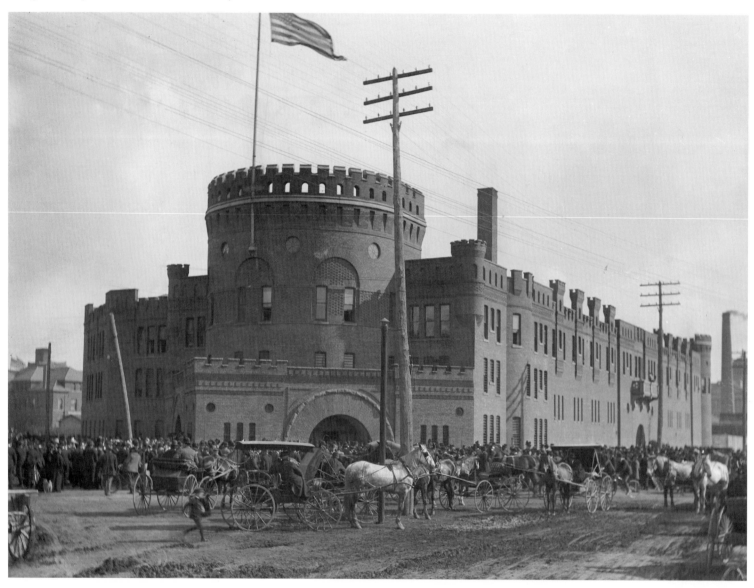

From Port Town to Factory Town

(1900–1929)

Toledo was home to various industries before the turn of the century, and the city remained an important Great Lakes port throughout the twentieth century, but the first thirty years of the twentieth century were especially notable for the growth of industry in the city. Some of these industries were begun by natives, like Dr. Allen DeVilbiss. Some were the brainchild of people who first came to Toledo to work for other companies, like Michael Owens. Still other entrepreneurs were attracted to Toledo for its skilled work force, cheap land, and financial help from the city, like John North Willys.

DeVilbiss was Toledo's first nose-and-throat specialist. He was frustrated with the difficulty, up to his time, of applying medications to throat infections. Out of that frustration was born his atomizer sprayer. This invention not only sprayed sore throats effectively, it also came to be used for perfumes—and, eventually, for painting automobile bodies. DeVilbiss also invented the computing scale, which led to the founding of the Toledo Computing Scale and Cash Register Company—eventually succeeded by the Toledo Scale Company.

Michael Owens moved to Toledo from West Virginia. Although not trained as an engineer, Owens had a mechanical bent, and could cogently explain his ideas to engineers. This led to his invention of the automatic bottle-making machine, which attracted other glassmaking companies to the area.

Perhaps the most important industrialist to move his company to Toledo was John North Willys. Willys had recently purchased the Overland Motor Company of Indianapolis. While looking for a larger factory, Willys received an attractive offer to move into the recently closed Pope-Toledo factory on Central Avenue in West Toledo. Willys-Overland soon became the largest employer in Toledo. Willys in turn attracted a variety of parts suppliers to the city—Champion Spark Plug, Tillotsen Carburetor, Electric Auto-Lite, among many others.

Summit Street bustles with Christmas shoppers and traffic around the turn
of the century. Many of the then independent streetcar lines had transfer
points on Summit—which was the most popular shopping destination in
Toledo at the time.

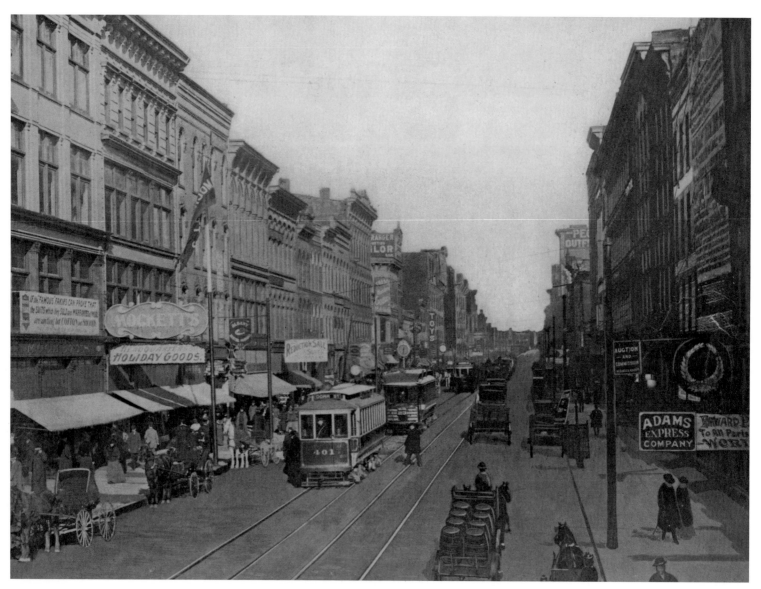

Another popular means of transportation at the turn of the century was the bicycle—even by well-dressed young women like this one. The bicycle this woman is riding could well have been manufactured in Toledo—the city styled itself the "Coventry of America" (Coventry was the main bicycle manufacturing center in Great Britain), and was home to several bicycle manufacturers, as well as makers of bicycle parts.

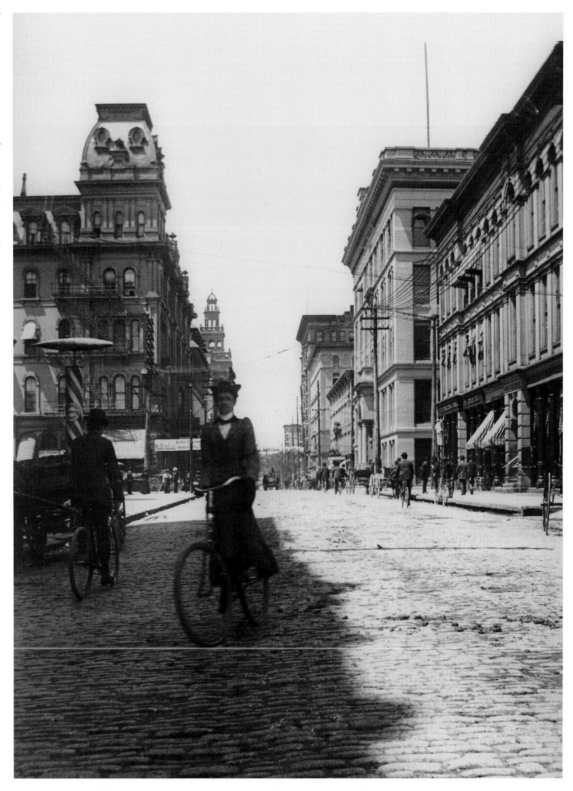

Among the advertising campaigns boosting Toledo, this sign proclaiming "You will do better in Toledo" was one of the most dramatic. This lighted sign, together with similar displays depicting a lake freighter and a railroad engine, sat atop a building at the corner of Summit, Cherry, and St. Clair streets.

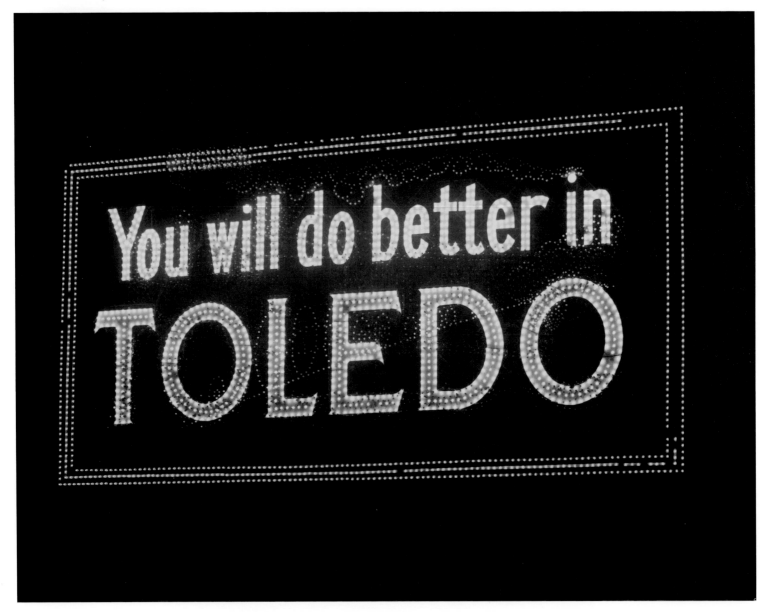

This photograph shows the comfort station at City Park, with a matron seated outside, and a park worker leaning against the building. It is part of a series of photographs that appear to have been taken at City Park around the same time. City Park was one of the oldest parks in Toledo, and this comfort station was probably part of an effort to upgrade facilities in the park (ca. 1914).

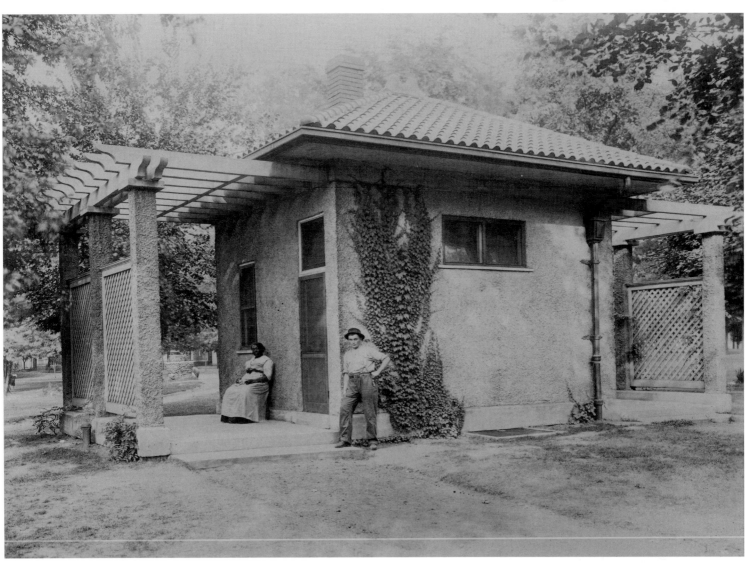

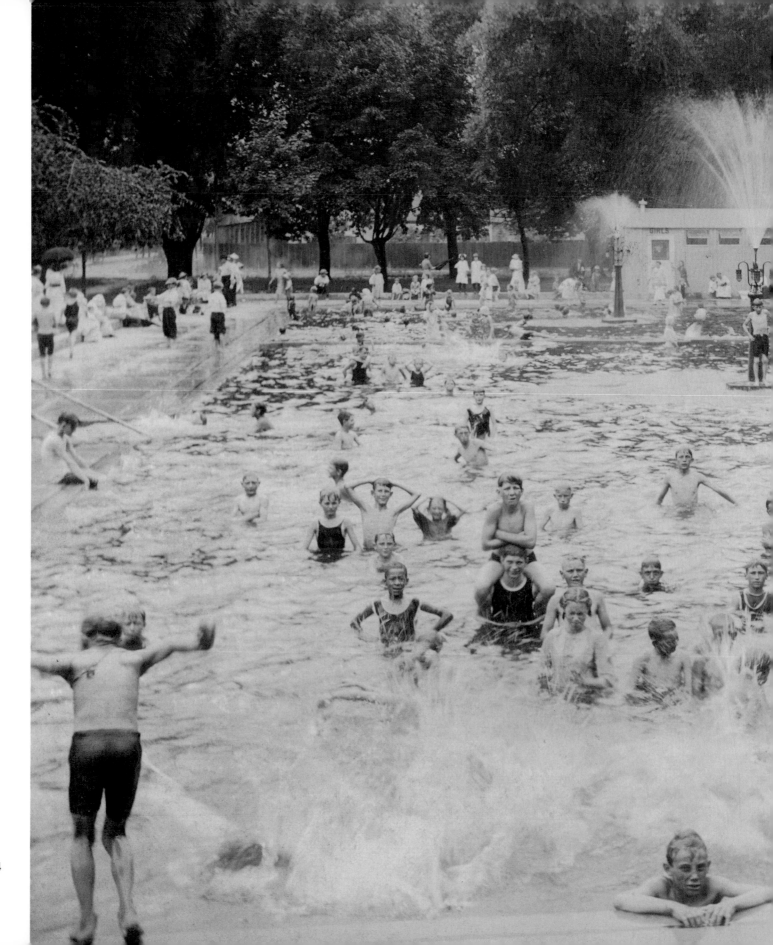

34

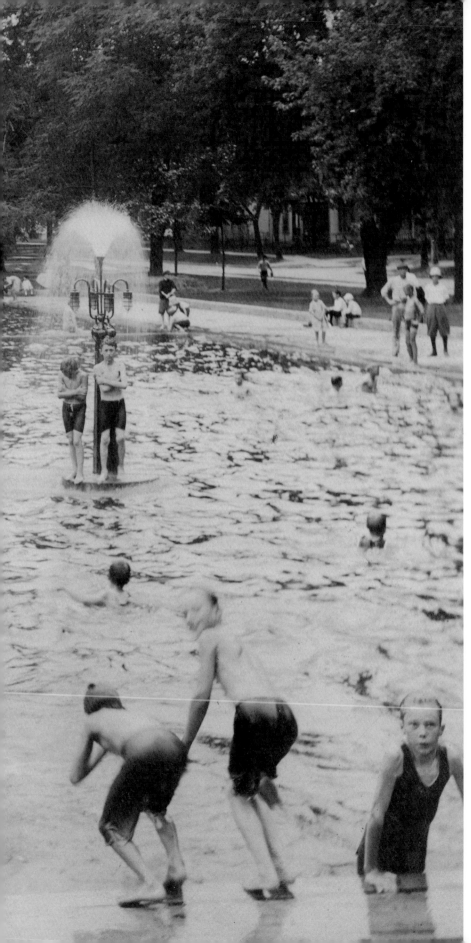

This pool was located in City Park, formerly Lenk's Park. Municipal pools were built in several city parks in the 1910s. Although there were earlier parks in Toledo, they were privately run. In the administration of Samuel M. "Golden Rule" Jones, a push was begun by Jones's associate Sylvanus Jermain to build a number of new parks, and to link them together with a boulevard system of streets. This photograph was probably made around 1914—evidence suggests that the swimming pools were added around that time.

This scene was recorded at City Park, probably ca. 1914. The earliest playground in the city was in a park located at the corner of Smith and Canton streets. After observing the success of this playground in keeping children from playing in the streets, playgrounds were added to other parks. This image was probably recorded to illustrate how nicely the children were using the new equipment.

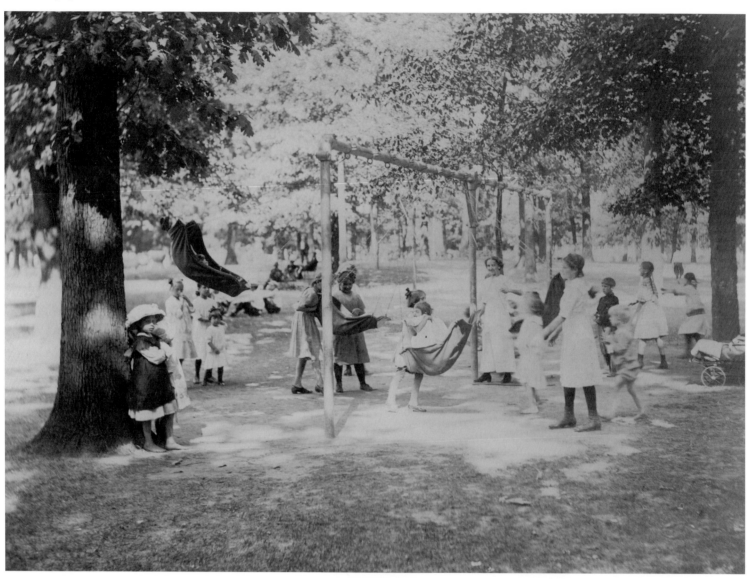

This hotel lobby displays all the amenities expected by patrons of such a space—a shoeblack, a tobacco counter, spittoons, and a comfortable place to enjoy the tobacco product.

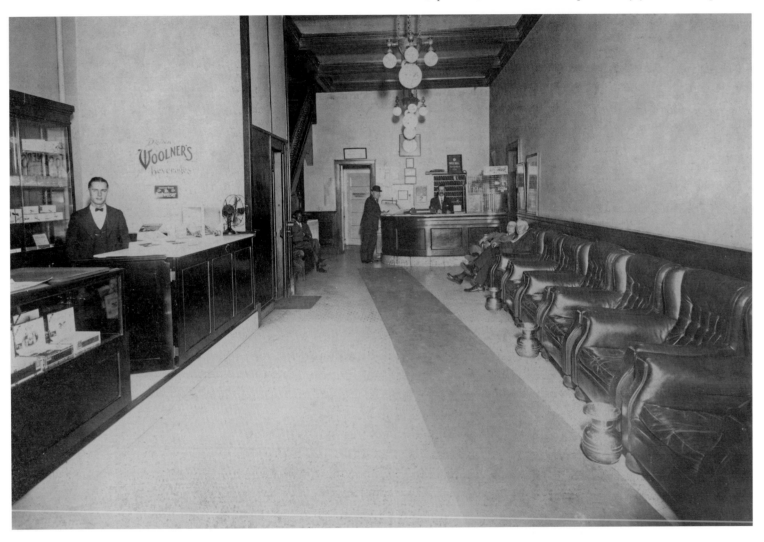

Inspired by the popularity of the Midway at the World's Columbian Exposition of 1892-93 in Chicago, the "exotic" became a regular attraction at circuses.

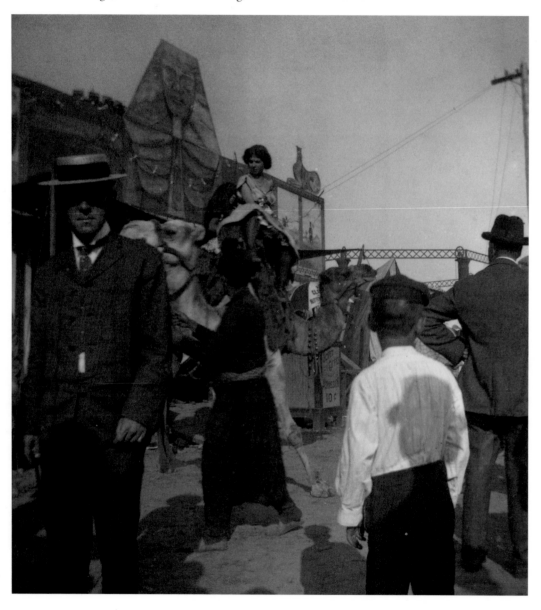

John Robinson's Circus provided a three-ring show under the
big top, as well as two stage shows, like this one.

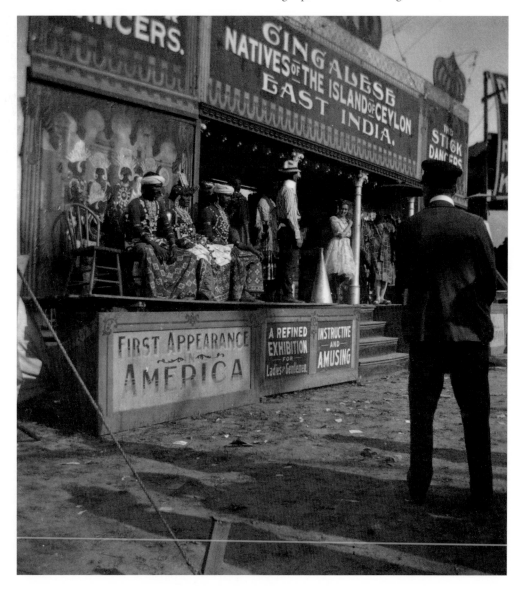

The *City of Toledo* made daily excursions between Toledo and Put-in-Bay during summer months. Here the boat is just getting under way, backing away from the dock on the Maumee River. Ohio's Lake Erie Islands were a destination for citizens who could afford a second home there or hotel fare.

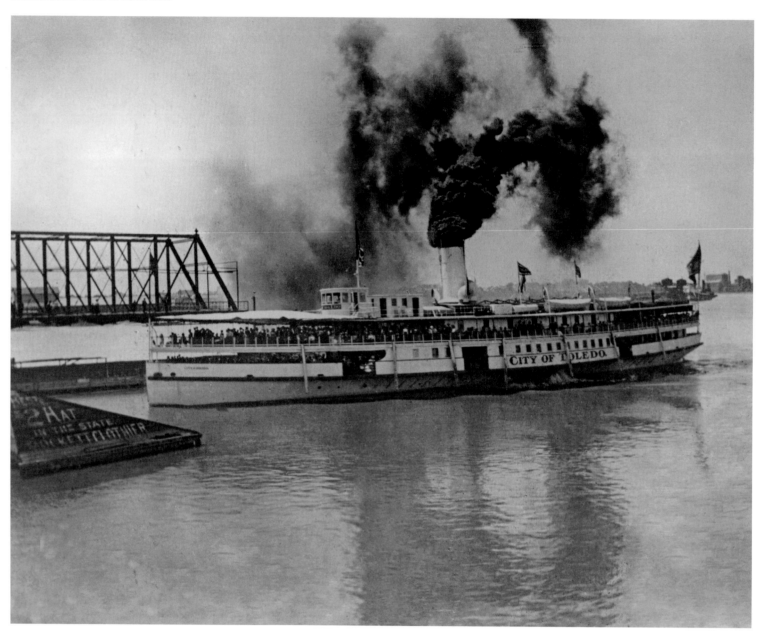

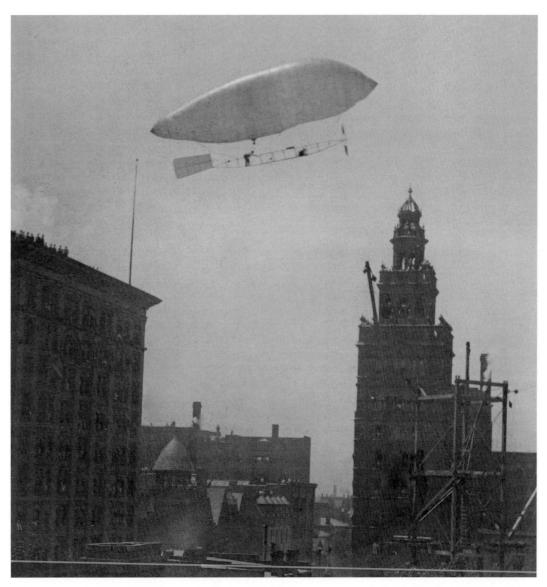

Aviator Roy Knabenshue won a $500 award from A. L. Spitzer for being the first dirigible pilot to land and take off from the top of the Spitzer Building in downtown Toledo. On June 30, 1905, Knabenshue piloted the *Toledo I* from the fairgrounds located at Dorr Street and Upton Avenue to the Spitzer Building, and back, in just around 30 minutes. Despite his derring-do, and the short life span of many aviators of the time, Knabenshue lived to the ripe old age of 83, dying in California in 1960—of natural causes.

Conant Street in Maumee. The welcome signs are for the Grand Army of
the Republic encampment taking place downriver in Toledo, indicating
that this photograph was made in 1908.

A popular way for church and civic groups to raise money just after the turn of the century was to hold a "lawn fete." Front yards were usually festooned with American flags and Japanese lanterns, and guests were served light snacks and lemonade (ca. 1915).

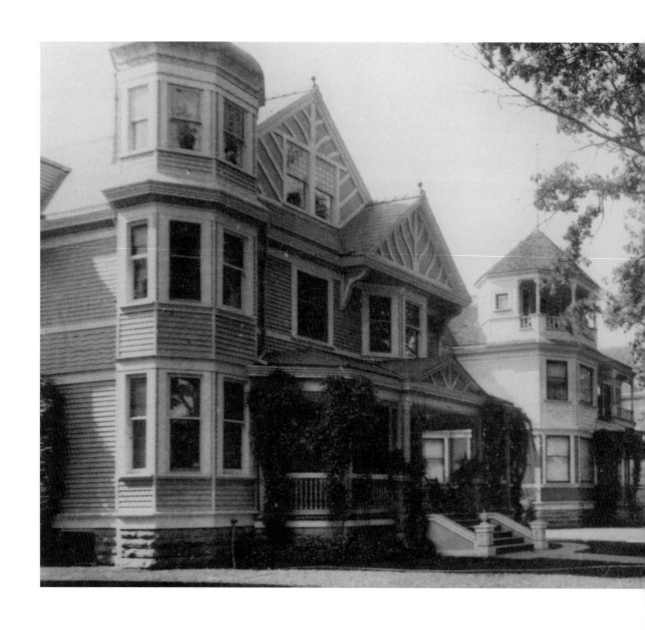

44

The Old West End became
a fashionable address during
the 1890s; it remains one of
the largest Arts and Crafts
architectural districts in the
nation today.

The lobby in the Boody House hotel around the beginning of the twentieth century. Many hotels catered to traveling salesmen, which explains the absence of women in photographs like this one.

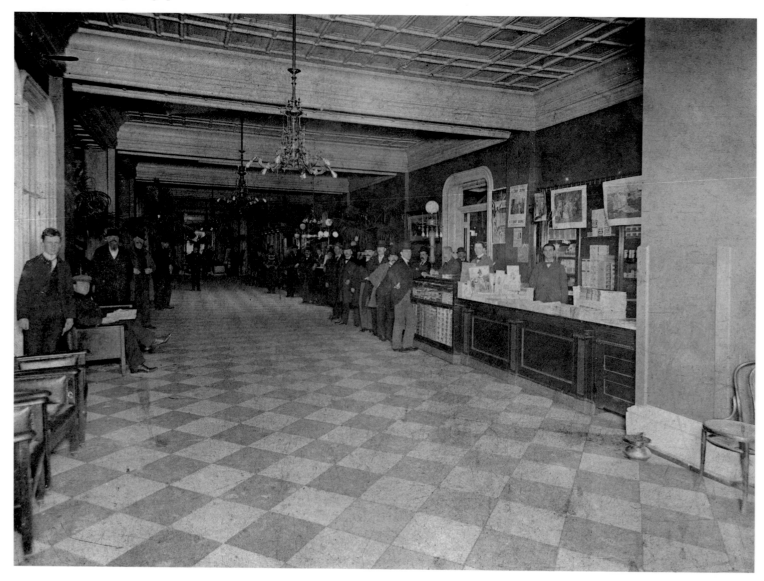

The National
Union Building was
constructed by a
fraternal insurance
company. These
companies provided
working-class people
with the means to
afford a funeral should
something untoward
happen. When this
building was erected in
1892, it was the tallest in
Toledo; by the following
year, it had lost that
distinction to the Nasby
Building.

The Nicholas Building site at the corner of Madison Avenue and Huron
Street. The workers in view are part of a demolition crew (ca. 1905).

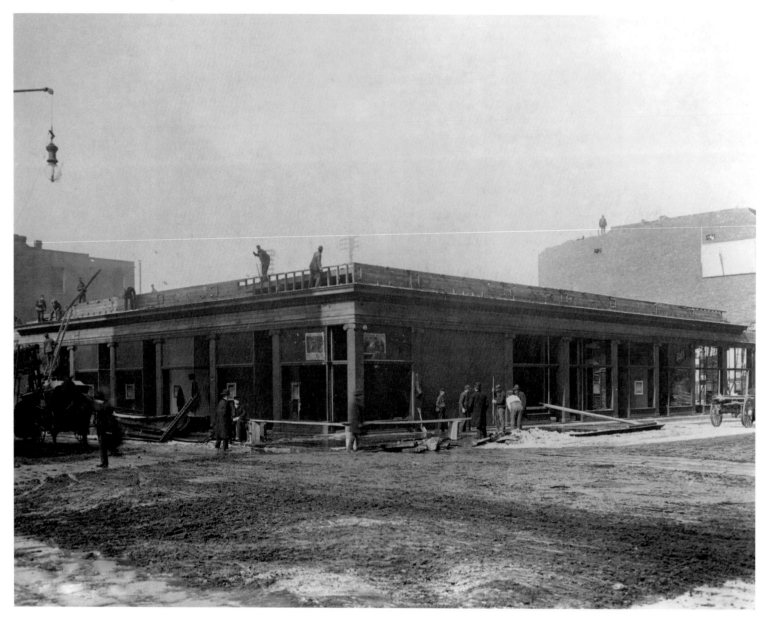

St. Paul Methodist-Episcopal Church (ca. 1905). A prime example of
Gothic Revival architecture, it was destroyed by fire in 1979.

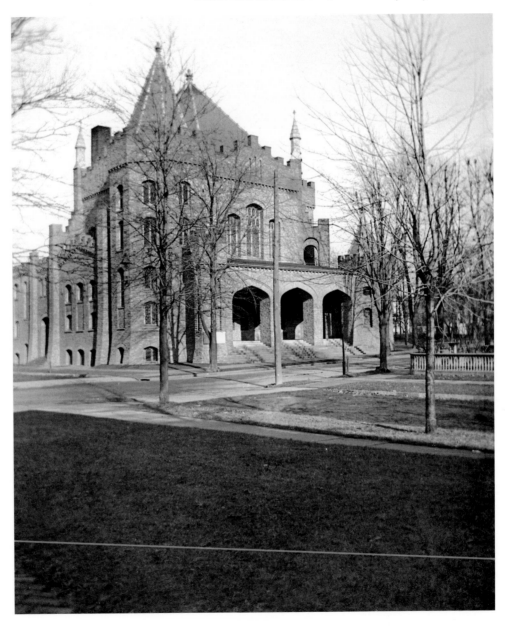

Washington Street. Washington has traditionally divided downtown from the Warehouse District—although just after the turn of the century, this difference was not quite so stark as it is today.

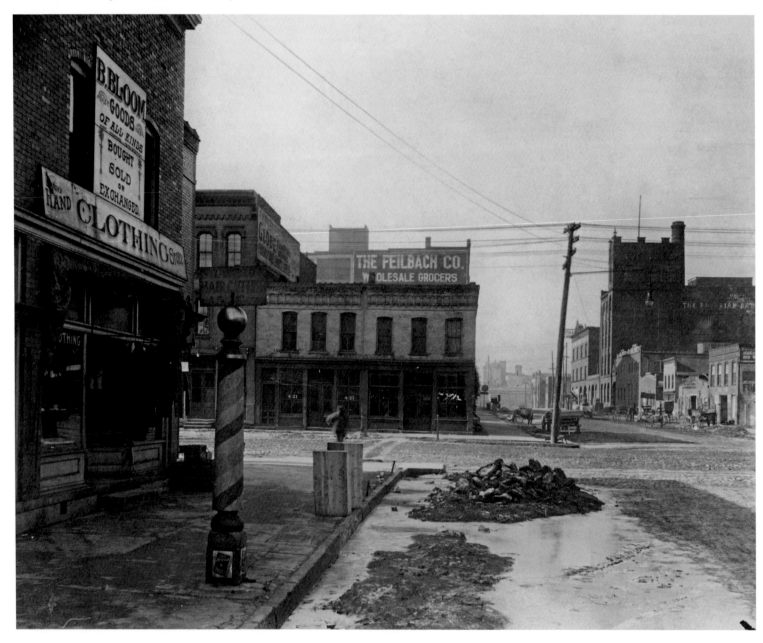

The influence of Chicago architects— particularly Louis Sullivan—is visible all around early- twentieth-century Toledo. Neither eight- story building here is tall enough to qualify as a "skyscraper," but their lack of ornamentation except at the cornice is Sullivanesque.

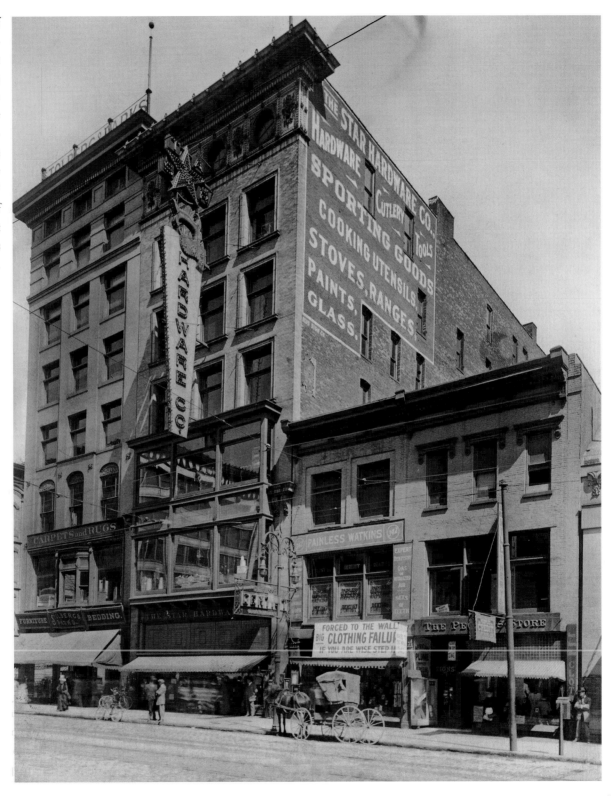

The amusement park at Walbridge Park was an extremely popular recreation spot for Toledoans—and would be until fire destroyed the park in 1960. This section was known as "the midway," after the Midway of the World's Columbian Exposition in Chicago, which had taken place twelve years before this photograph was made (1905).

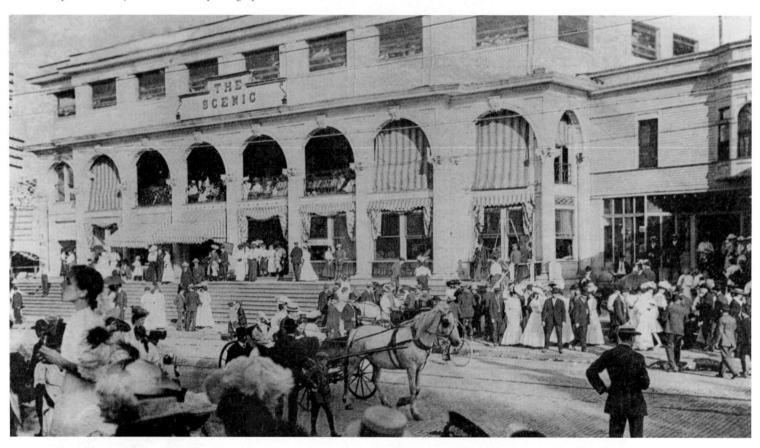

Lake Erie Park and Casino was at the end of the trolley car line in point place, popular for its roller coaster and its boardwalk around the turn of the century.

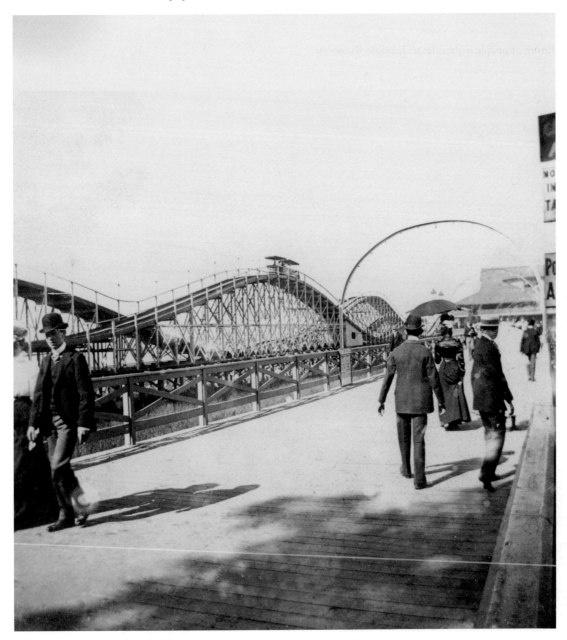

Somewhere in this throng of people is President Theodore Roosevelt
(ca. 1906).

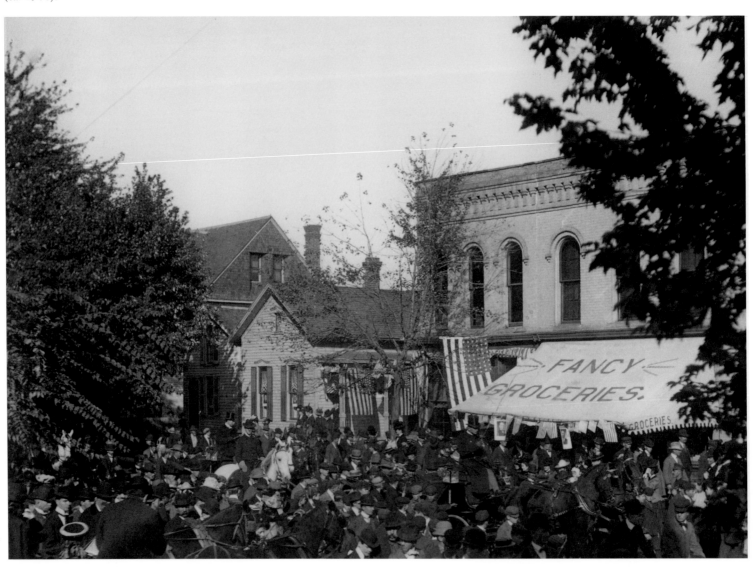

Grand Army of the Republic (G.A.R.) week, downtown Toledo, 1908. Much of the city was decorated for the event. This encampment seemed to resonate with the participants and observers, who must have recognized that there would not be many more such occasions—the Civil War had ended more than forty years before.

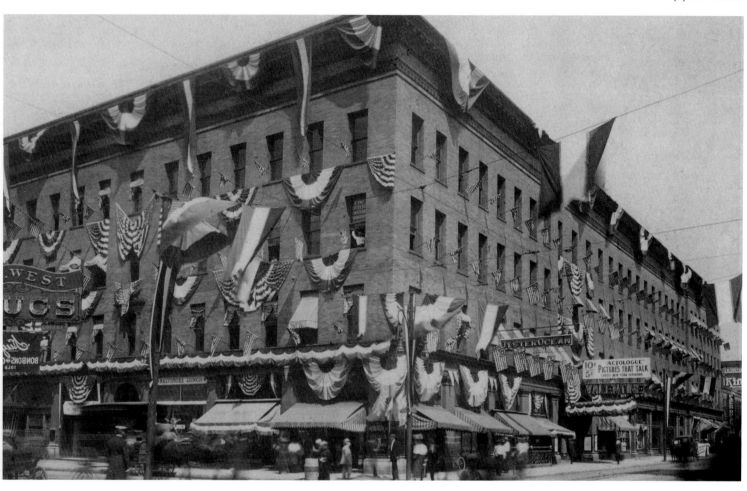

This show of patriotic zeal was probably decoration for a festive
Independence Day celebration ca. 1912.

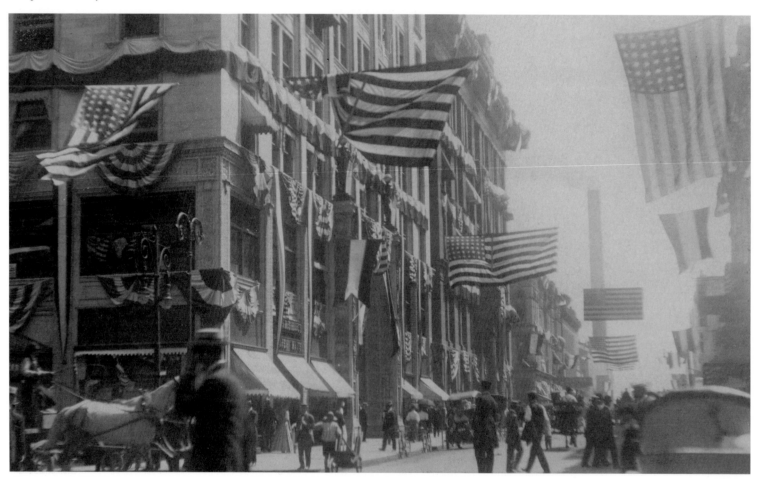

The Wamba Festival was held to demonstrate what a fun city Toledo could be. City leaders appropriated a mythical figure from the history of Toledo, Spain, and built a festival—with parades and the crowning of a king and queen—around it. The festival was held in 1909.

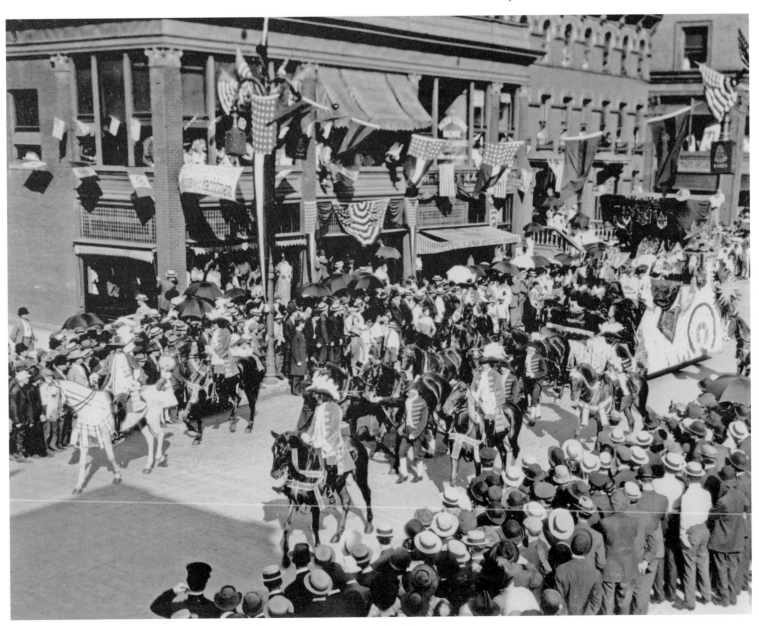

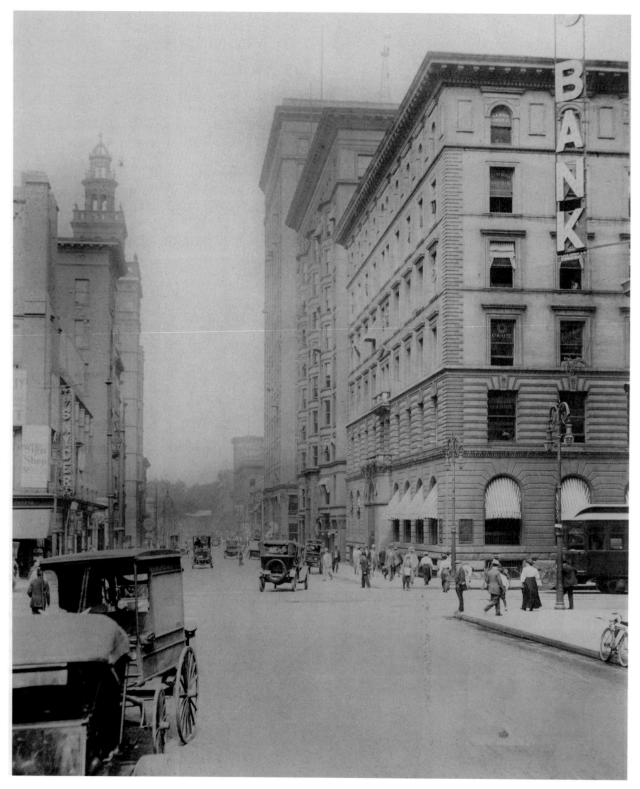

Madison Avenue, facing west from St. Clair Street, ca. 1915. Madison has long been the heart of the financial district in Toledo.

Jess Willard was known as "the Great White Hope," a reference to white boxers who attempted to defeat black boxer Jack Johnson. After becoming the lone successful great white hope, defeating Johnson in Havana, Cuba, Willard refused to fight any black challengers. When Jack Dempsey became champion, he followed suit—leaving potential African American challengers like sparring partner Robert Buckley, the "Jamaica Kid," out in the cold.

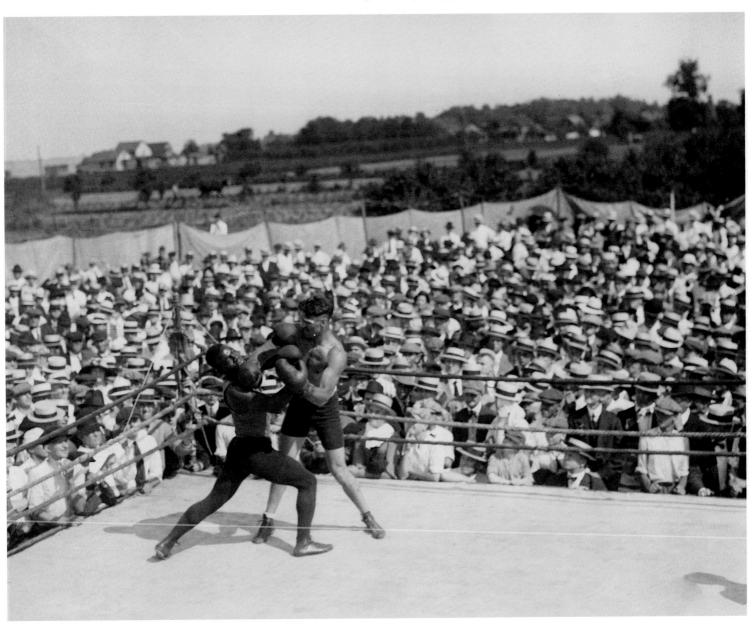

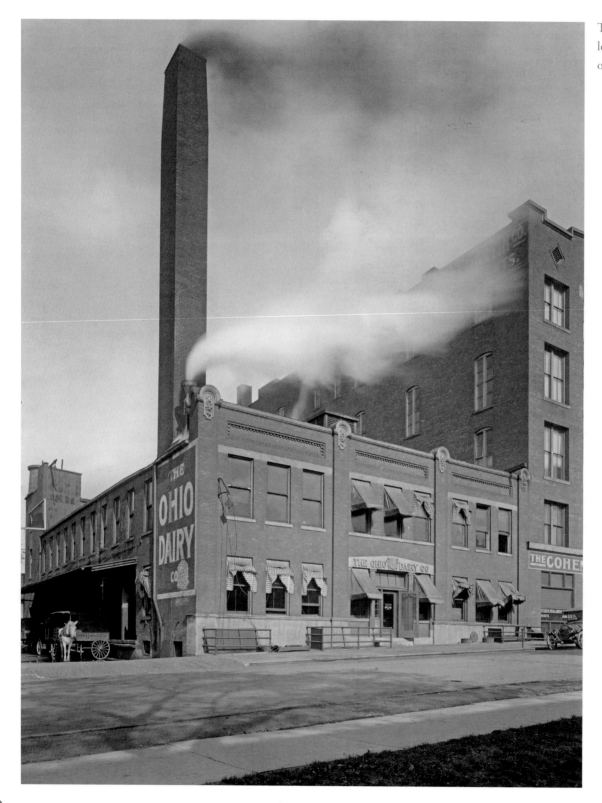

The Ohio Dairy was located near downtown, on Erie Street.

Employees of the Tiedtke Brothers Department Store pose for the camera ca. 1910. This photograph was probably made when the store opened at 410 Summit Street, near the corner with Adams. Shoppers could find just about anything they wanted at low prices at Tiedtke's. One sign promises "We search the markets of the world for desirable goods."

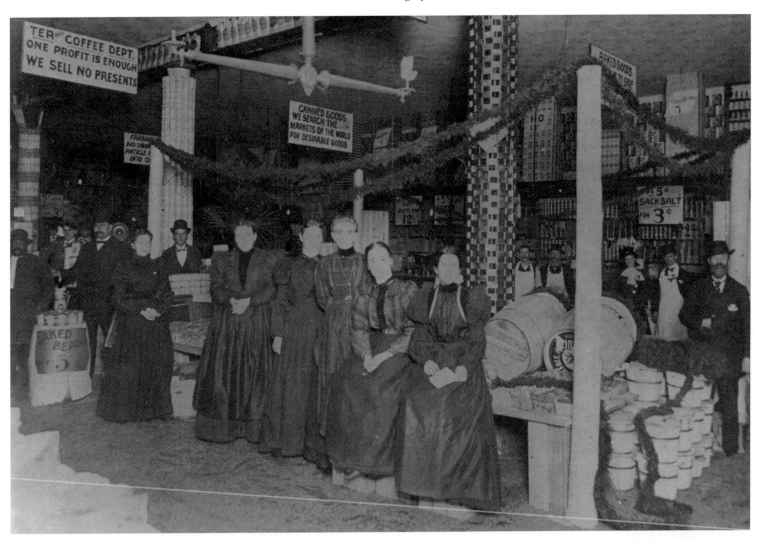

The LaSalle and Koch Department Store was located at the corner of
Jefferson and Superior in 1910. Within a few years, the store moved to
its new location on Adams at Huron.

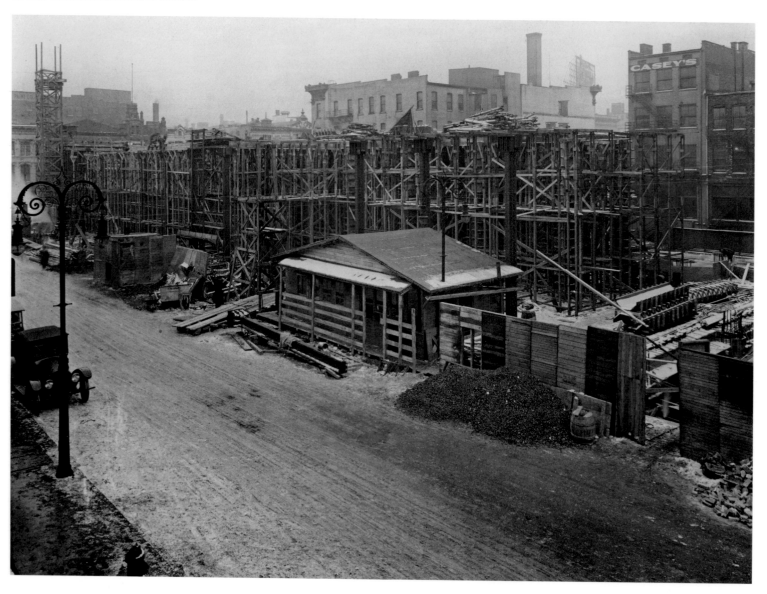

The Willys-Overland Company, like many other companies of the day, often sponsored cultural activities for employees, like this concert in the engineering department in 1912.

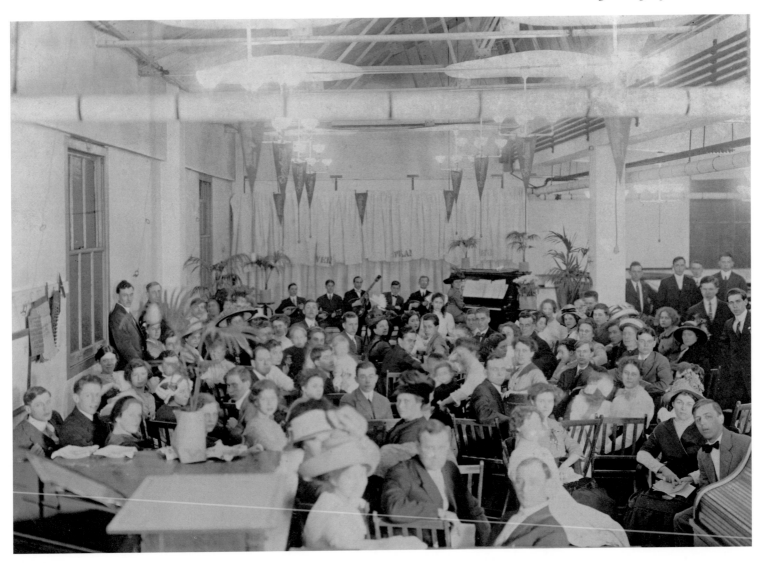

Following Spread: As the center of legal activity for the county, the Lucas County Courthouse has been a busy place—especially around 1910, when this image was recorded.

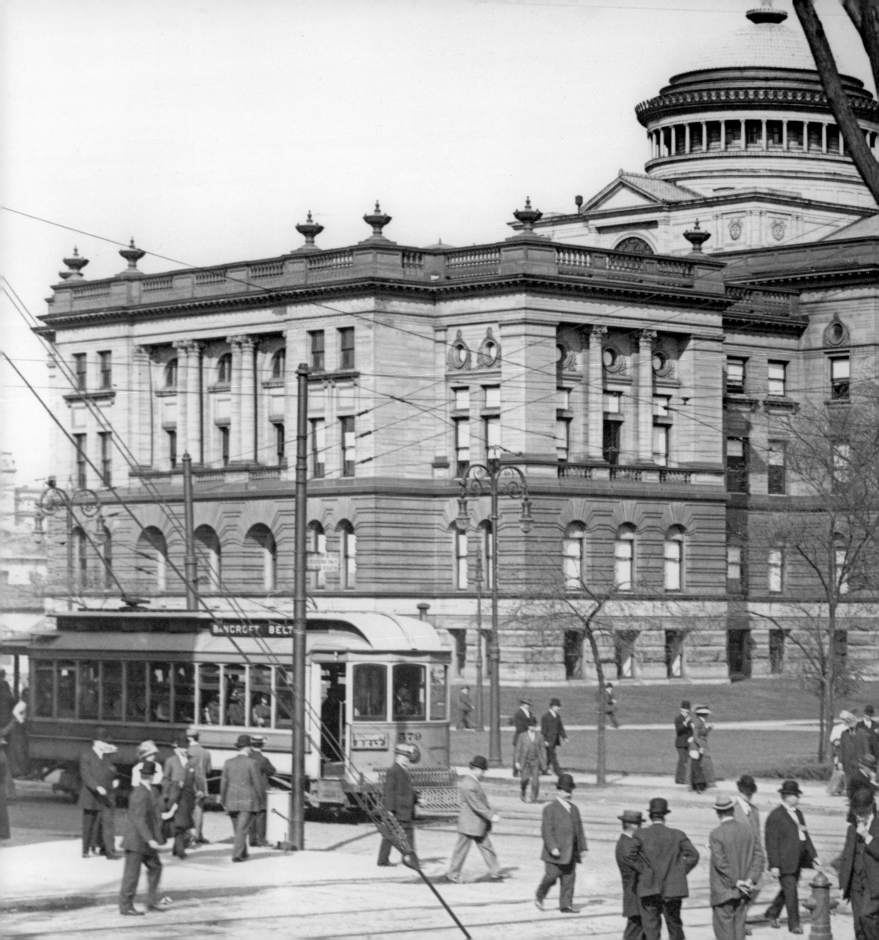

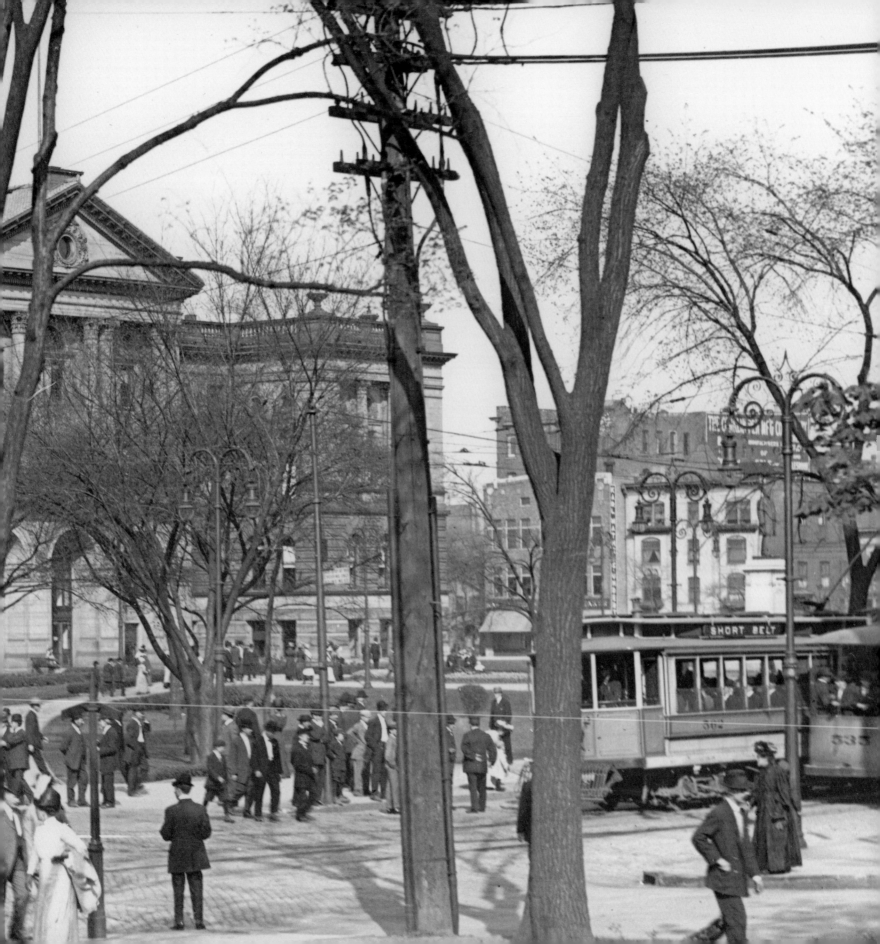

Fred J. Edler was able to show off his skills as an upholsterer in his modified runabout (ca. 1910).

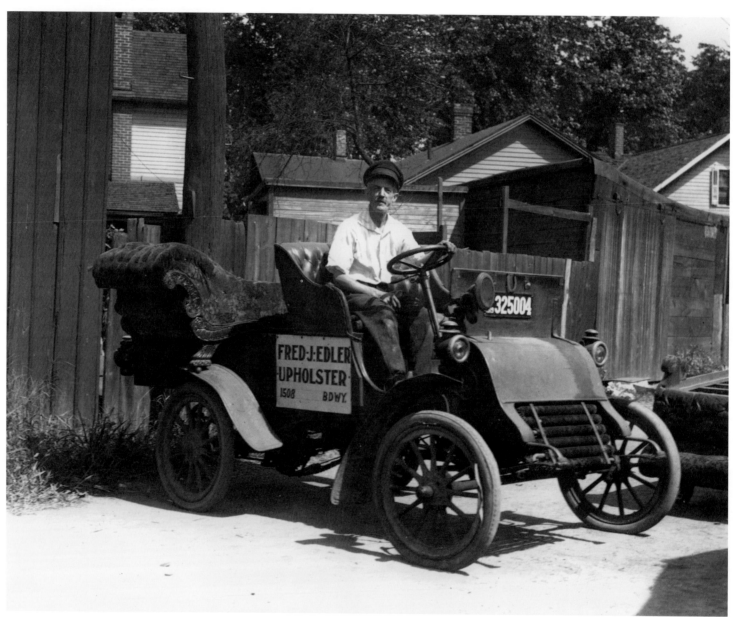

The men in view here are John and Fred Zurfluh in 1913. Their jewelry shop was on Monroe Street.

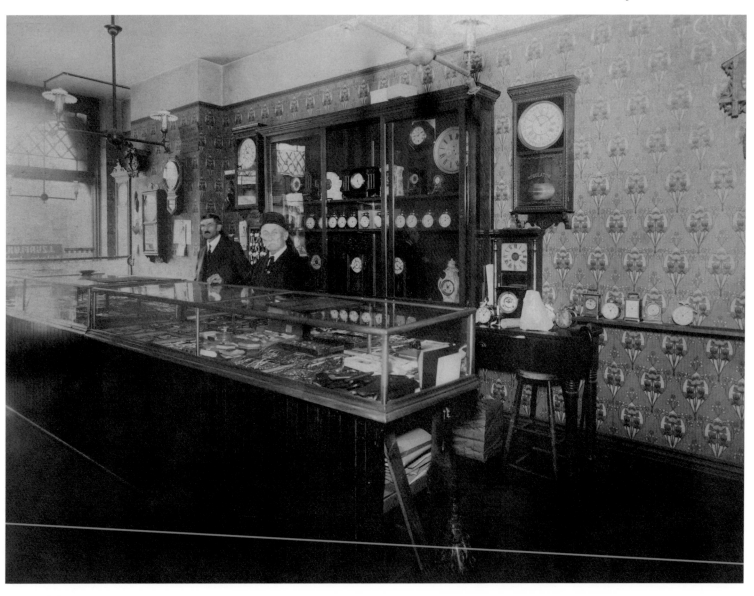

The Holmes Snowflake Laundry Building was the first Toledo location for the
Champion Spark Plug Company, attracted to the city by the Willys Overland
Company. Willys agreed to buy spark plugs from Robert and Frank Stranahan,
if they would relocate their company to Toledo (ca. 1910).

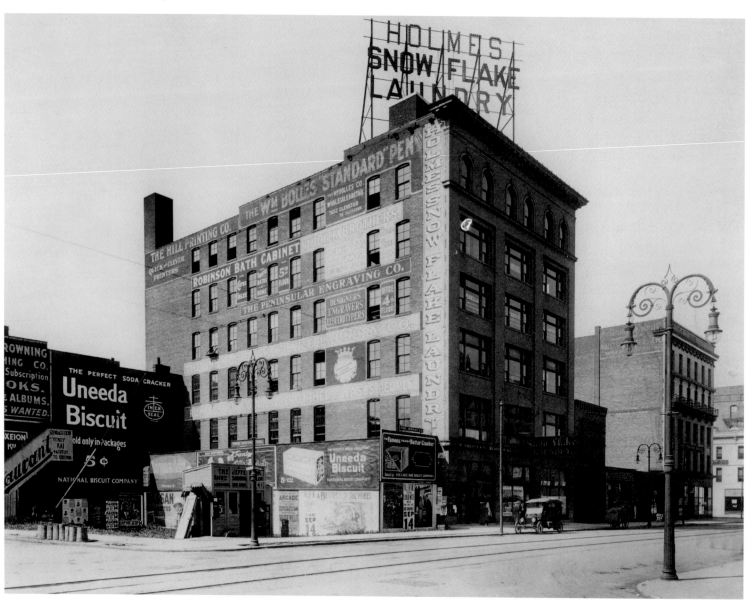

In celebration of Commodore Oliver H. Perry's victory over the British on Lake Erie, a replica of the *Niagara* visited Toledo, escorted by the *Wolverine,* in 1913.

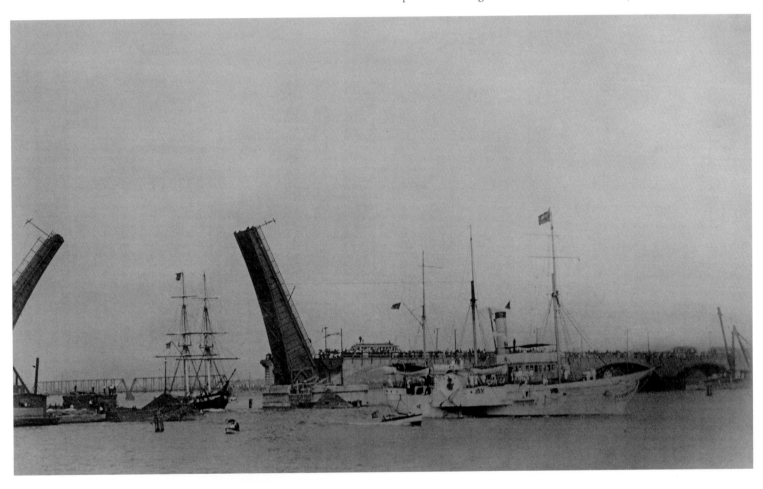

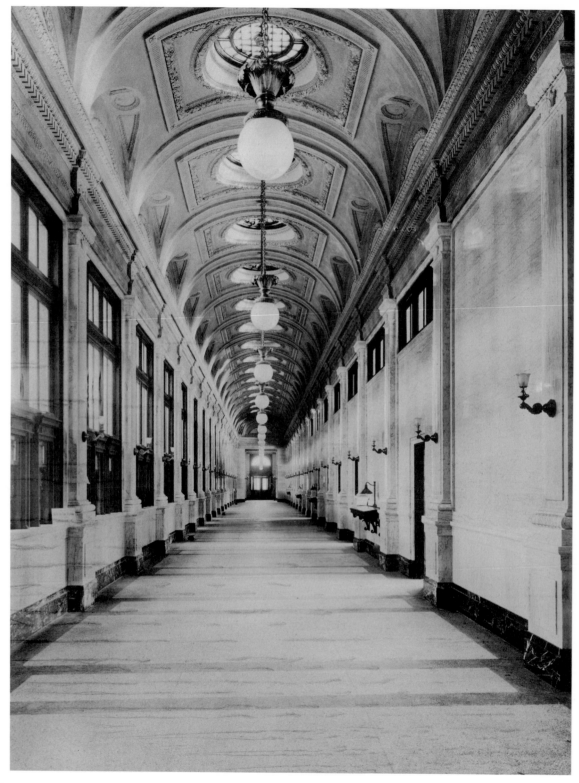

The long hallway of the newly opened Main Post Office on 13th Street, just before it opened in 1911. It served as the post office until 1962, when a new building was constructed on S. St. Clair.

The circus parade from the train station to the circus grounds was always a reliable way to attract a crowd, like this one ca. 1910.

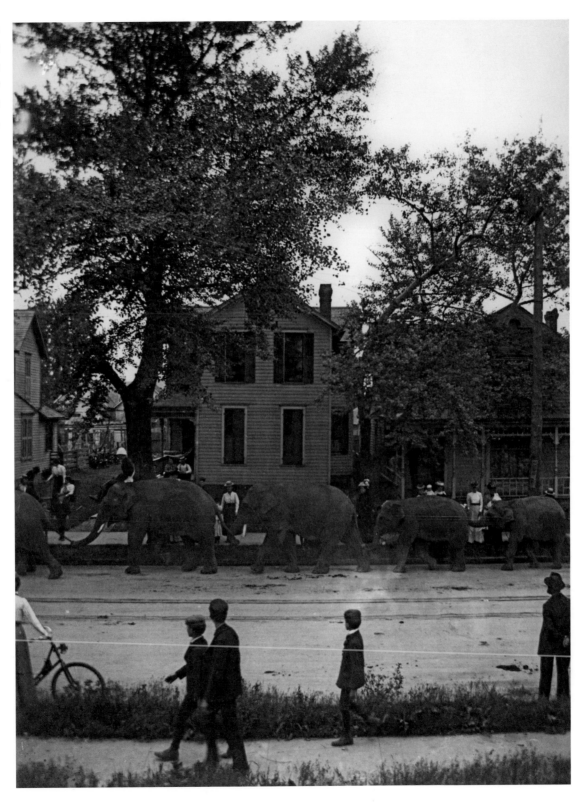

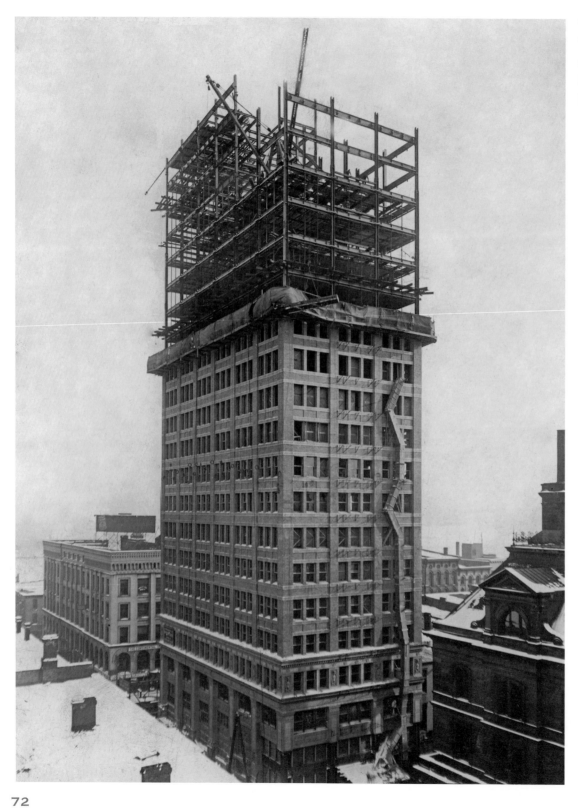

The Second National Bank (later Toledo Trust) building was the tallest building in Toledo when it opened in 1913. The Ohio Building surpassed it in 1930.

With airports still far and few between in 1912, pilots were always looking for new places to take off and land, sometimes on the water.

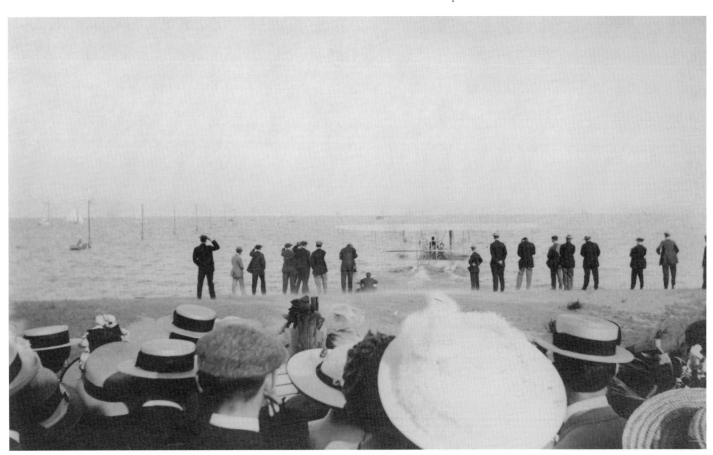

These gentlemen are looking over the cannon aboard the replica *Niagara* during the Perry Centennial in 1913.

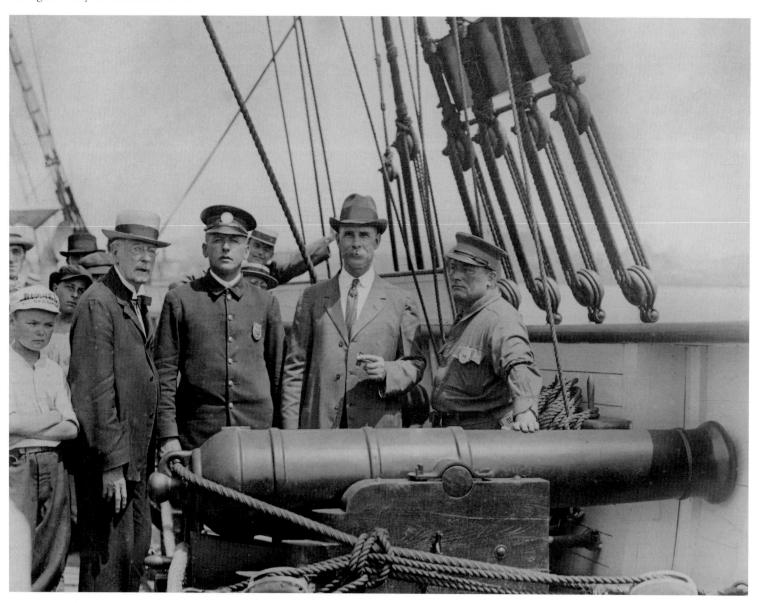

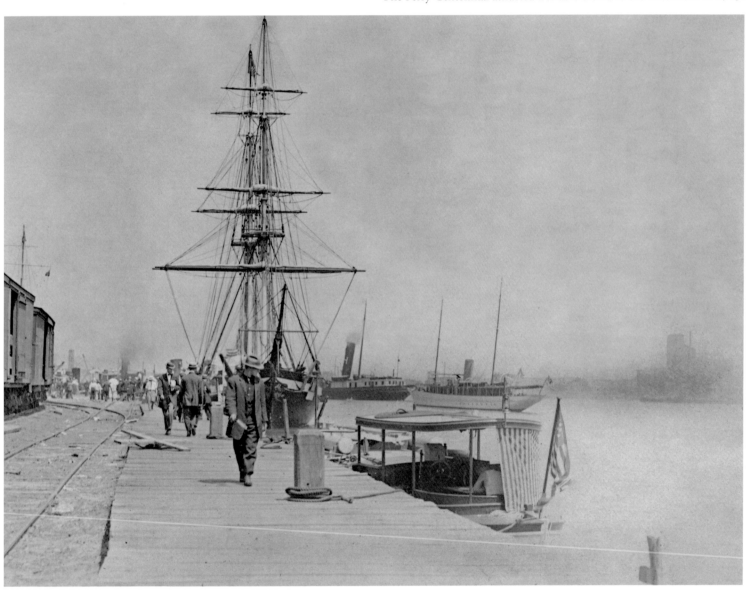

The Perry Centennial attracted a sizable crowd to the waterfront in 1913.

This trained bear was photographed behind the old Main Library, which
was located at the corner of Madison Avenue and Ontario Street. The
photograph was taken about 1915.

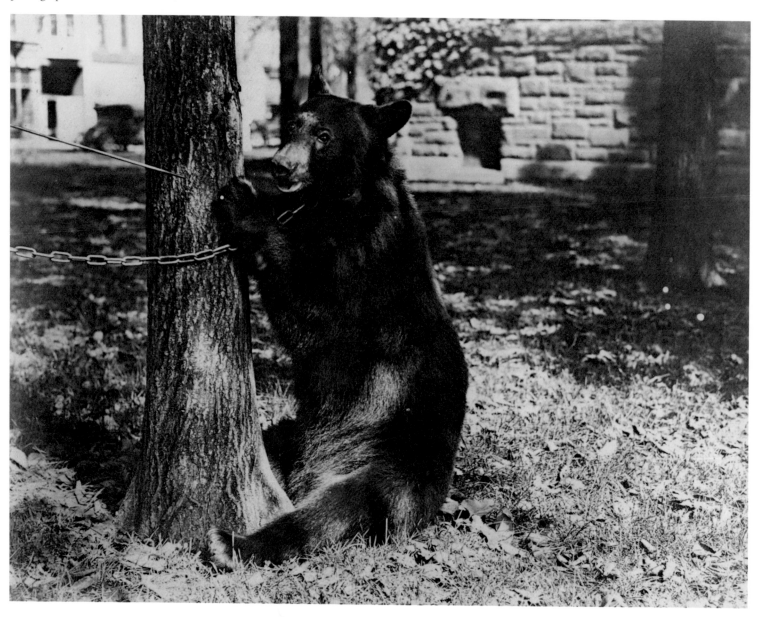

Members of an early Scott High School track team get into position for a footrace.
The school opened in 1914.

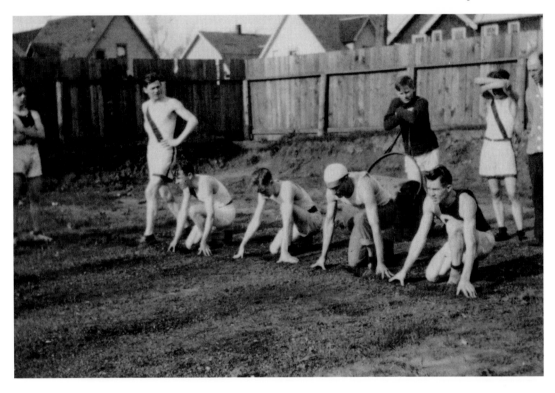

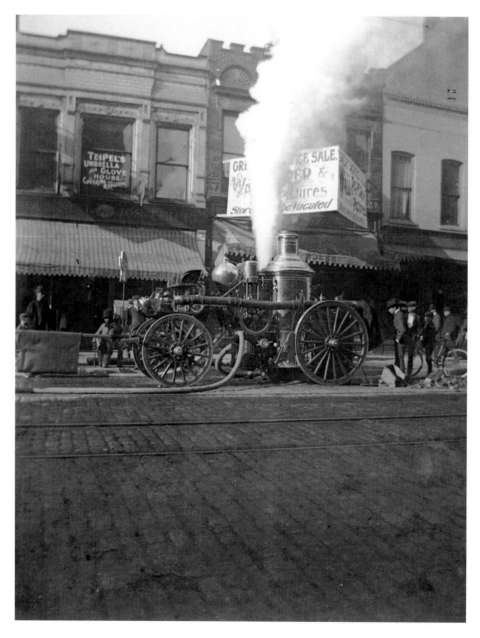

The Niagara Hotel Fire began around midnight on April 4, 1915. Two guests were killed, and several others suffered serious injuries.

Fire fighters face difficult
circumstances in performing
their duties, particularly
when the weather turns cold.
Shown here is the aftermath
of the fire at Wilmington and
Company about 1915.

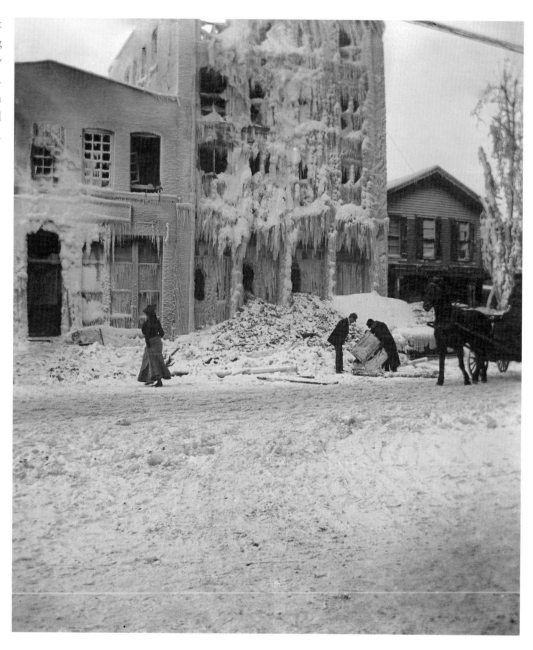

The *Wolverine* had a storied history on the Great Lakes. During the Civil War, the ship helped to maintain security at the prison for Confederate soldiers on Johnson's Island in Lake Erie.

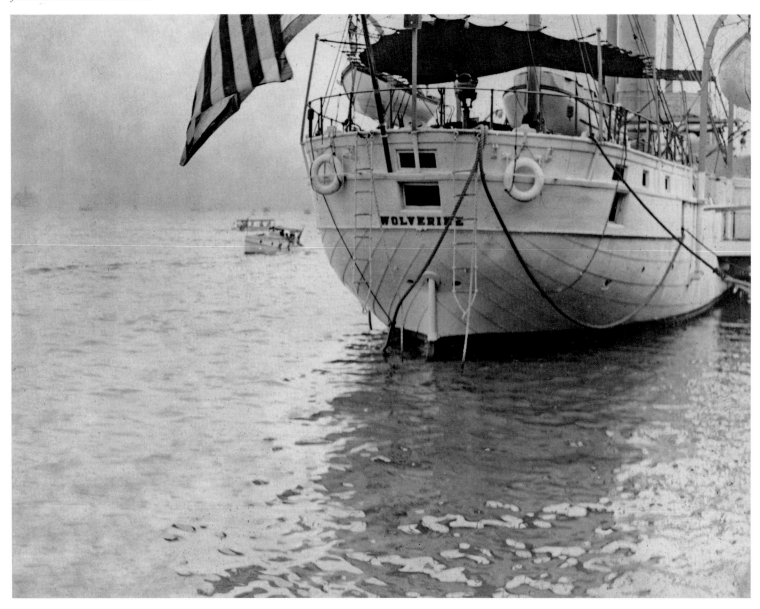

The automobiles in this showroom were both made in Toledo, produced by the
Willys-Overland Company (ca. 1915).

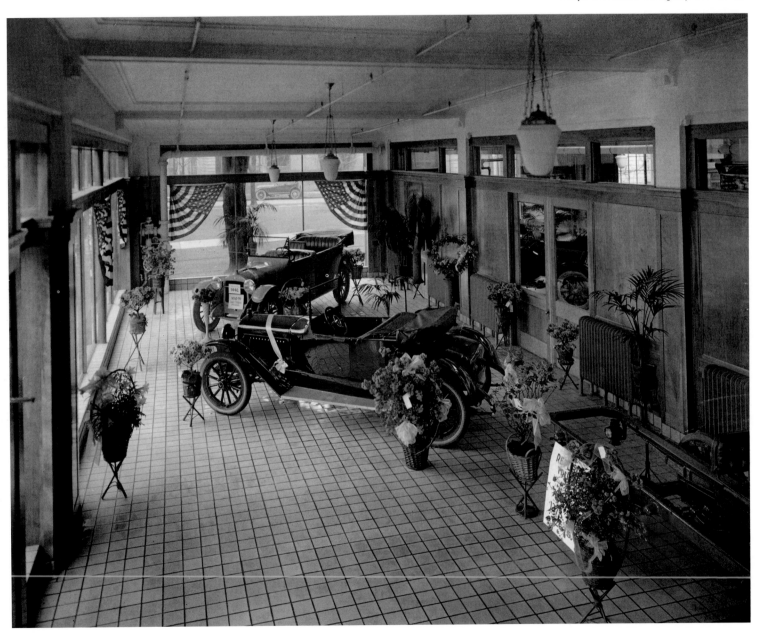

Joseph Ptones is standing in front of the American Express office on Summit
Street about 1917.

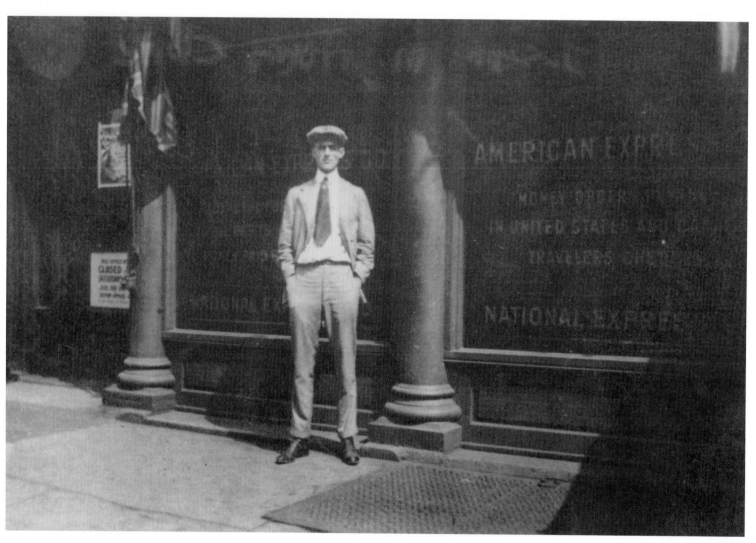

The swing bridge of the Wheeling and Lake Erie railroads pivoted open to allow the *Wolverine* and the *Niagara* replica to pass through—and allowing a throng of people to get a close view of the two ships in 1913.

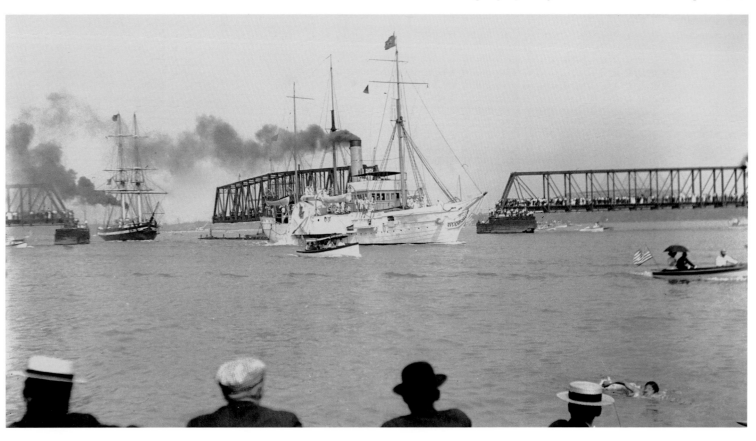

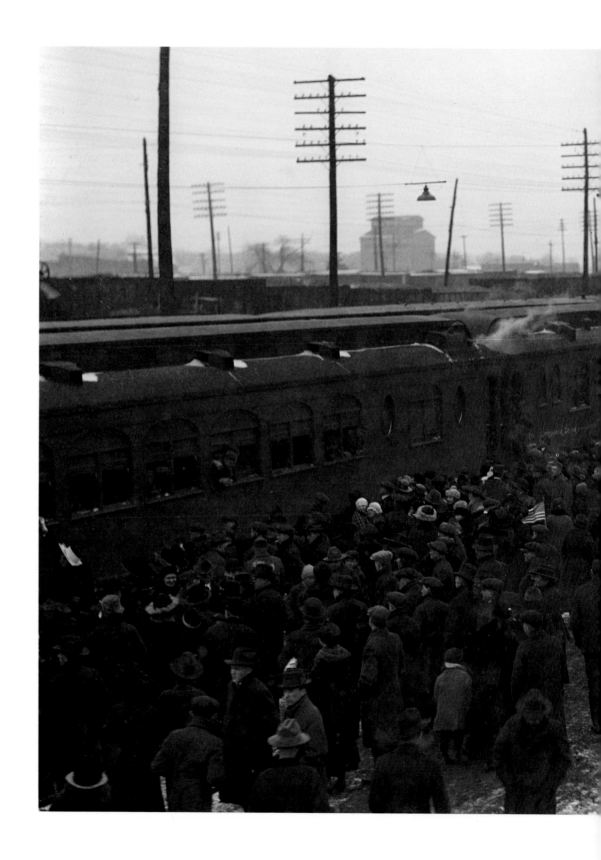

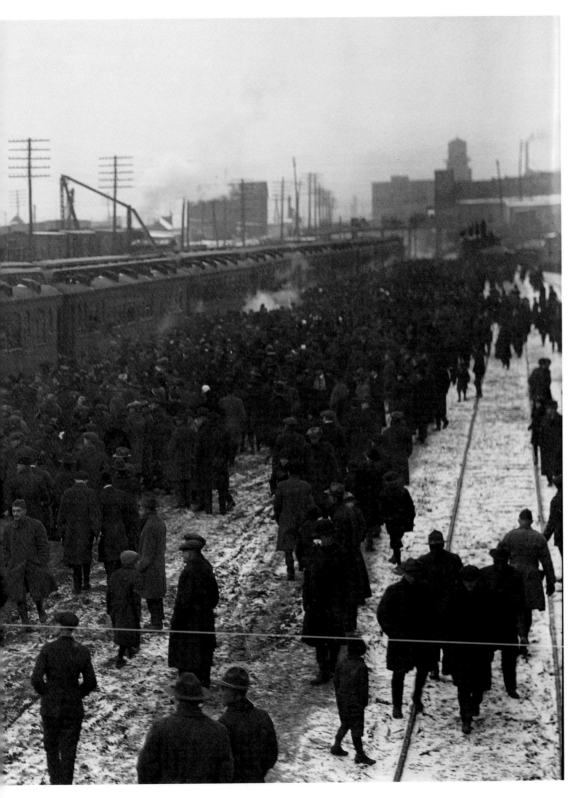

This is part of the crowd that went down to the Ann Arbor train station to greet the soldiers returning from "Over There" in 1919.

Adams Street and St. Clair Street (ca. 1919). The billboard on top of the
building at center-left proclaims that "Budweiser spells Temperance."

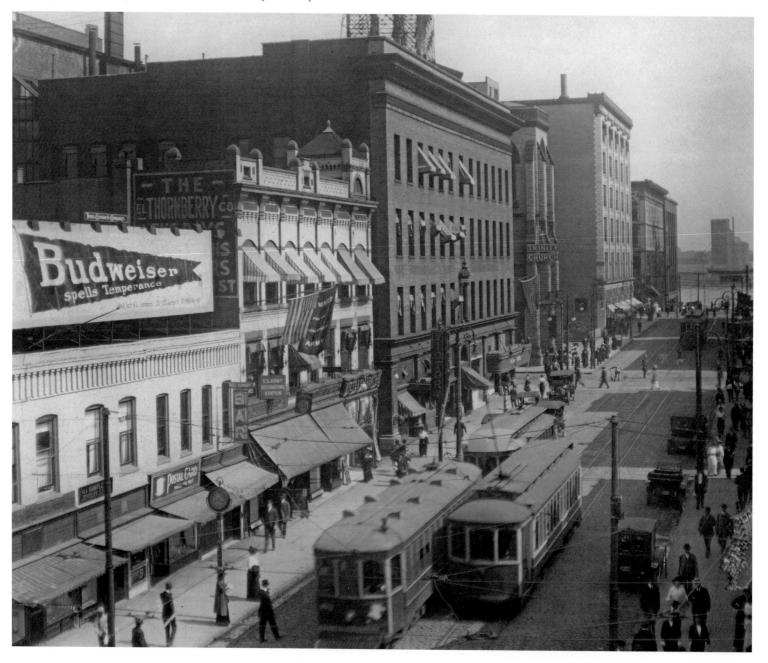

The Vita Temple theater was home to the First Congregational church from 1878 to 1913, when the congregation moved to Collingwood Boulevard. The Temple, located on St. Clair, shared the street with a number of other theaters during the Roaring Twenties (ca. 1920).

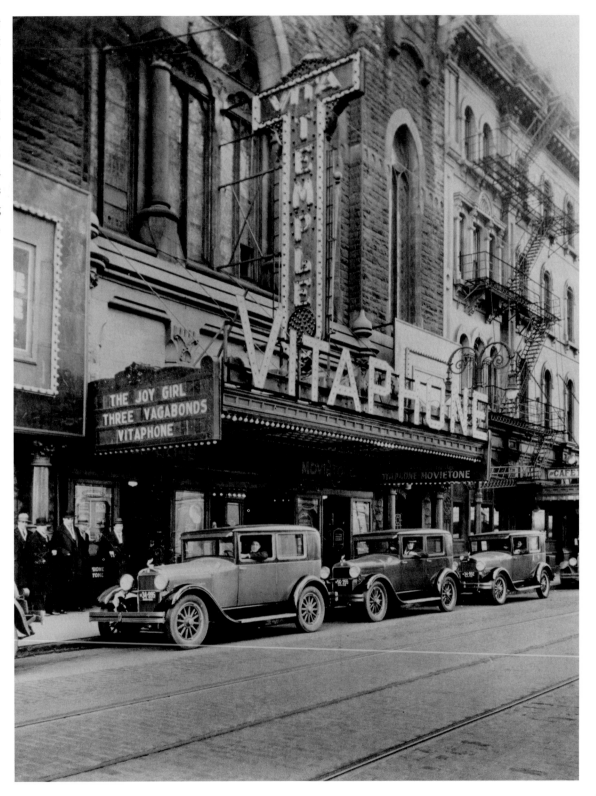

The Knights of Columbus march down Madison Avenue, probably
after ceremonies marking the opening of the Catholic Club in 1929.

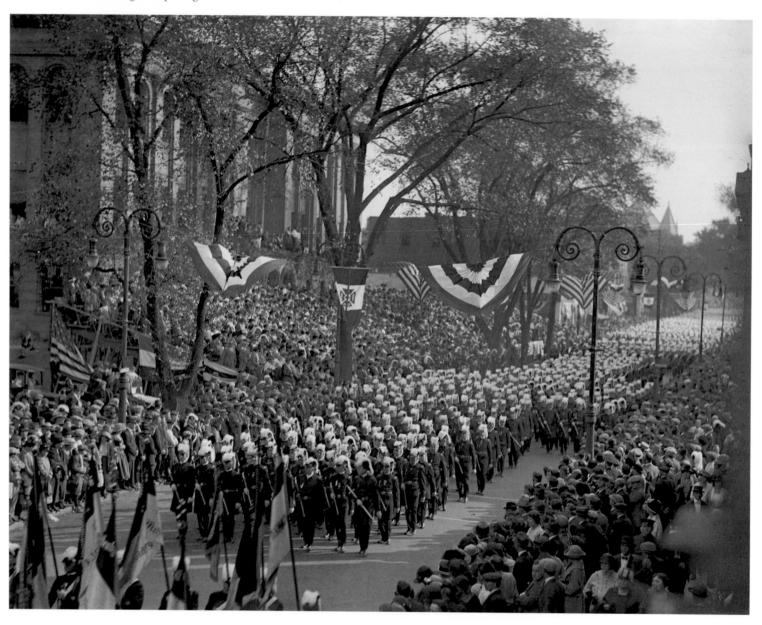

Shown here is some of the destruction from the Palm Sunday tornado of 1920, which nearly blew Raab's Corners off the map.

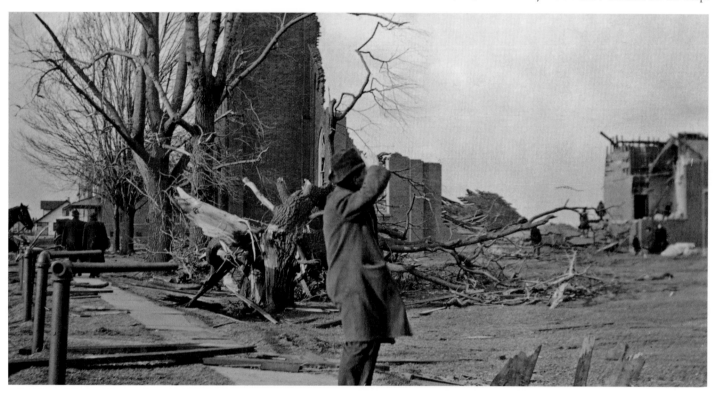

The Secor Hotel as it appeared around the time of its opening in 1908.
Unlike many other buildings of this era, this one is still in use.

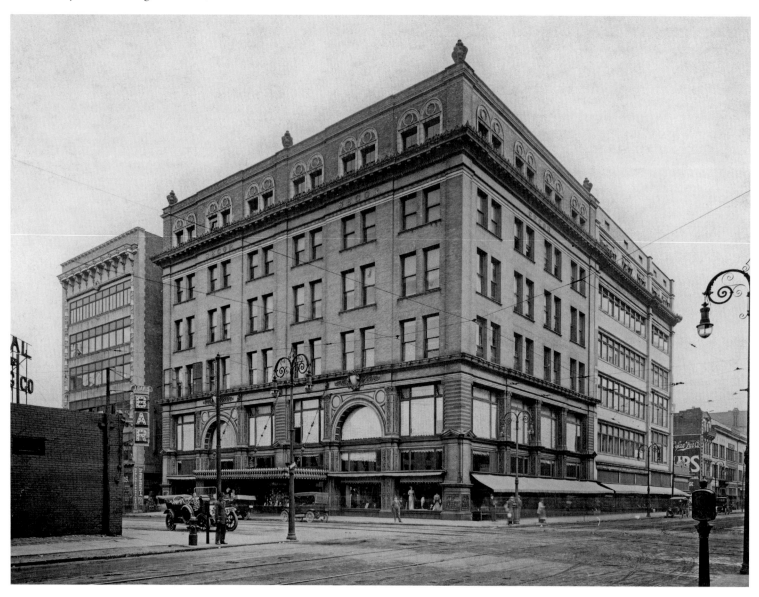

The Niagara Hotel Fire drew a large crowd of spectators in April 1915.

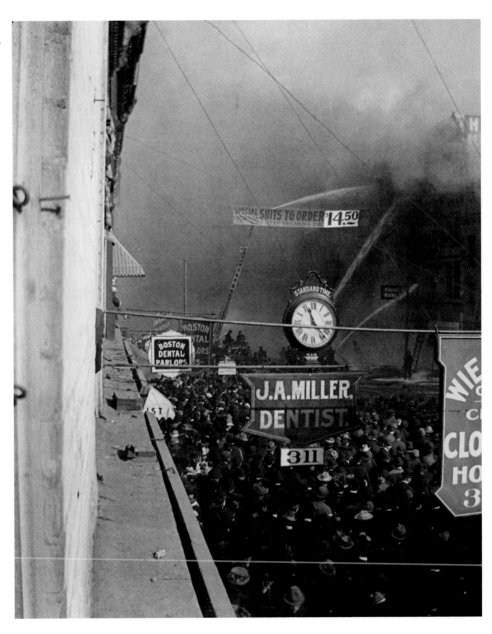

Decoration Day 1921 left fewer memories of the veterans of 1865, but
fresh memories of the veterans of 1917–1918.

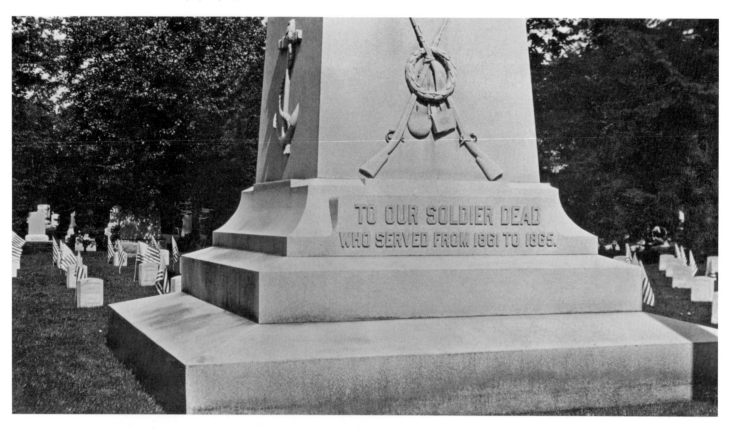

By the 1920s, the best days of the Boody House were long gone. By the end of the decade, it would be leveled to make way for the Ohio Savings Bank Building (later headquarters for Owens-Illinois).

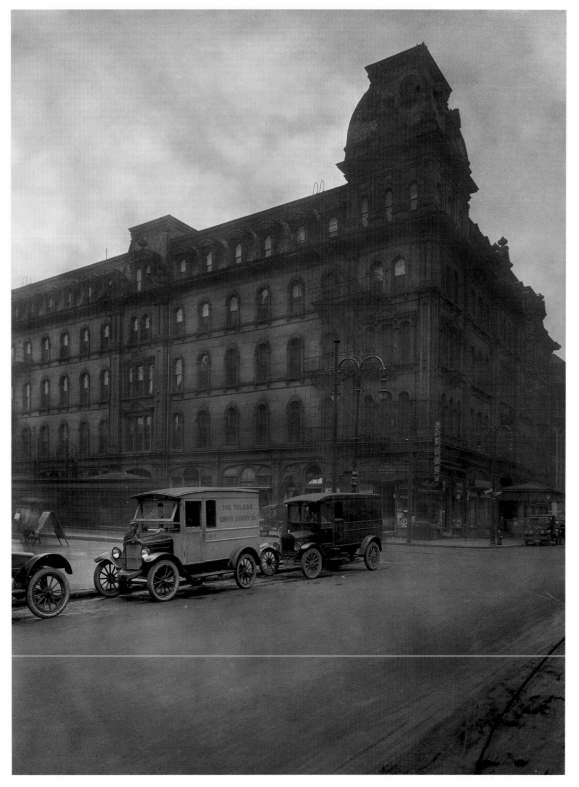

The fifth-grade class at South Street Elementary School, with their teacher
Miss Gertrude Geer, in 1923.

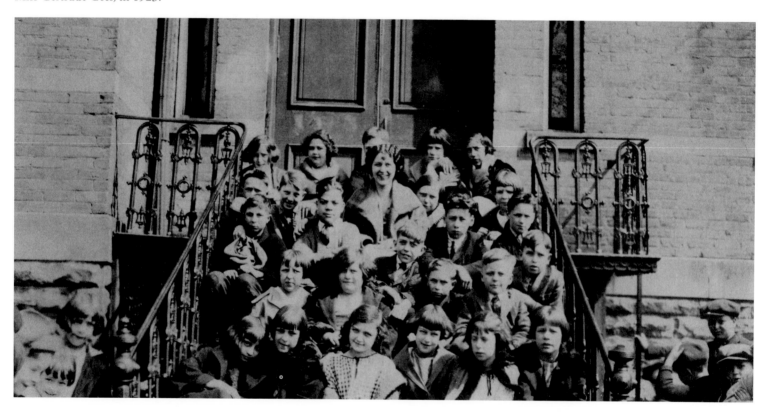

Union Station opened in 1886, and served rail passengers well for many years. In 1950, a new station was built and the older building was demolished.

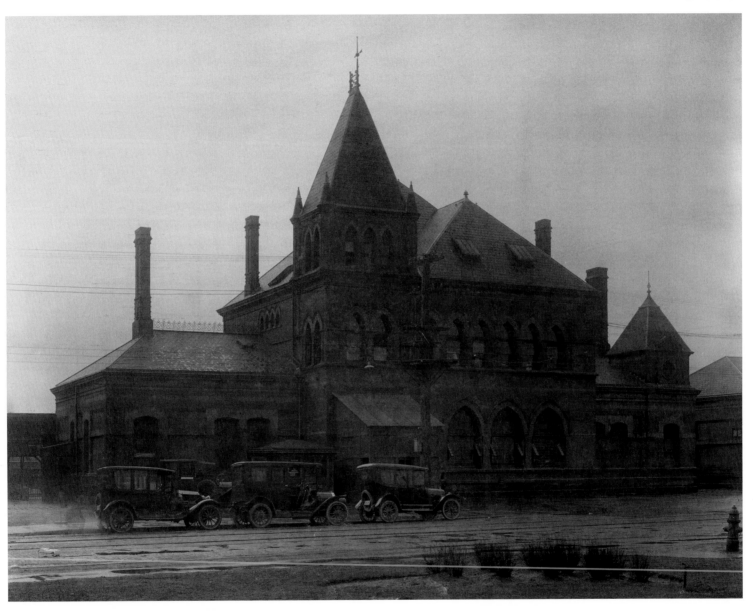

After fire damaged much of the 1886 Union Station, repairs were inadequate.
Clamors for a new station finally prevailed twenty years later, when the
Central Union Terminal opened in 1950.

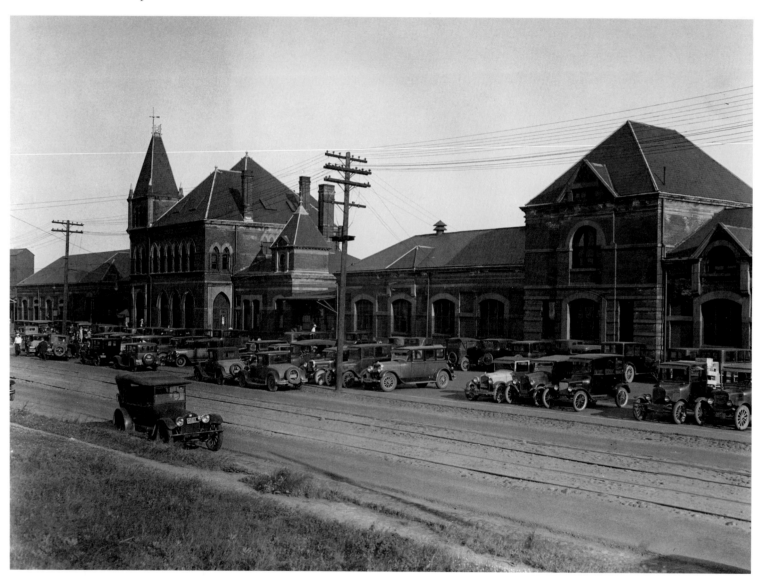

The 1920s saw the flowering of Toledo's love affair with high school football, in evidence here as a large crowd attends a game at Scott High School's Siebart Stadium in 1926.

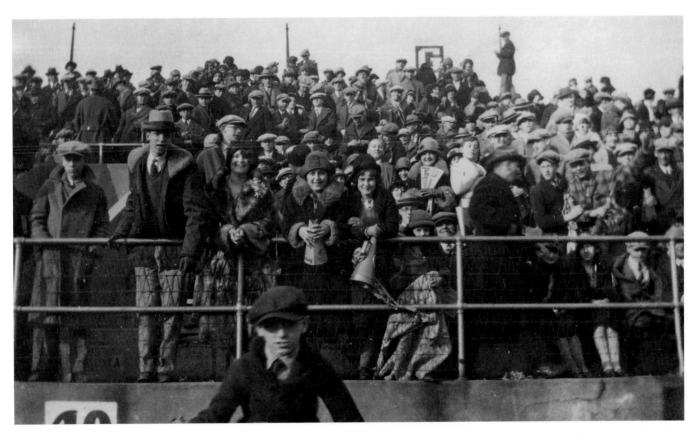

Adams Street, facing generally west from Superior Street, as it appeared on
a rainy day ca. 1925.

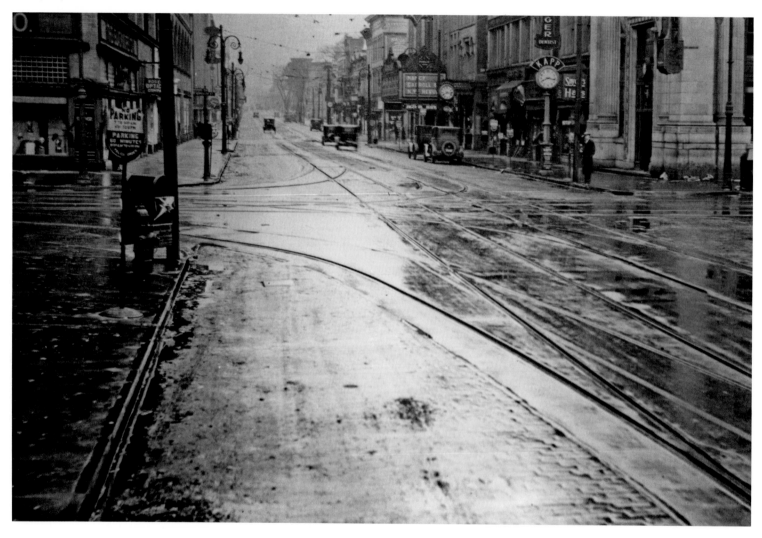

In view here are some of the airplanes and people present for the opening of Transcontinental Airport in May 1928.

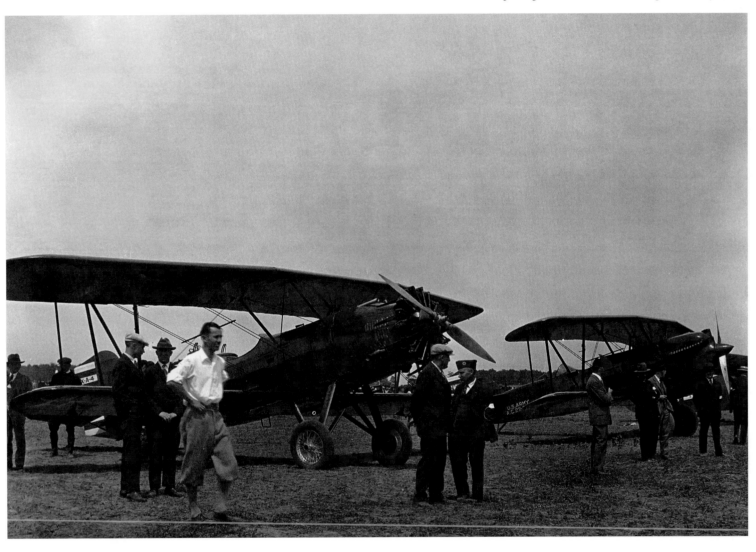

This image shows what was left of Lock 49 of the Miami and Erie Canal, near downtown Toledo. The photograph is part of a series taken in 1927 to document the canal in Lucas County before it was filled in and turned into the highway that we know as the Anthony Wayne Trail.

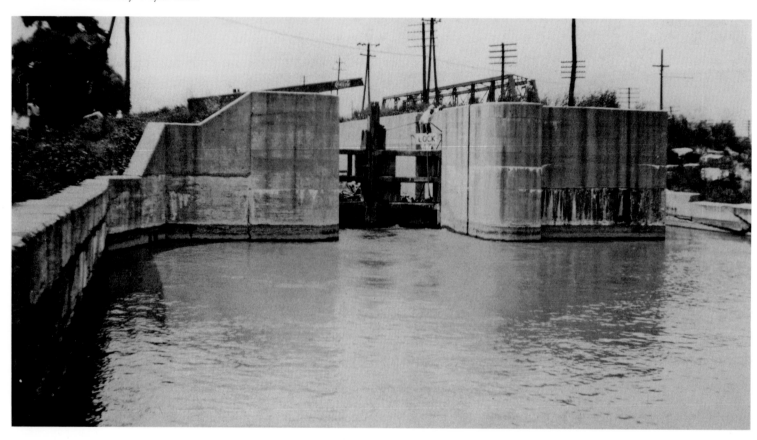

Activities were planned for all ages at the opening of Transcontinental
Airport in 1929, including this group of balsa wood airplane hobbyists.

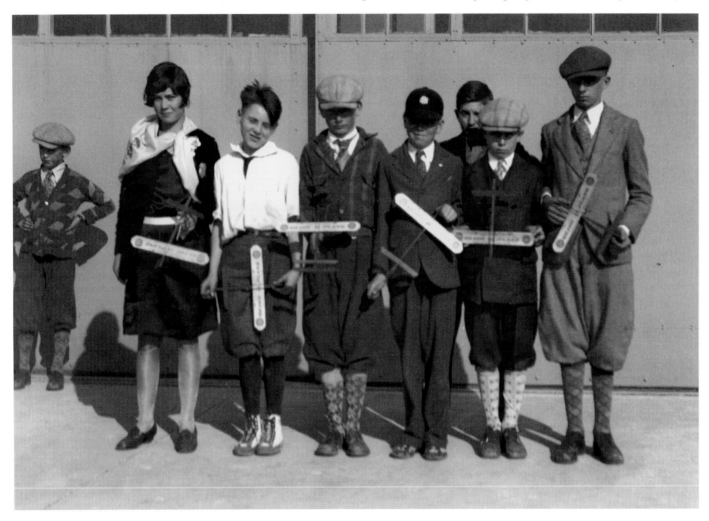

The early 1920s were a prosperous time for Toledo, and the city began
building municipal structures, like the Safety Building here in 1923.

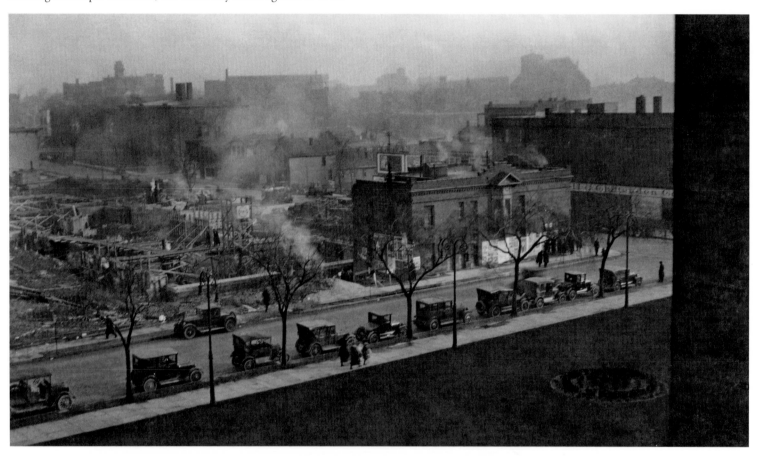

Young Jules Vinnedge helps his grandfather Julius Lamson break ground for the new downtown Lamson's department store (April 11, 1928).

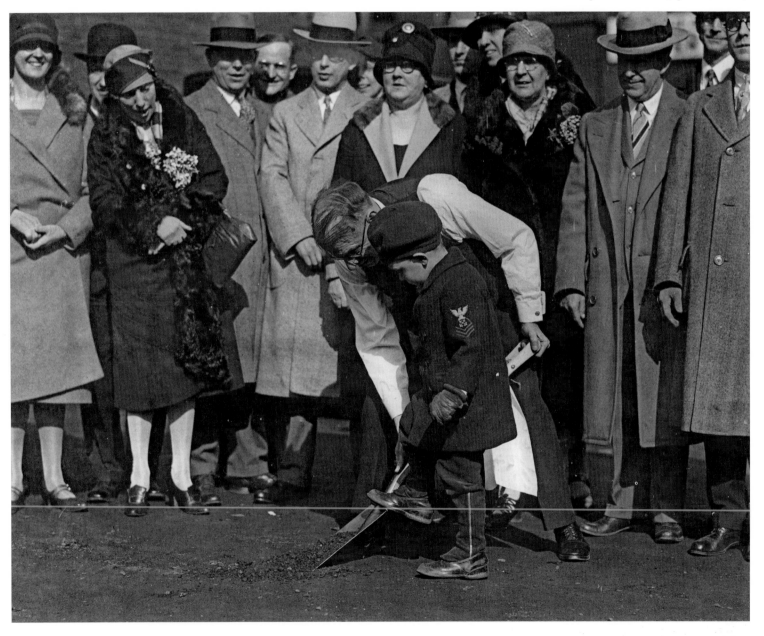

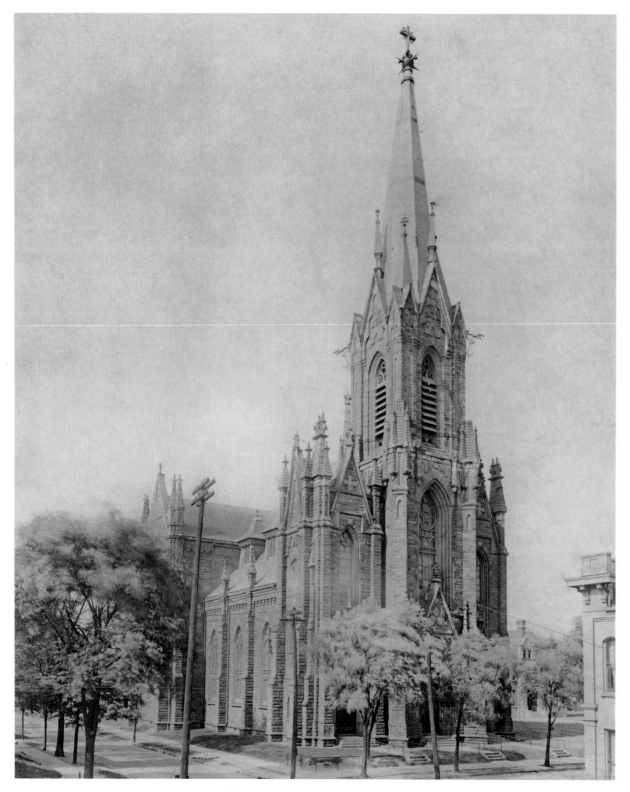

St. Patrick's Roman Catholic Church has commanded the high point near downtown since 1893, when it replaced the wood-frame church that was built in 1862. This photograph of the church was made ca. 1915.

The Woolworth 5 and 10 store operated at the corner of Adams and Superior streets from 1923 to 1994. The building is under construction in this 1923 image.

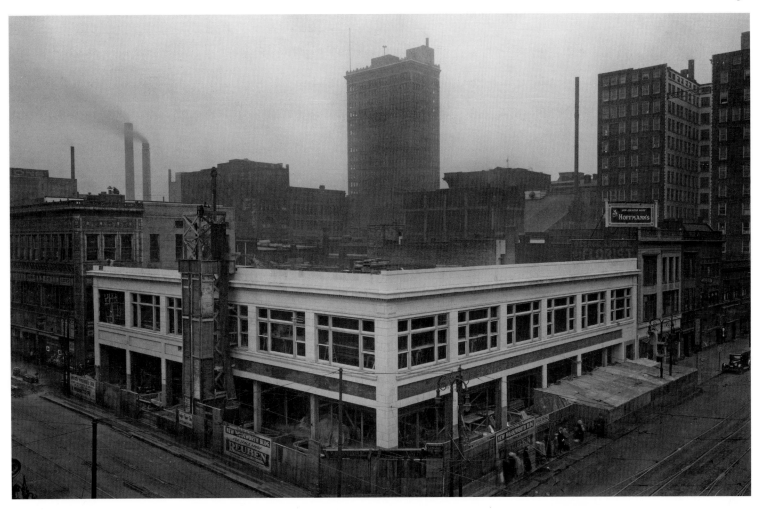

Charles Lindbergh is shown here in 1928 making an unscheduled fuel
stop in Bono—the extreme eastern edge of Lucas County.

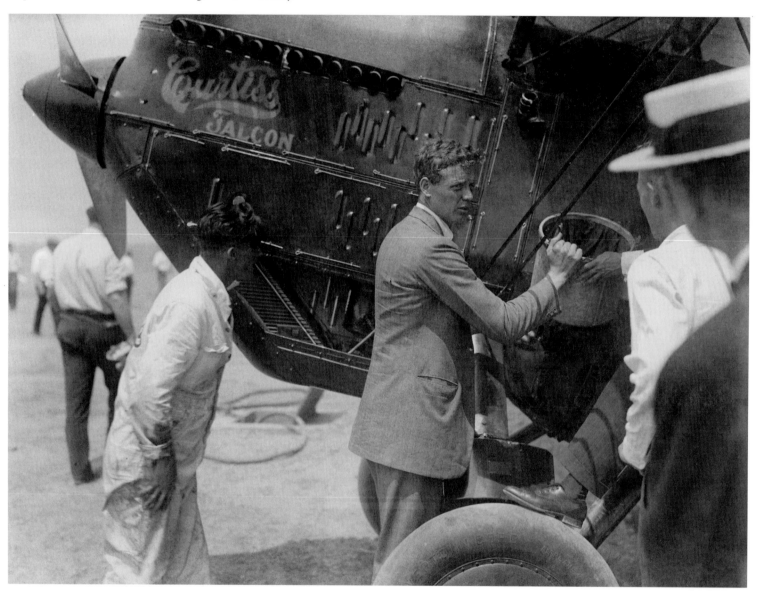

The Toledo Blade opened a new building in 1927, with President Calvin Coolidge doing the honors of turning on the electricity for the presses.

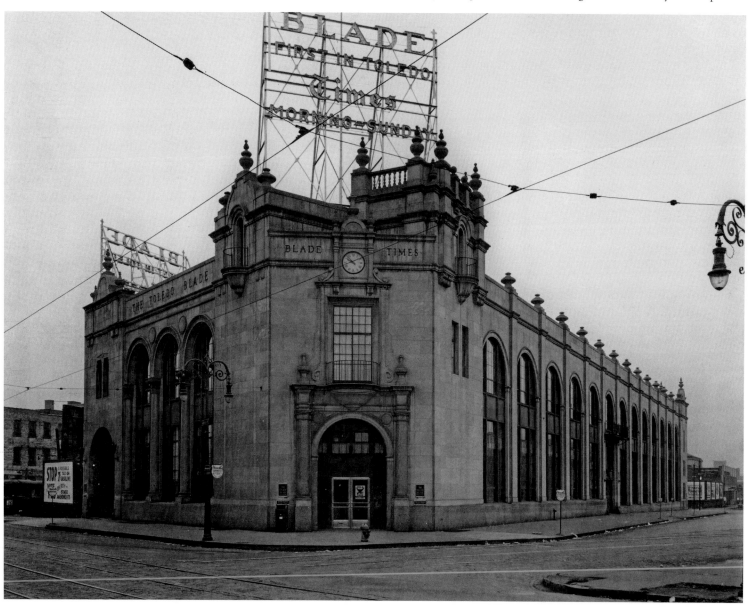

The new Lamson's Department Store was able to open its doors in time for the Christmas shopping season, November 12, 1928—after not breaking ground until April 11 of that year.

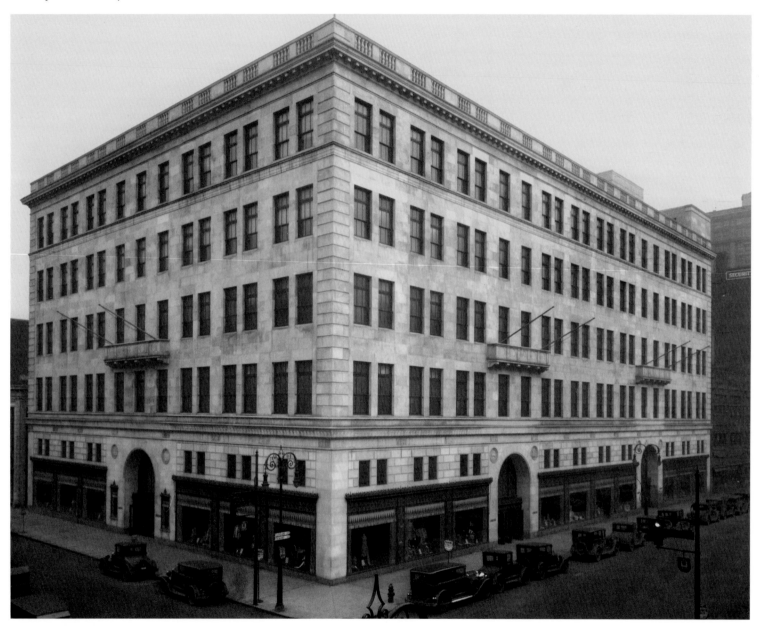

DEPRESSION AND WAR

(1930–1949)

An nationwide unemployment rate estimated at 25 percent, but 50 to 75 percent in Toledo. Many of the property holders in the county in default on their property tax. Police and teachers paid in scrip, because the city had no money to pay them with. People losing their life's savings in bank failures. People forced to live in hovels in city dumps, because they could not afford rent. The early years of the Great Depression were a scarring experience for many.

The election of a new president in 1932 created a sense of hope for some. The new administration used the "alphabet agencies" like the CCC and WPA to create work for the many unemployed. The fruits of their labors are enjoyed today when visits are made to the Metroparks system, or the Toledo Zoo, or the library downtown.

Workers, with little to lose, began to organize and join unions. When President Roosevelt was asked what he would do if he worked with his hands, it was reported that he answered "I'd join a union." This encouraged thousands more workers to join the union movement. This new exercise of working-class power was not unopposed, and these disagreements were often settled with strikes. In 1934, one of the most significant took place in Toledo, the Electric Auto-Lite Strike. The eventual success of that strike created the conditions that allowed the United Auto Workers to organize most of the industry in the latter 1930s and early 1940s.

Prosperity did not return to Toledo—or to the nation—until the nation began preparing for war in 1940. Willys-Overland, which had teetered on the brink of going out of business for much of the 1930s, won a contract from the Army to produce a General Purpose (GP) vehicle that soldiers began calling the "jeep." Other companies picked up government contracts, as well, and after the attack on Pearl Harbor in December 1941, winning the war became the primary focus of government spending.

The clutter of signage and traffic on Summit Street gives no clue to the
fact that Toledo—like the rest of the nation—was in the midst of the most
severe economic depression in American history (ca. 1931).

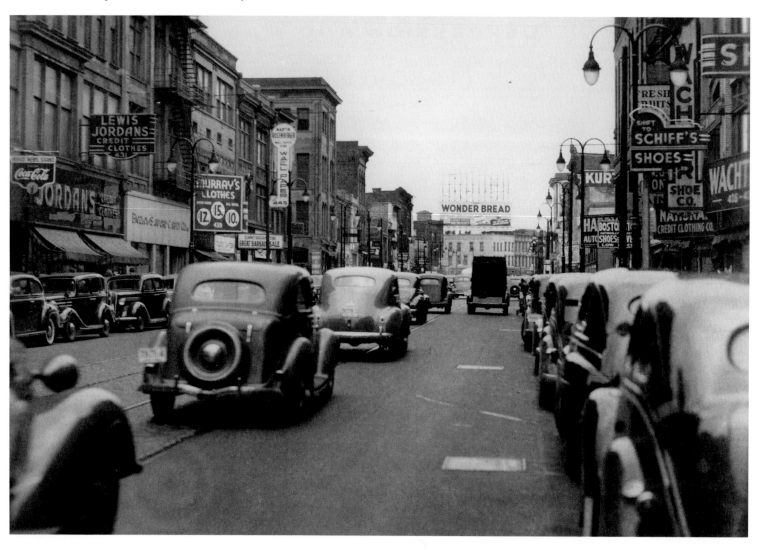

By 1930, the Valentine Theater was showing movies, and touting itself as a place to come in and beat the summer heat.

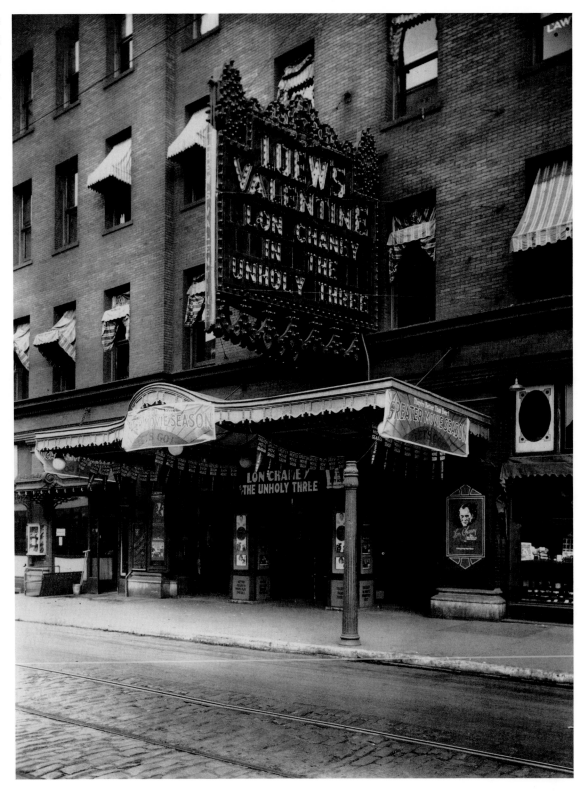

The Police and Fire Alarm Building, completed in 1934, was part of the municipal building program—and one of the few examples in Toledo of the Western Reserve style of architecture.

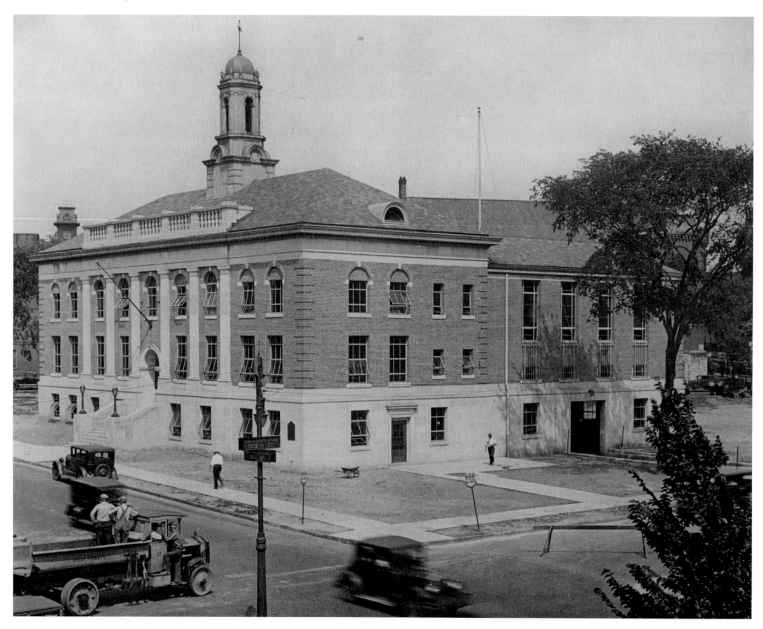

The Nasby Building—which is looking somewhat forlorn—has been overtaken by other skyscrapers by 1933. Several years later, much of the fenestration of the Nasby, which had become unstable, would be removed.

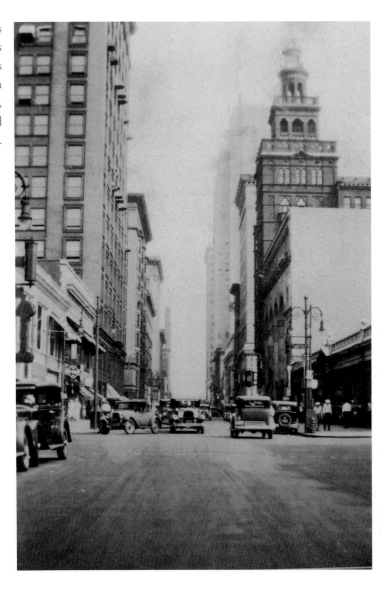

This was the backyard of the Frank D. Stranahan home on River Road in
Perrysburg in 1935.

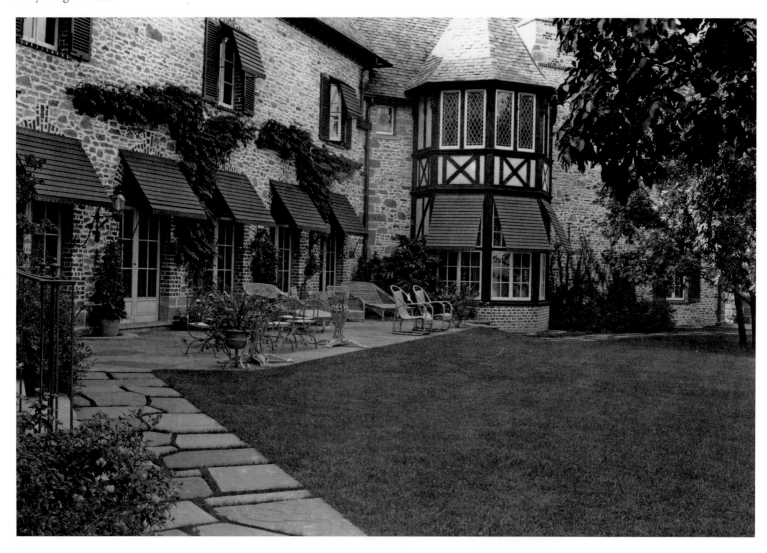

Those made homeless by the economic downturn of the Great Depression often constructed lean-tos made of material they found. Such areas were sometimes referred to as "Hooverville." Here along the east bank of the Maumee River is a row of lean-tos known as "Prosperity Row" (1933).

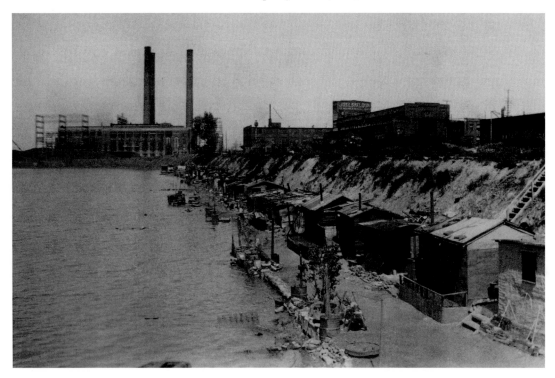

Pictured here is an anniversary celebration of the founding of Tiedtke's
Department Store (1936).

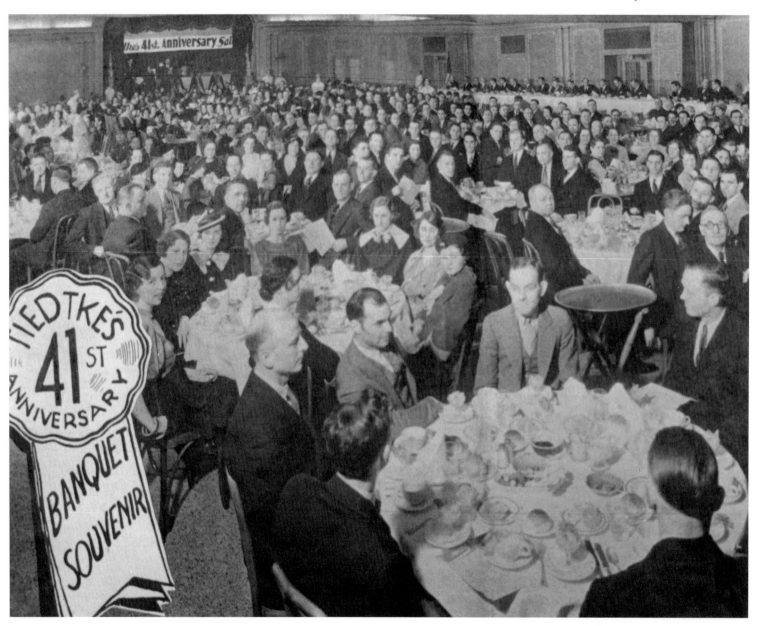

The worst years of the Great Depression in progress, these women walk the picket line during the Auto-Lite Strike in 1934.

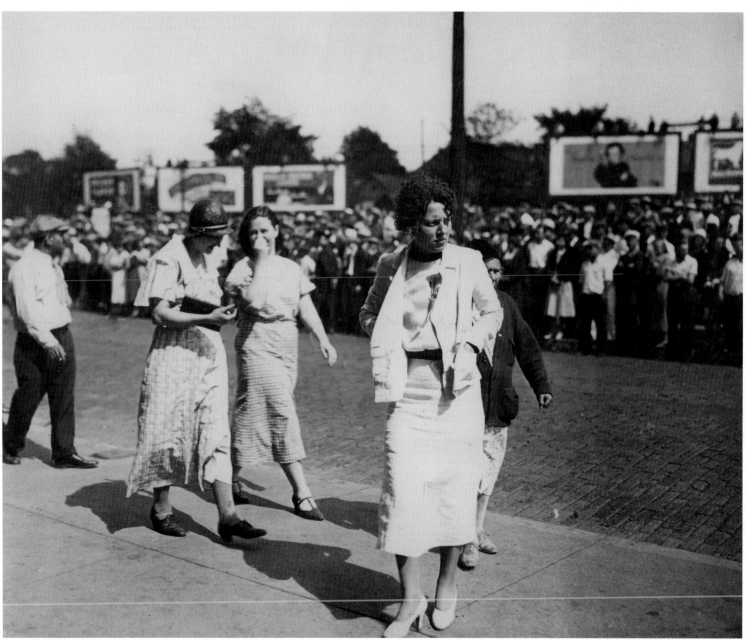

Following Spread: Despite the slowing of economic activity during the Great Depression, the city remained an important port—particularly for the shipment of southern Ohio coal.

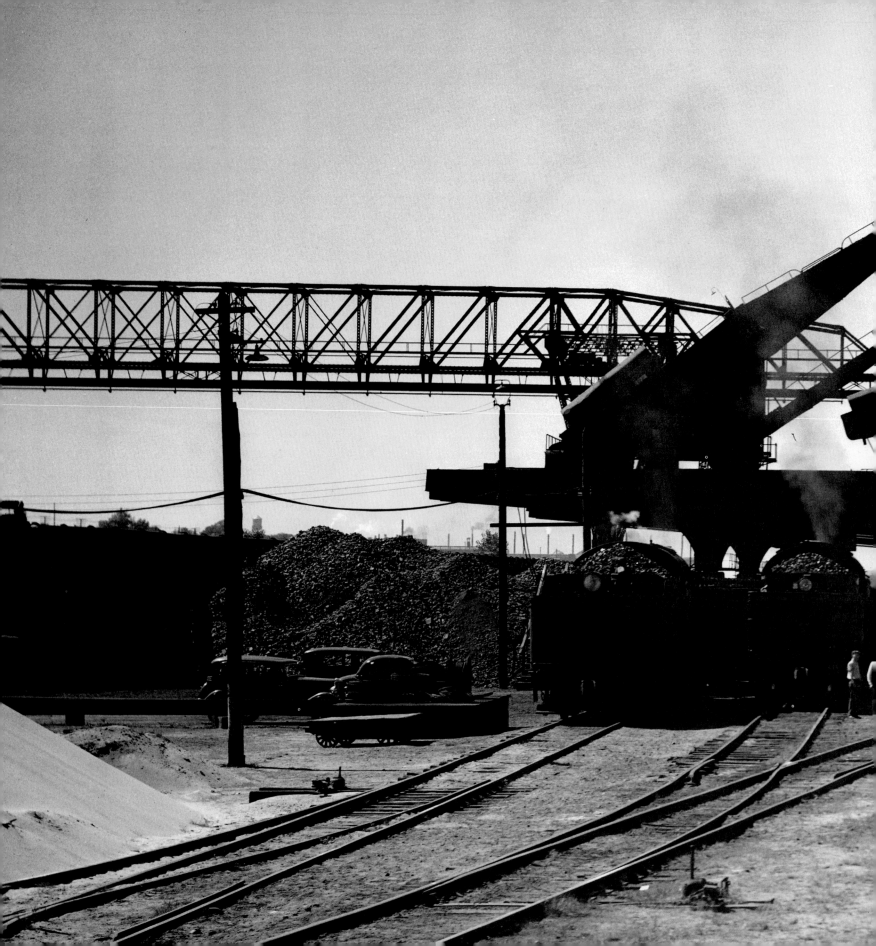

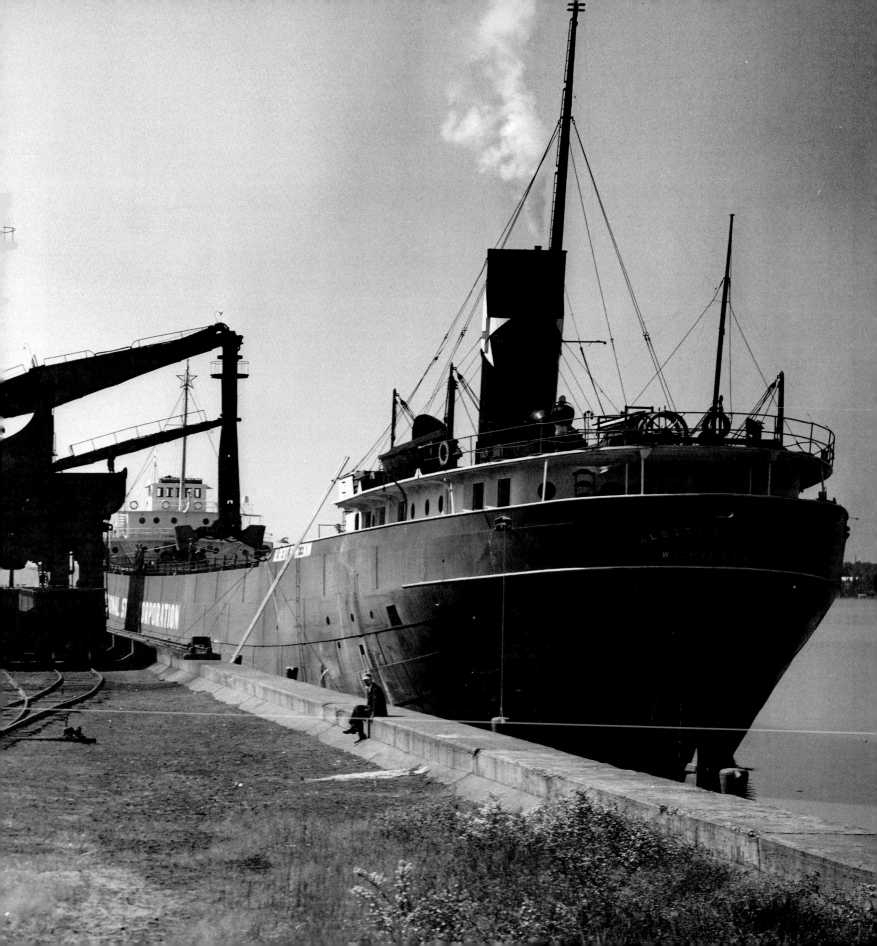

Incendiary behavior erupts in this view of striking workers in
one neighborhood.

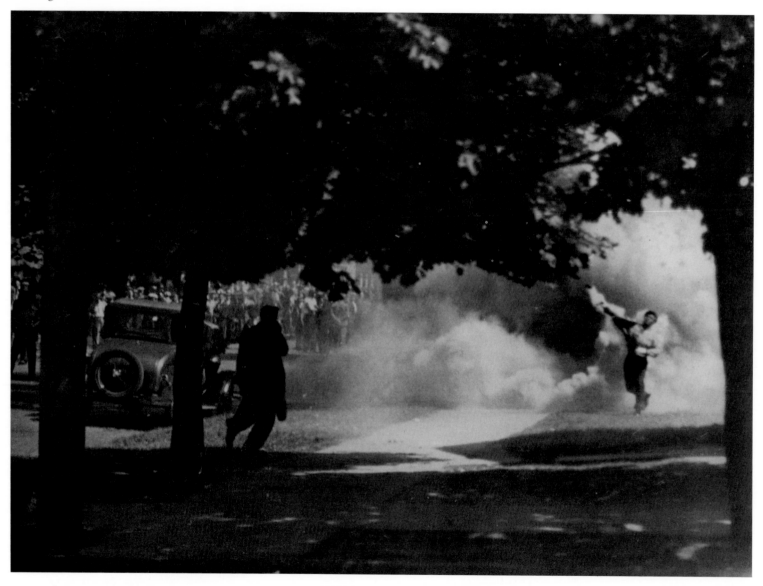

A young Ohio National Guardsman, suffering an injury to the head in the Battle of Chesnut Hill, is carried to safety.

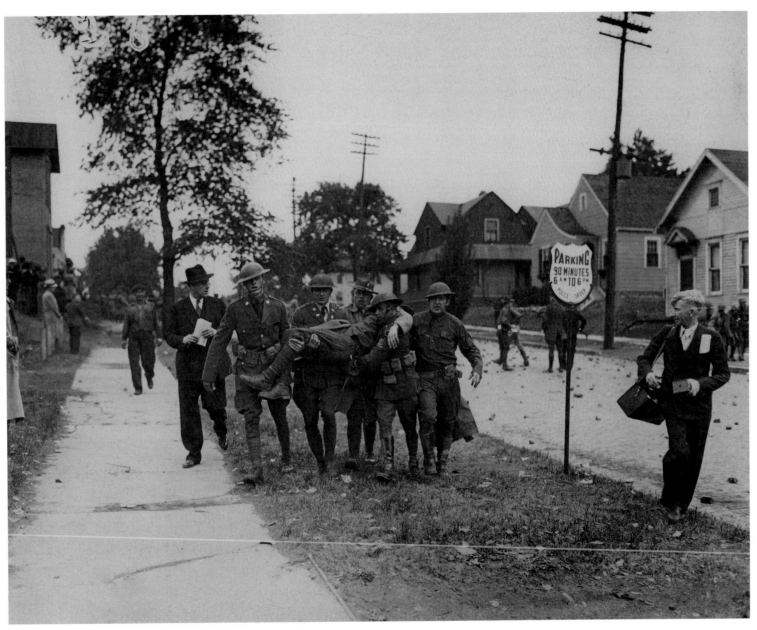

Because the favorable currents of the Maumee mean there is less need for dredging, East Toledo has long been the favored area for ports.

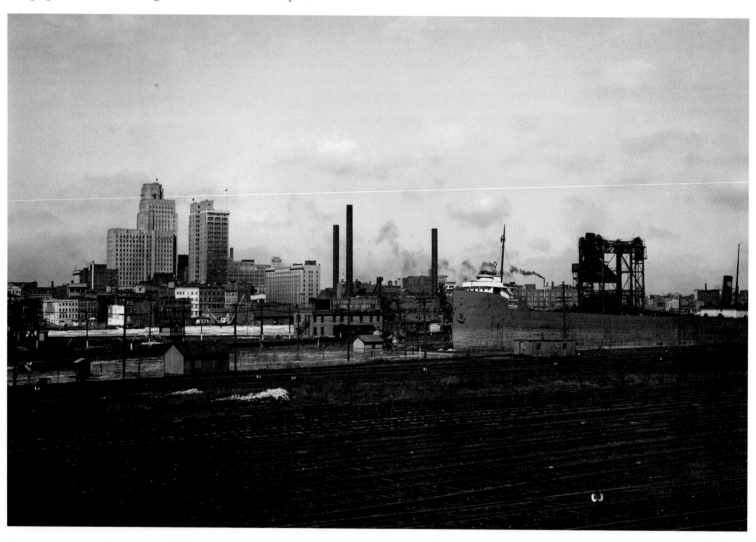

These men are working the pots in the Libbey-Owens-Ford plant in Rossford.

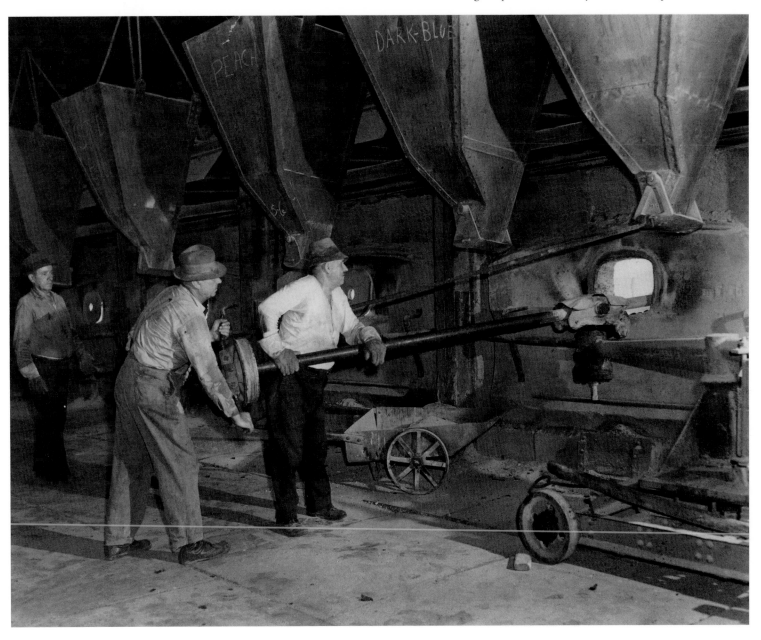

The Division of Inspection building in downtown Toledo was converted to a flop house, providing shelter for homeless men during the worst years of the Great Depression.

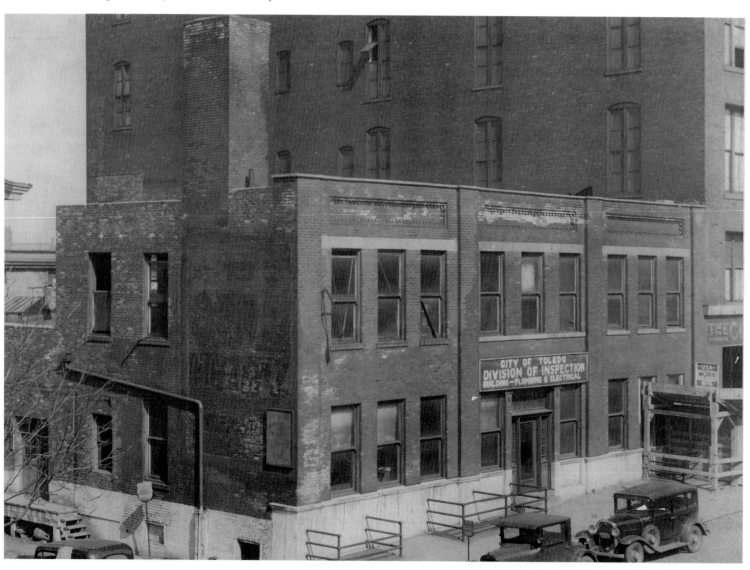

Boy Scouts in Lucas County also benefited from WPA projects, like these treehouses at Camp Miakonda.

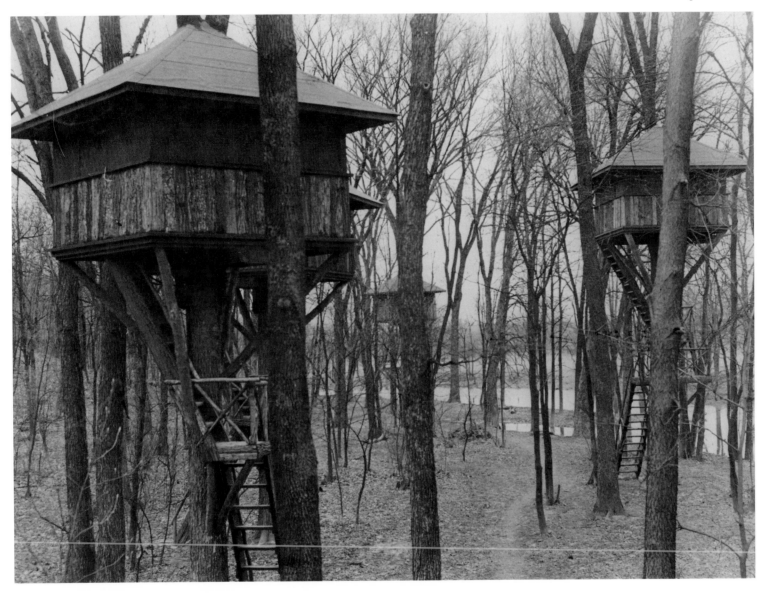

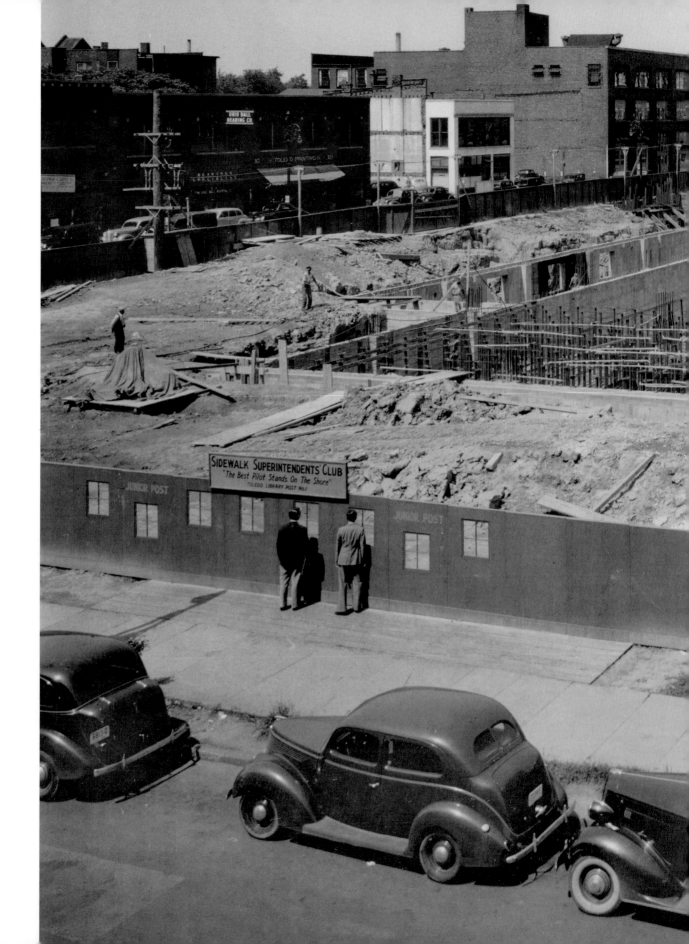

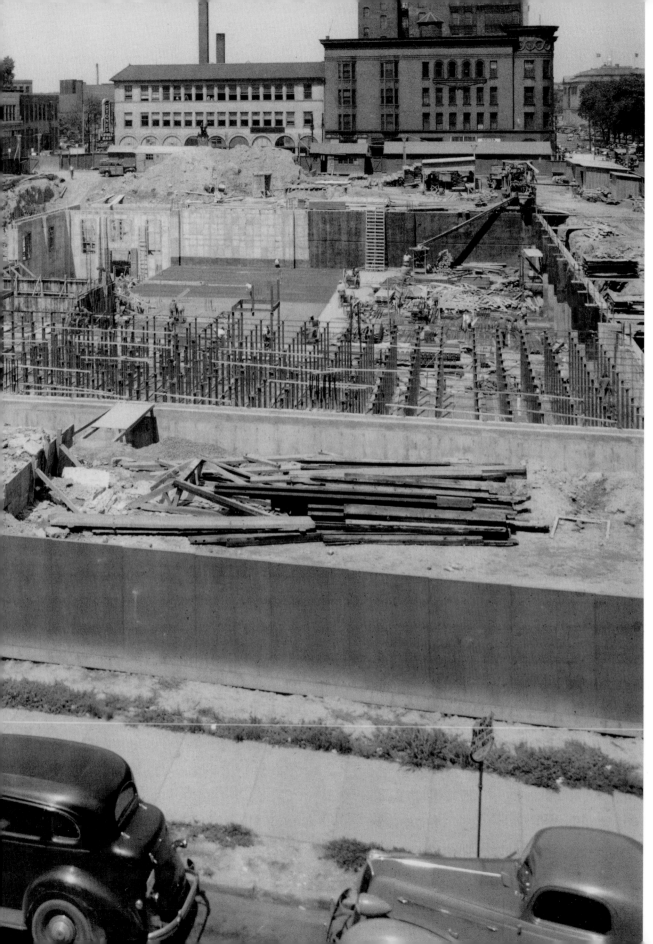

One WPA legacy was
built on Michigan Street,
between Adams and
Madison—the Toledo
Public Library, here shown
under construction in
1939.

This was a popular ride in the 1930s—for those who had strong stomachs—at the Walbridge Park amusement park.

This neoclassical building looks like a bank—and it is. The former home of the
First National Bank, it became a branch for the Toledo Trust in the 1930s.

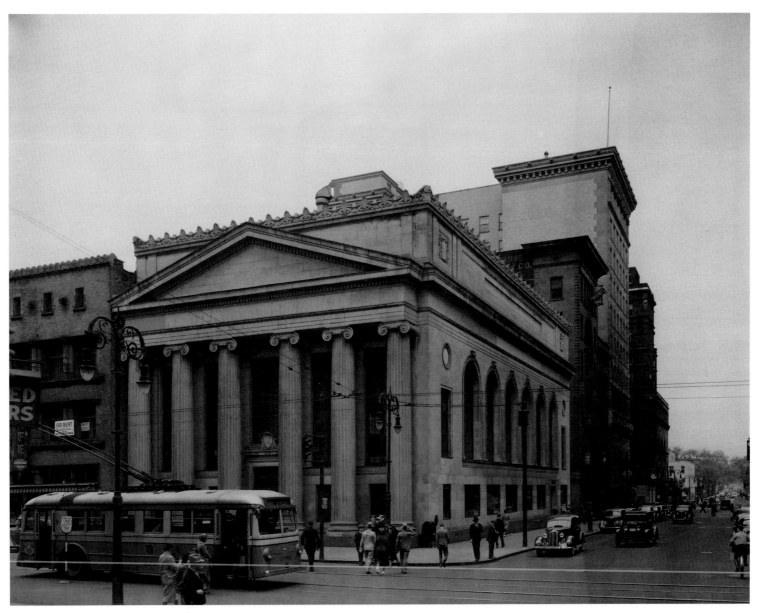

Streetcar #801 made the last run in East Toledo in 1939. By December 31, 1949, all streetcars of the Community Traction Company had been retired.

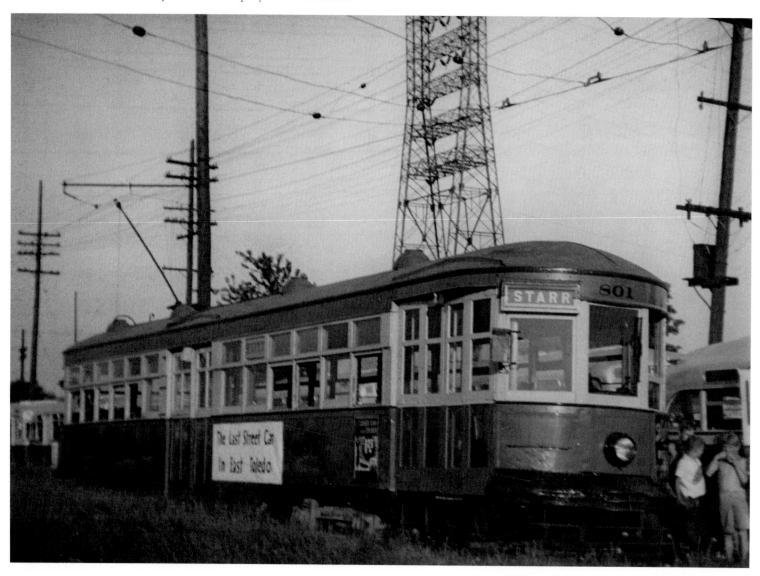

This APCOA parking garage was located behind the Secor Hotel on Superior Street, and had the advantage of looking nothing like a parking garage—considered a mark of distinction when this photograph was taken in 1937.

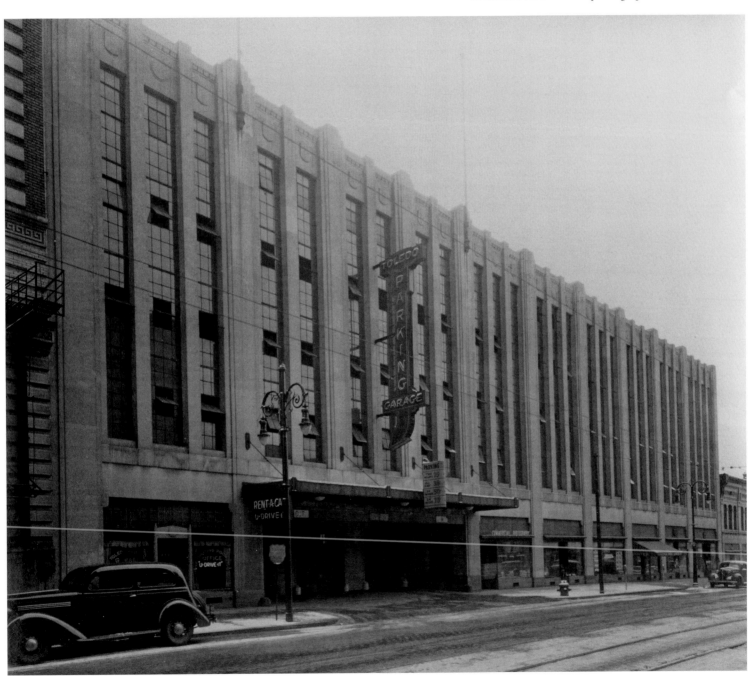

Change was under way in rail transportation in the 1930s: the men in the background are detraining a steam locomotive; the man in white in the foreground is engineer of a new diesel-powered locomotive.

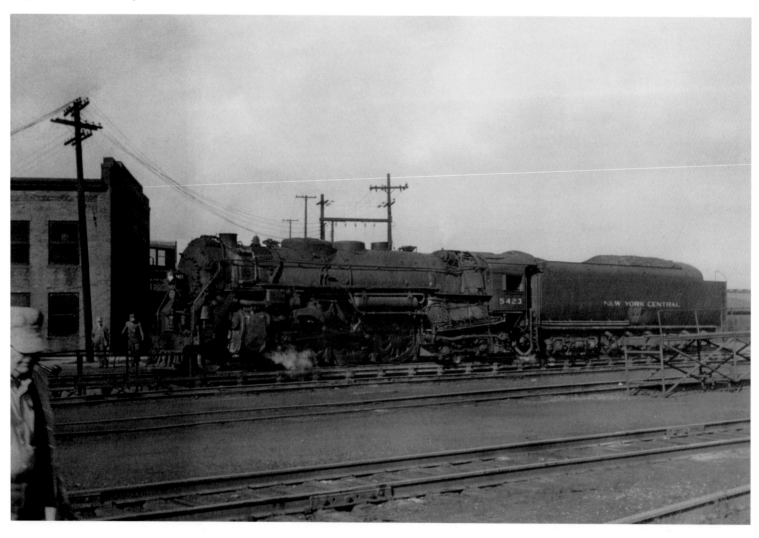

The Great Ziegfeld was released in 1936. The Palace Theater was located on St. Clair Street, along with a number of other movie theaters. Downtown at this time was *the* place to see first-run movies.

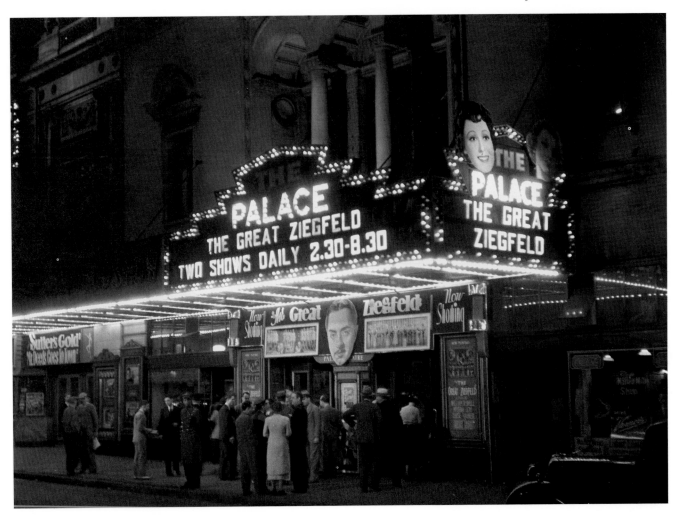

The Wheeling and Lake Erie (successor to the Ann Arbor) Railroad passenger
station, as it looked ca. 1940.

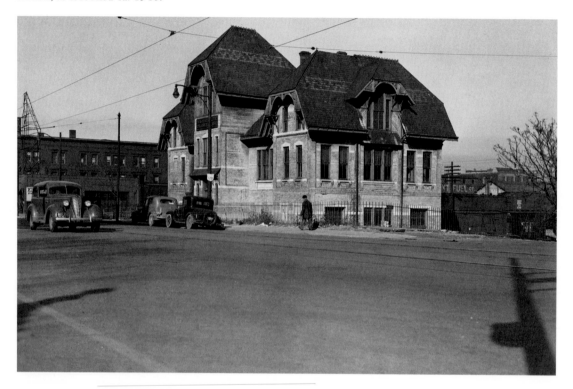

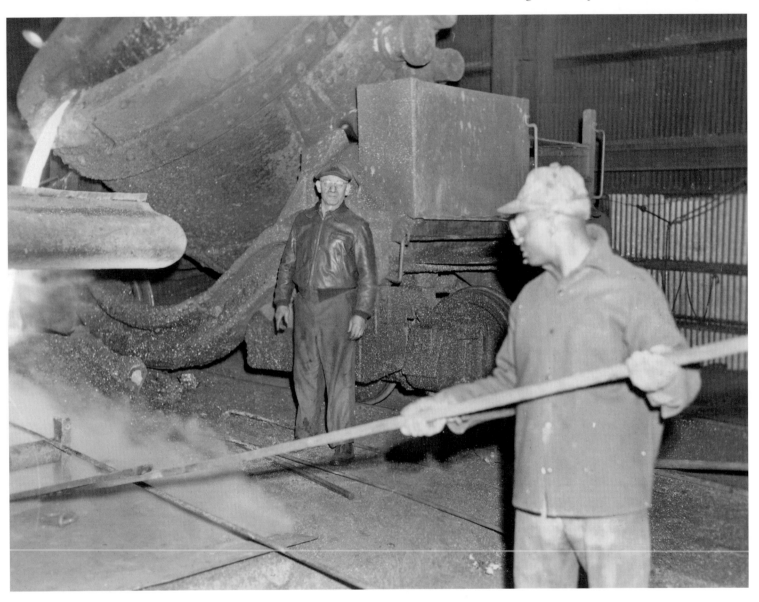

Interlake Iron Company, located in East Toledo near the Ironville neighborhood, produced rolled steel (ca. 1941).

This Romanesque Revival building housed a number of Toledo firms over the years, including the Toledo Steel Products Company in 1940.

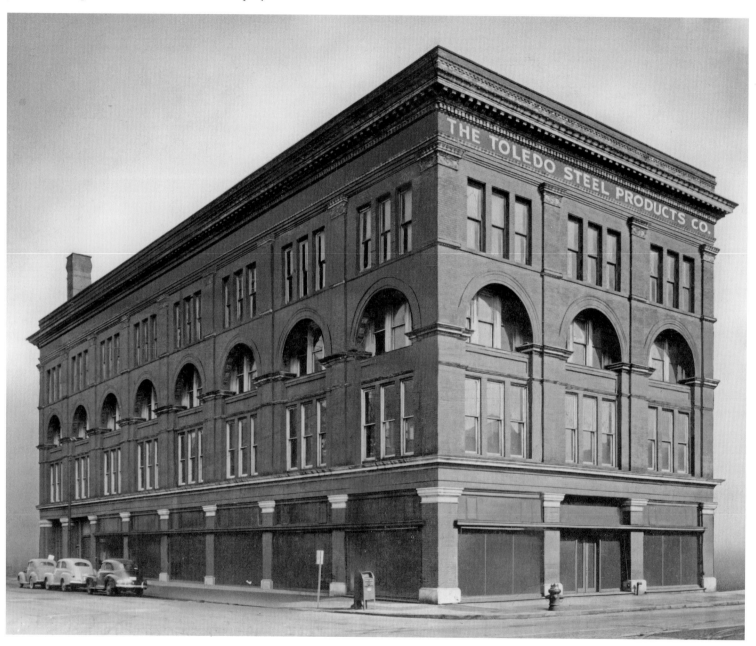

The Waldorf Hotel was located on Summit Street, at the corner of Jefferson Avenue, until it was demolished in 1965.

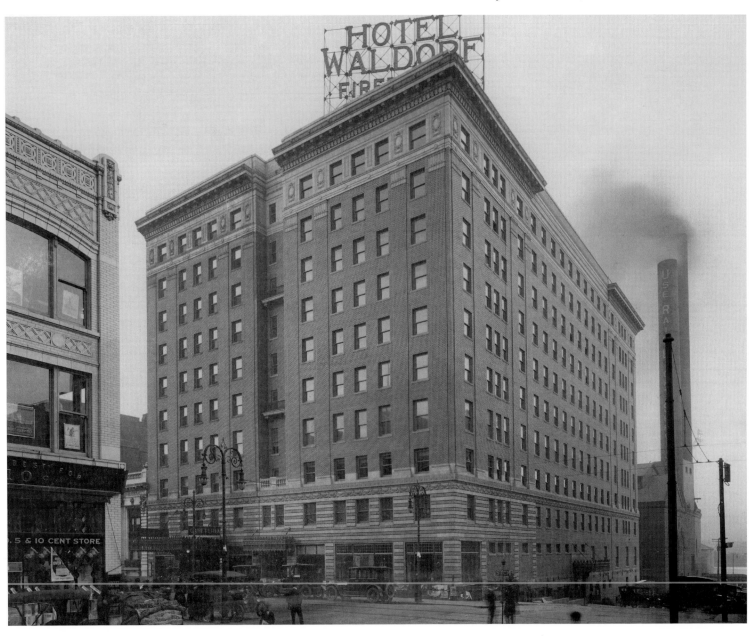

On a campaign swing in 1940, President Franklin D. Roosevelt gives a
short speech to the crowd gathered at Union Station.

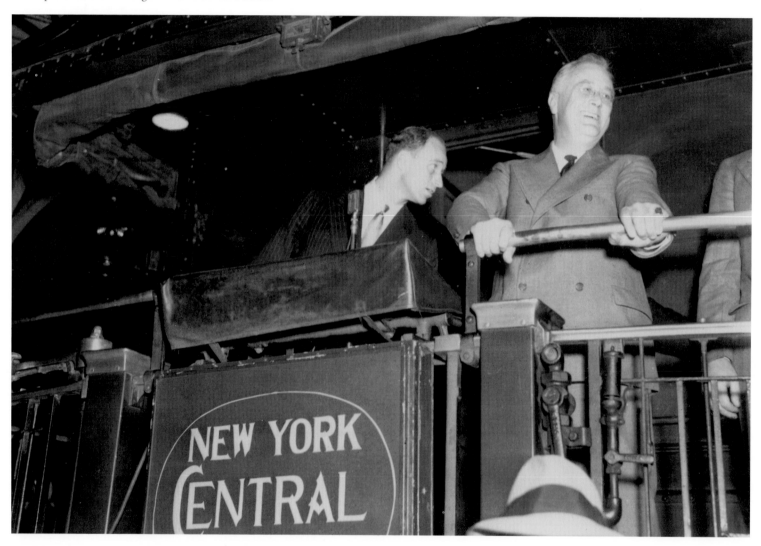

The boys under the train shed roof enjoy an excellent view of the president.

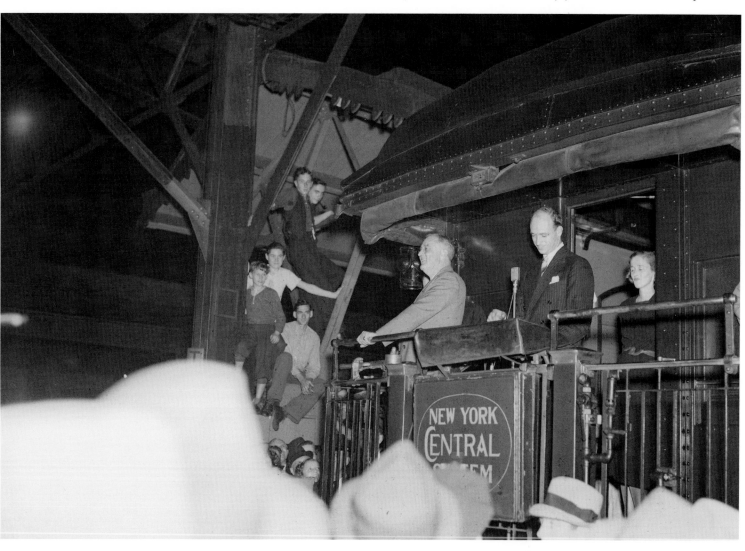

On Summit Street, hats are
88 cents "while they last"
(ca. 1940).

This photograph provides some insight into how all-consuming the war effort became. The auto carrier driver is loading jeeps onto the trailer to transport to another shipment point from the Willys-Overland plant in West Toledo (ca. 1941).

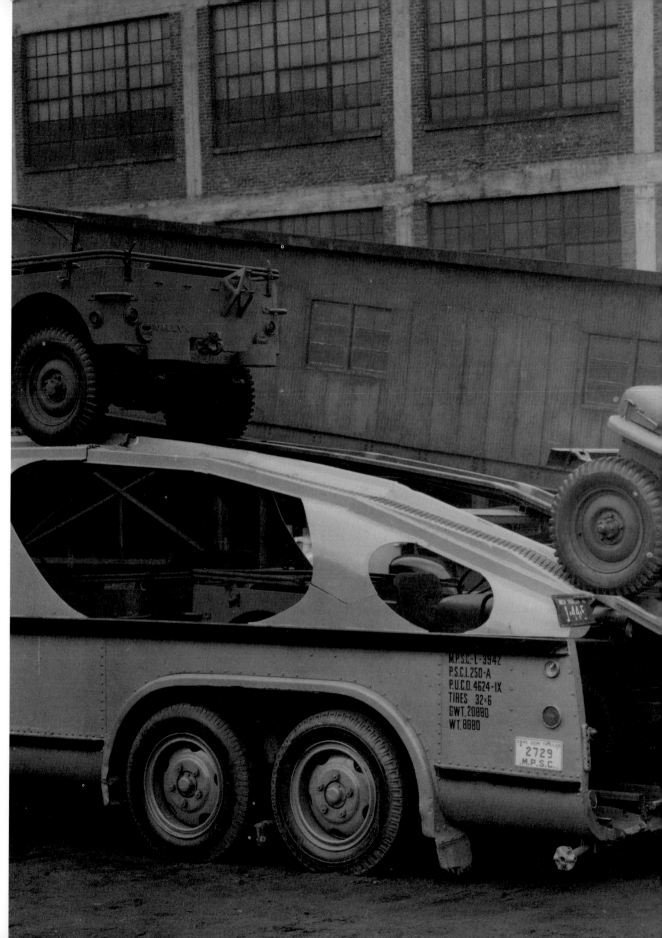

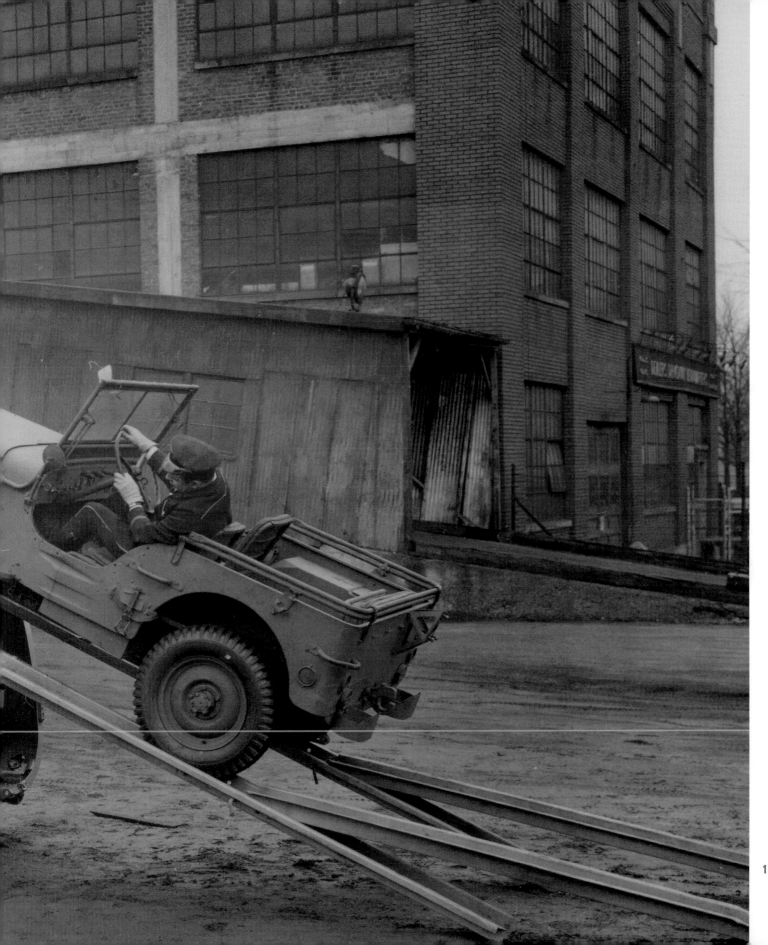

143

To sell war bonds during the Second World War, Marlene Dietrich made Toledo one of many stops on her agenda. She is accompanied by a naval officer at the intersection of Erie and Adams Street (1942).

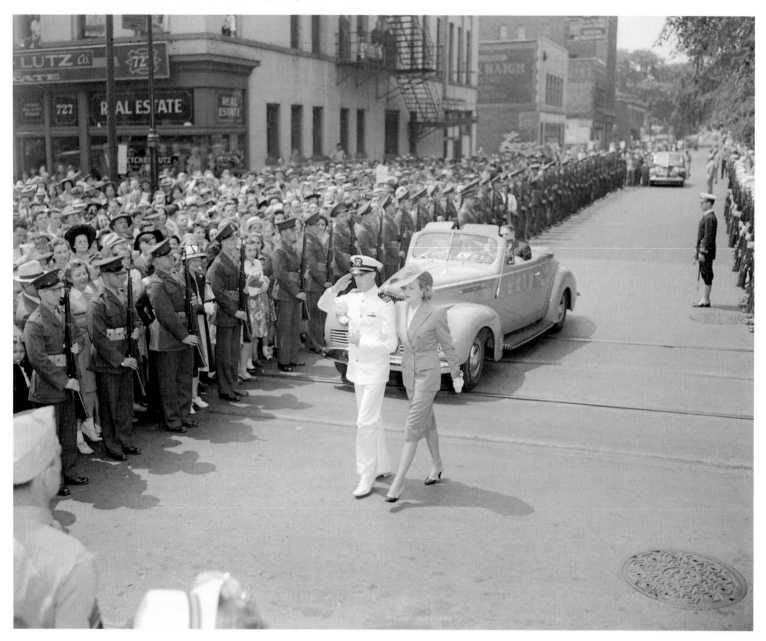

This streetcar ran on the Cherry Street line. It is shown here pulling past
St. Francis church, preparing to turn onto Cherry (ca. 1940).

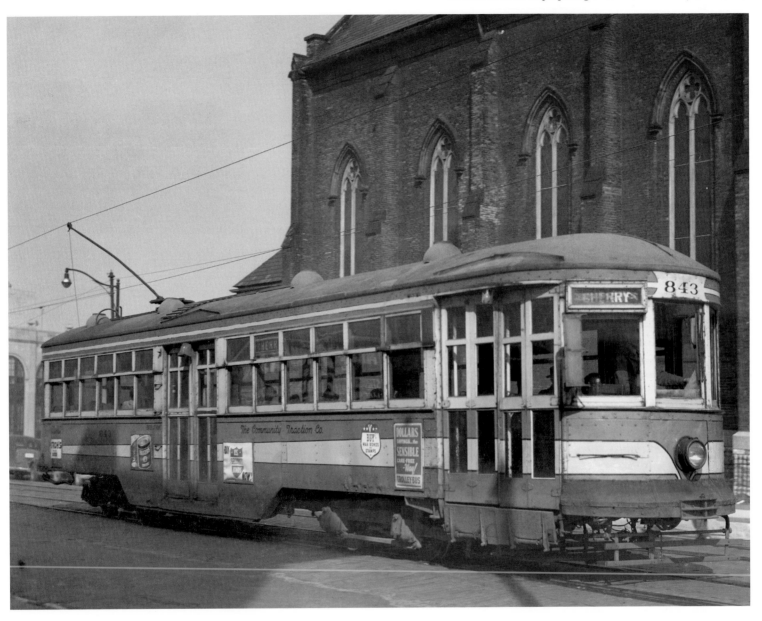

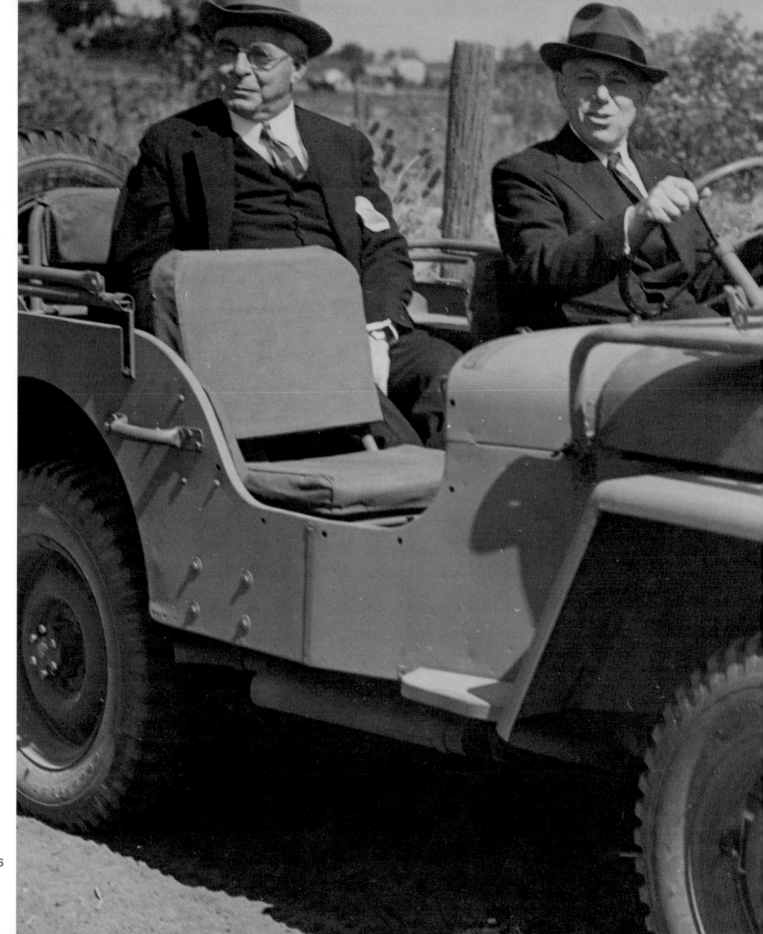

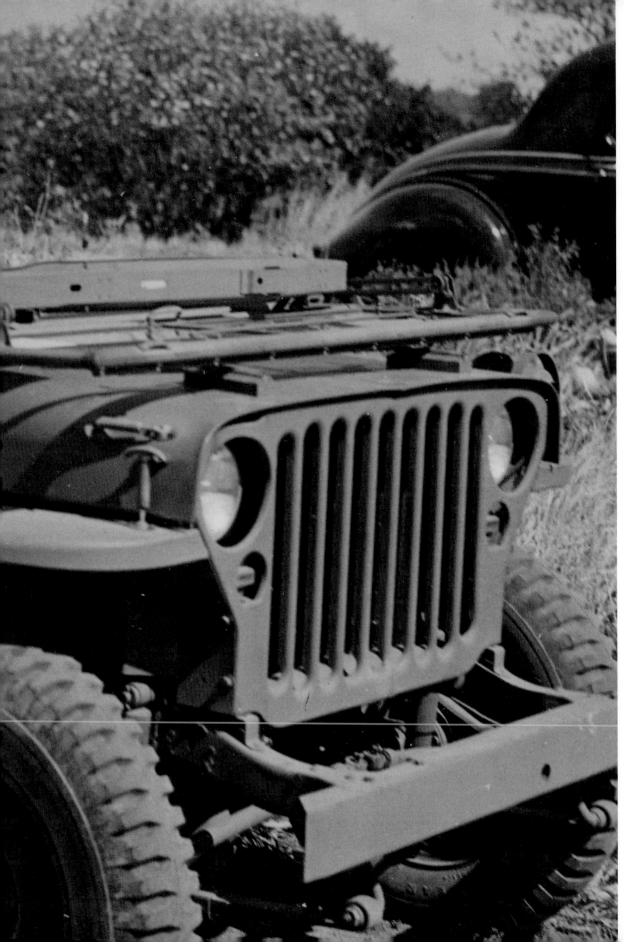

Perhaps Toledo's best-known product during the Second World War was the jeep, here on a test run about 1940. The jeep was not invented in Toledo, but the U.S. Army was reluctant to give a contract for production to the company that designed most of the vehicle, American Bantam of Butler, Pennsylvania, because the small company was in bankruptcy. So was Willys-Overland, which contributed the engine.

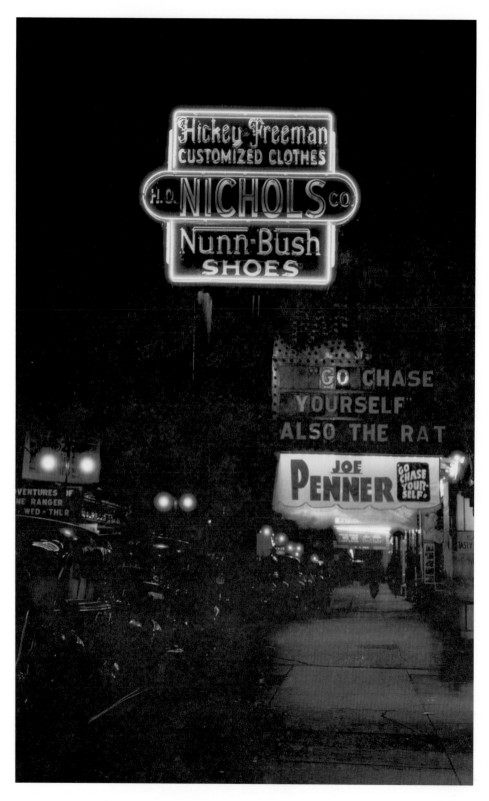

It's not the Great White Way, but Toledoans of a certain age remember that St. Clair Street downtown was home to a large number of movie houses, as well as specialty shops like Nichols Men's Wear.

Main Street in suburban Sylvania, November 1941. Sylvania sits atop an enormous deposit of Devonian age limestone, but for most of its history it remained a sleepy crossroads hamlet. In the postwar era, that image changed—Sylvania became one of the most rapidly growing municipalities in Lucas County.

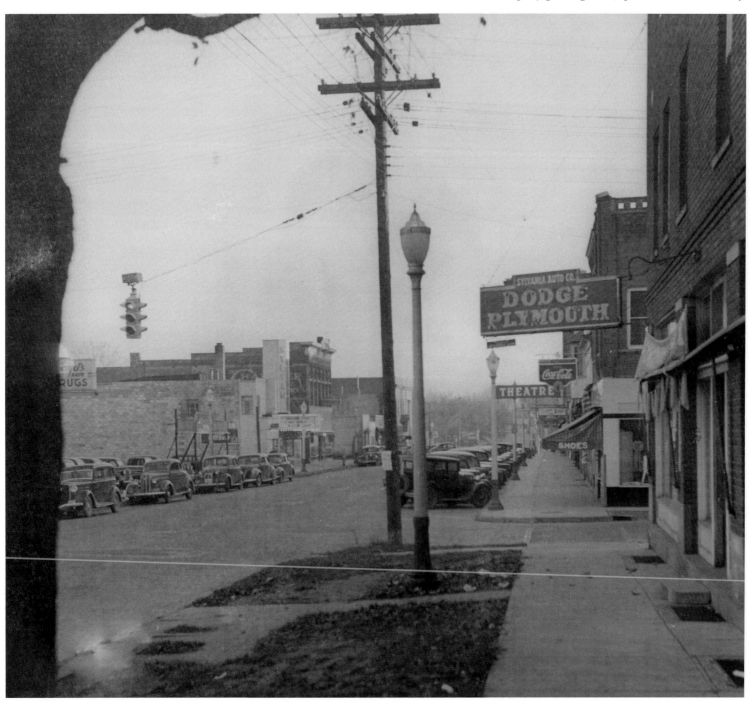

Top executives at Toledo firms—including here Robert A. Stranahan, William E. Levis, and John D. Biggers—participate in a war bond fundraiser, held in the Commodore Perry Hotel, probably around 1942. Toledoans not only served in the military during the Second World War, they worked in war-related industries (almost all industries became war-related after Pearl Harbor), using their savings to purchase war bonds to help the government fund the war.

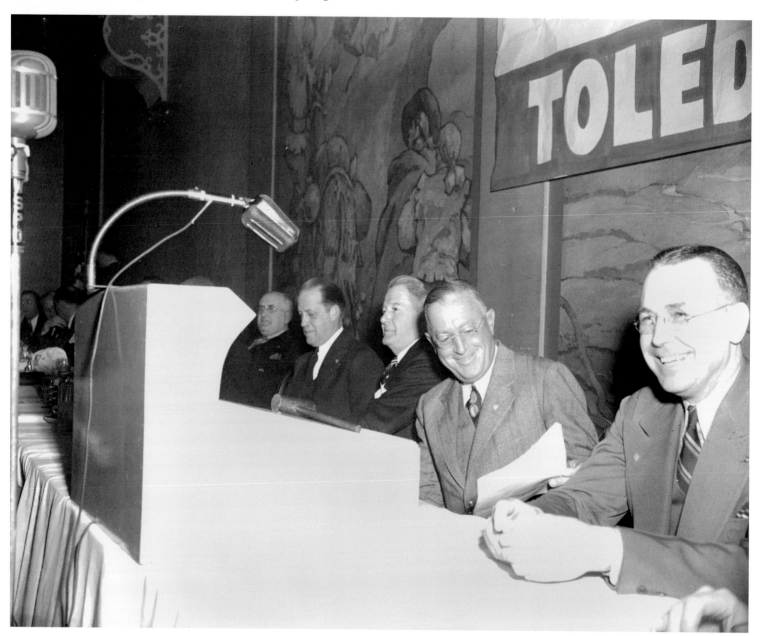

The Willys-Overland Jeep was not the only contribution to the war effort that industries in Toledo made. Here a technician checks results from a wind tunnel test utilizing Toledo scales.

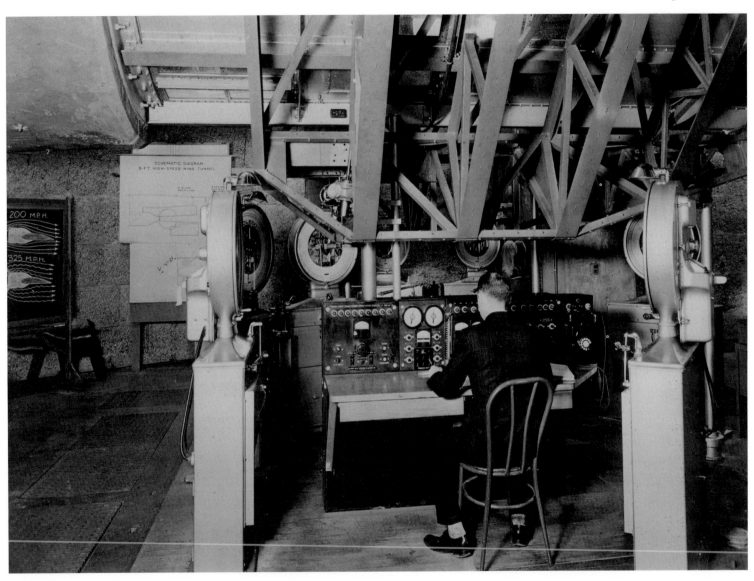

152

The Jeep look went into most vehicles that Willys-Overland made in the postwar era. This station wagon had four-wheel drive and that rugged Jeep profile. It was also the first all-steel station wagon. Car buyers still desired wood body panels in 1948, so the panels have a faux wood coating.

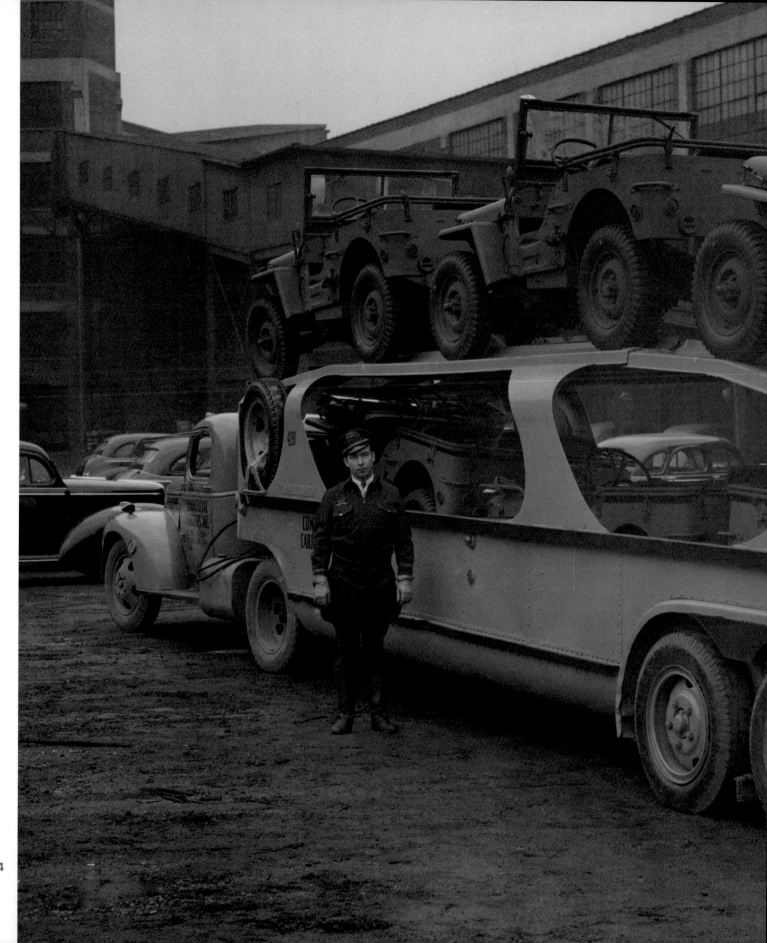

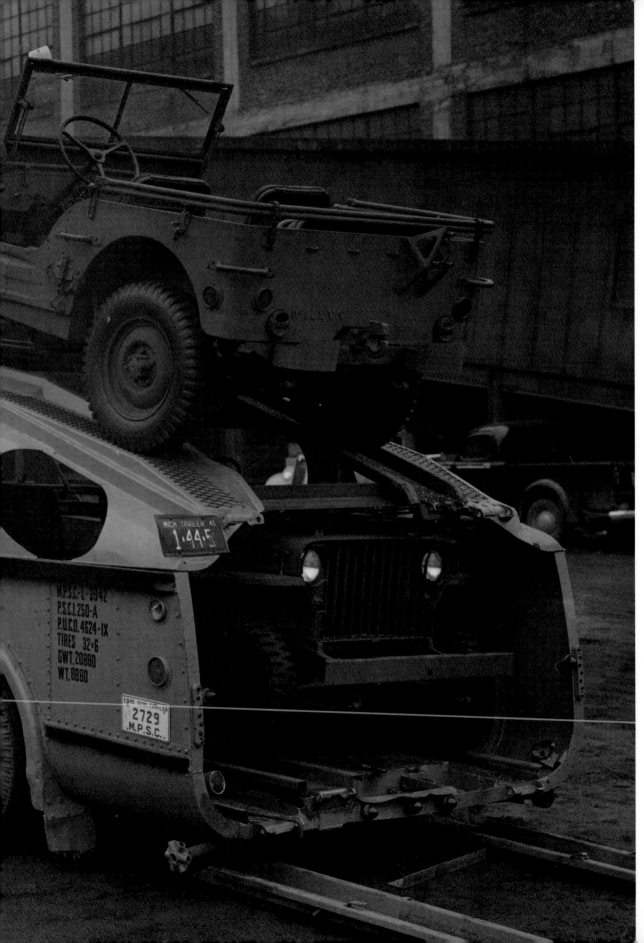

Jeeps are loaded onto a trailer for shipment (ca. 1941). The Jeep remained the transportation vehicle of choice in the U.S. military for more than forty years, until it was replaced by the Humvee in 1985.

This photograph was taken from the 22nd floor of the Toledo Trust (Second National Bank) Building in November 1944, looking northwesterly along the Maumee River. The unknown lake freighter is headed downstream to Maumee Bay, and has cleared three of the six drawbridges operating in the 1940s on the navigable stretch of the river.

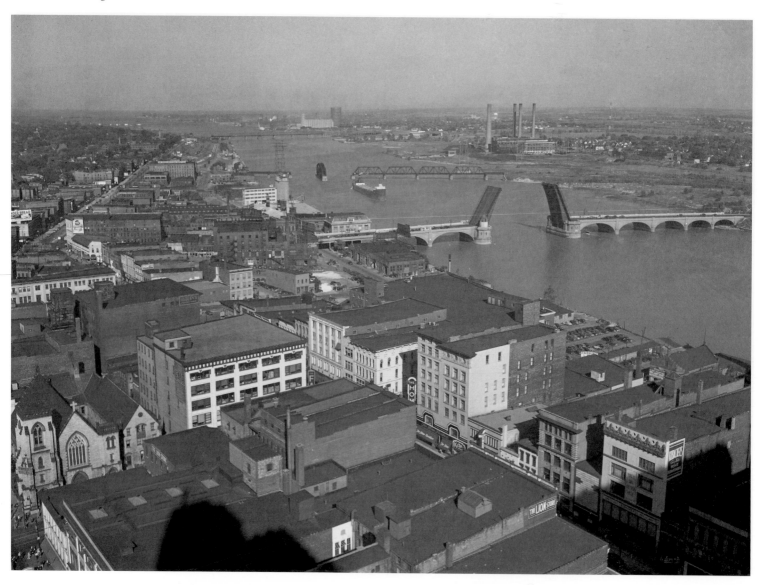

This Ice Follies skater jumped this jeep at the Icehouse, which was located near the Babcock Dairy and the Willys-Overland plant in West Toledo. The Ice Follies troupe was founded in 1937 and was featured in the movie *Ice Follies* in 1939. After the Sports Arena opened in 1948, the Icehouse found it difficult to book acts.

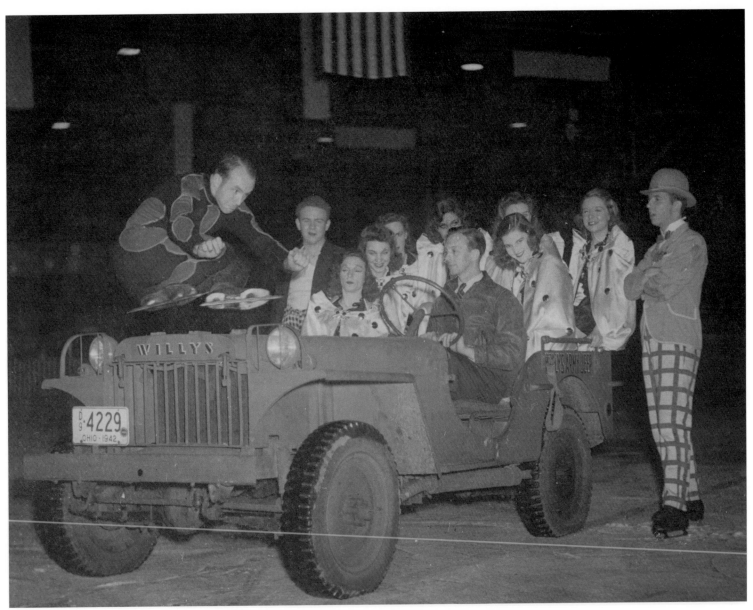

Perry's Victory and International Peace Memorial, located on South Bass Island in Put-in-Bay, commemorates Oliver Hazard Perry's victory over the British fleet in the War of 1812, the men who fought in the battle, and the long-lasting peace between Canada and the United States. This photograph was taken in 1943, probably around the 30th anniversary of the monument, and the 130th anniversary of the Battle of Lake Erie.

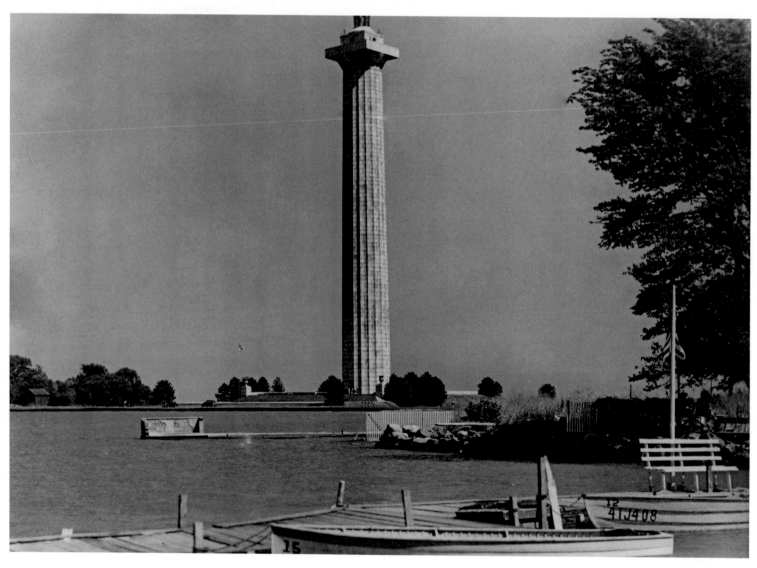

This parade was part of the Aquarama festivities that were held in Toledo in 1947 and 1948. Most of the events focused on water activities. In the first year, this included a three-day canoe race from Fort Wayne (the source of the Maumee) to the Maumee Bay. Much like the Wamba Festival forty years earlier, it was hoped that such activities would attract more tourists to the area.

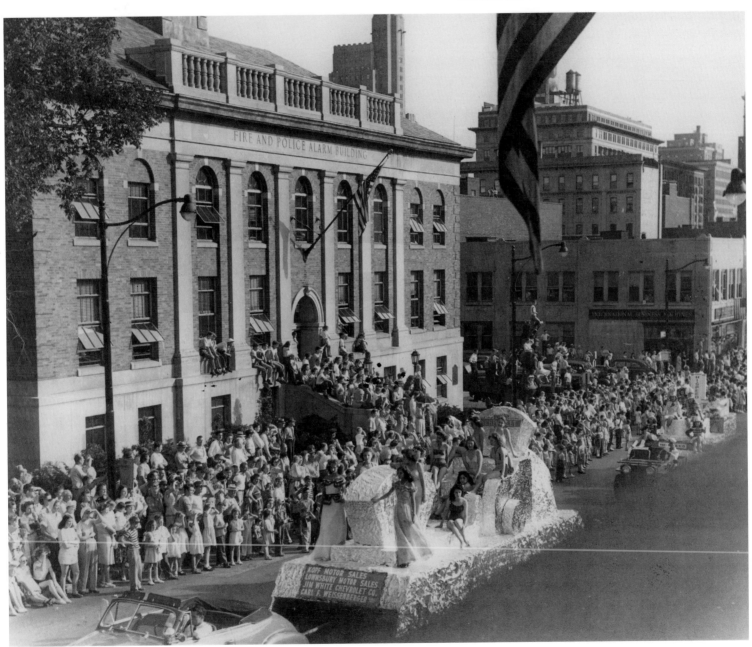

This is the intersection of Summit Street and Clayton Street around 1940. The two tallest buildings visible in the distance had changed ownership in the previous decade. The Second National Bank Building was taken over by the Toledo Trust Company after the former bank failed. The Ohio Savings Bank had failed in the 1930s as well. That building was bought by Owens-Illinois.

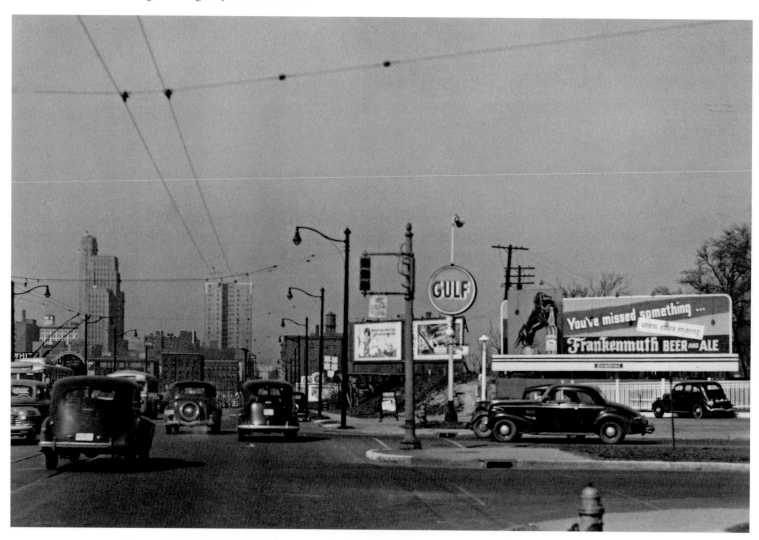

Changes in modes of transportation seemed to have little effect on the shopping patterns of Toledoans of the 1940s, some of whom are boarding this bus.

Following Spread: The Jeepster was yet another jeep-themed vehicle produced by Willys-Overland in the postwar era. Shot on the campus of the University of Michigan, this photo was part of a national sales campaign, run by the Toledo agency Flournoy-Gibbs, aimed at young college graduates.

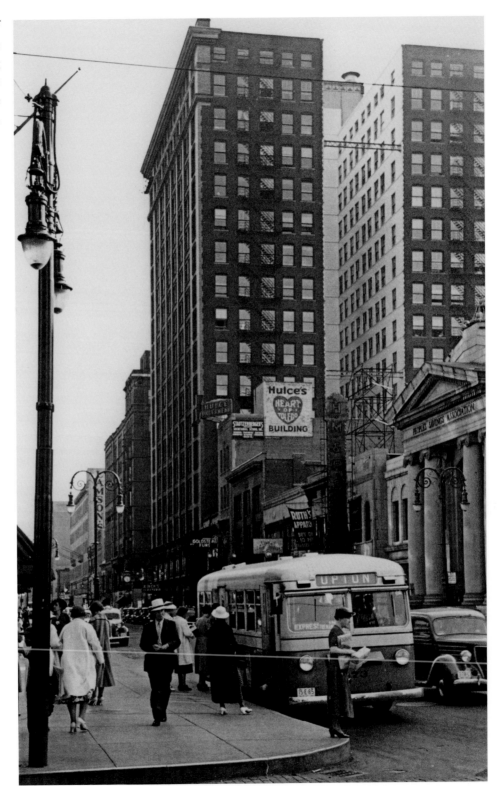

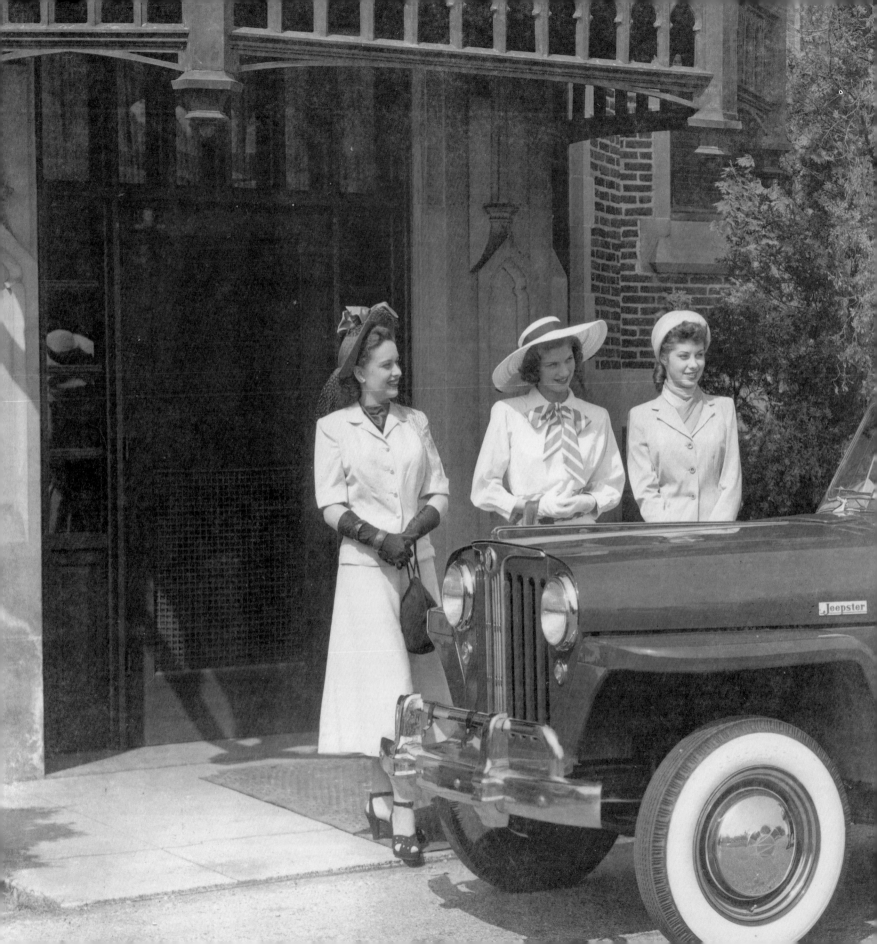

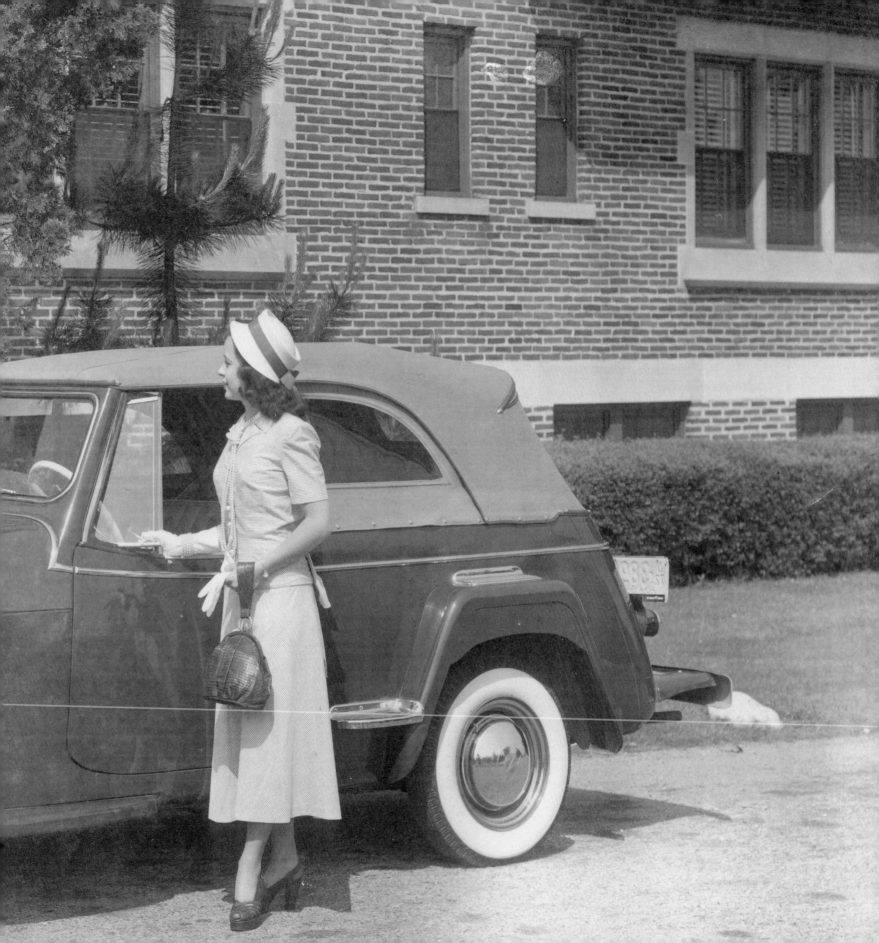

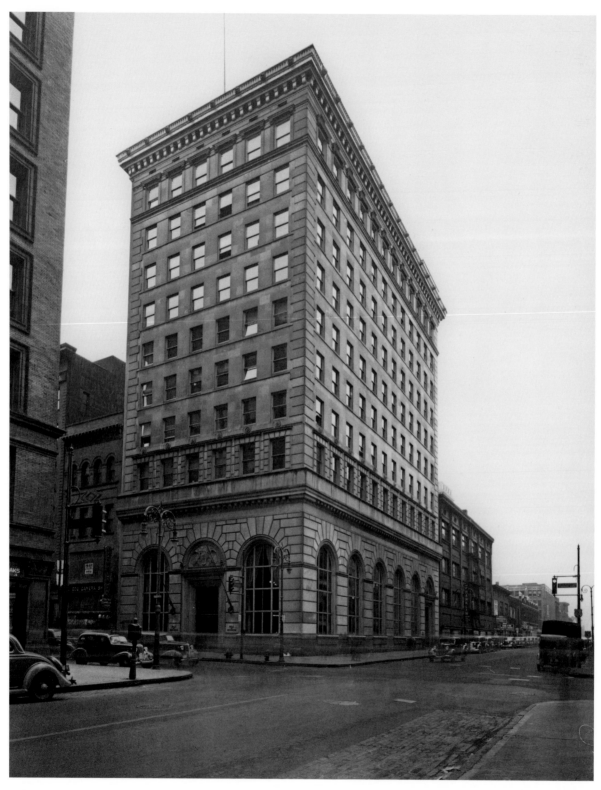

Bell and Beckwith was a longtime Toledo investment firm, which by 1940 was well-enough established to build this staid, impressive-looking building at the corner of Madison Avenue and Superior Street.

This aerial view of downtown Toledo and the Maumee River, from around 1946, shows a city at its commercial peak.

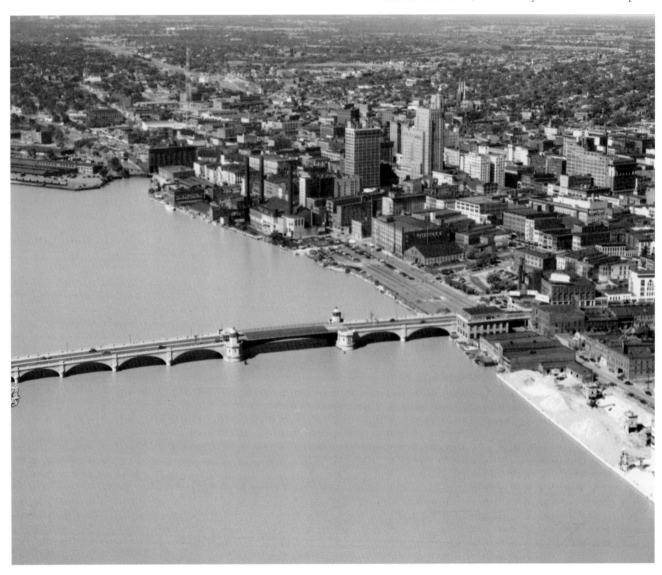

Following Spread: The Jeepster, this photograph intimates, was one's ticket to fun. The engine Willys-Overland put in the automobile, however, was unable to deliver on this promise, and the Jeepster was not a great sales success—although it remains popular in parades in Toledo.

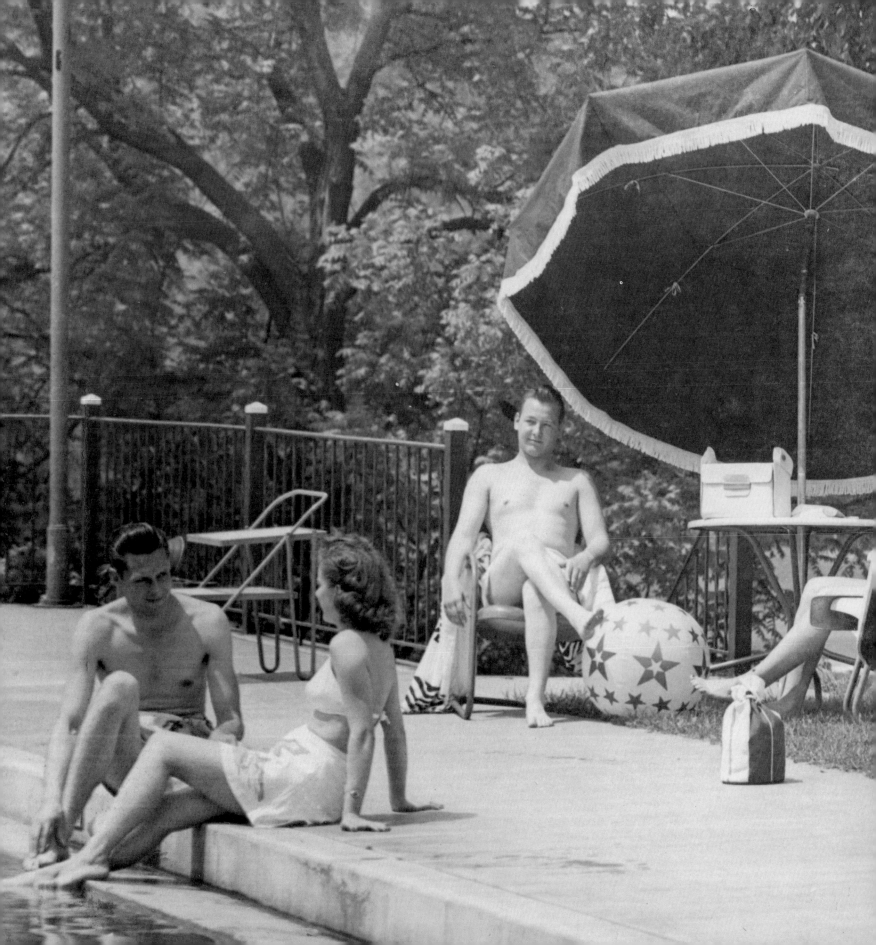

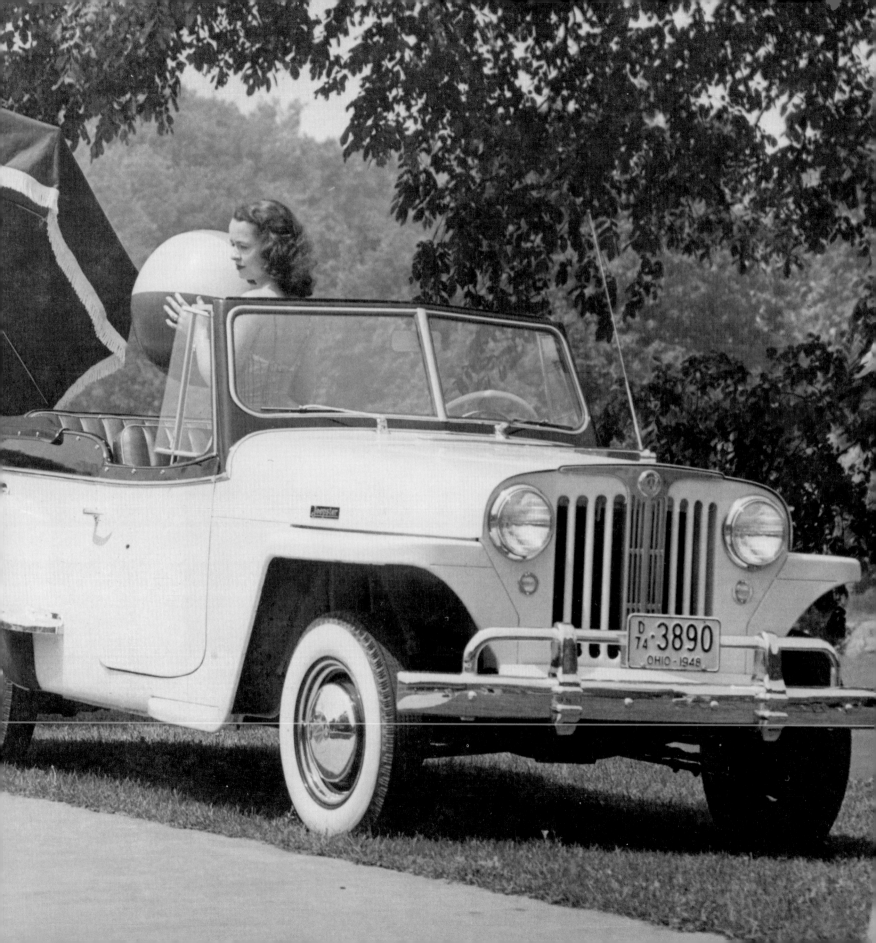

This Sohio station was located at 1603 Canton Street, just north of downtown Toledo. Canton Street is the only street downtown to run in a true north-south direction. Streets that seem to run north-south actually run northeast-southwest, because they are oriented toward the Maumee River.

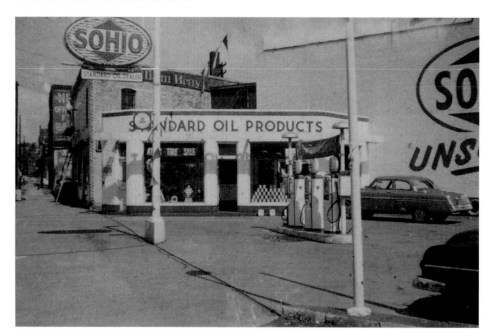

THE POSTWAR DECADES

(1950–1975)

Toledo in the postwar decades, like the nation itself, changed dramatically after the war. Working people in the city began to enjoy a middle-class lifestyle, and as part of that new lifestyle (and easier financing owing to Veterans Administration loans) they moved to new housing developments outside the city limits.

New shopping centers opened to complement these new developments, and shopping downtown entered a steep decline. To keep the downtown area vibrant, many solutions were implemented, many of them requiring the leveling of buildings to provide parking spaces for the cars that weren't coming anymore.

Economic changes also had detrimental effects on Toledo industries. Many were consolidated or bought by out-of-town interests, or closed completely. By 1975, Toledo Scale no longer manufactured in Toledo, Electric Auto-Lite had been closed for more than a decade, and Willys-Overland had been purchased by two other manufacturers. Toledo had become the buckle on the Rust Belt.

Although the city has not suffered to the extent that Detroit, Flint, or Youngstown has, the economic downturn has created challenges the city must face as the future unfolds.

Tiedtke's Department Store provided customers a wide variety of products—everything from meat to moccasins—at low prices. The same idea that Sam Walton later turned into billions. The Tiedtkes, and the Kobachers after the Tiedtkes sold the store, were masters of in-store marketing. In the 1950s, bananas were not a regular grocery item—except at Tiedtke's.

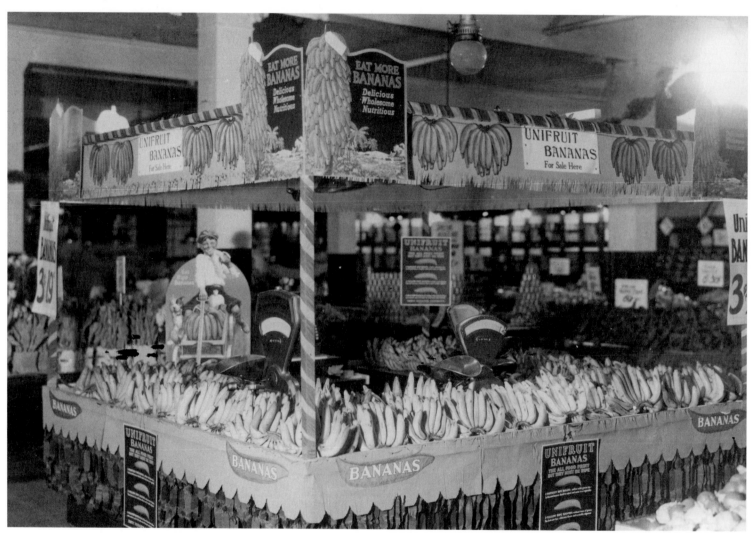

The lobby of the Commodore Perry Hotel, still elegant in 1950. The Commodore Perry was the last large hotel built in the downtown area from the time it opened, in 1932, until the late 1970s, when a Holiday Inn was built at the corner of Summit and Jefferson.

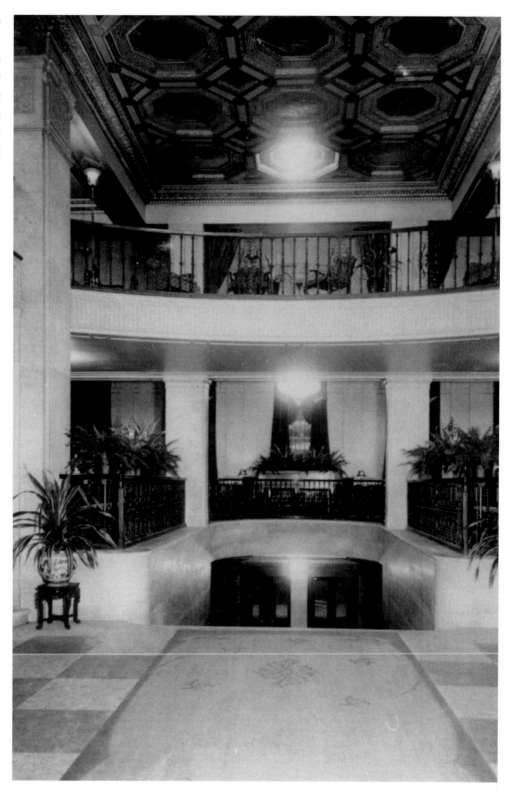

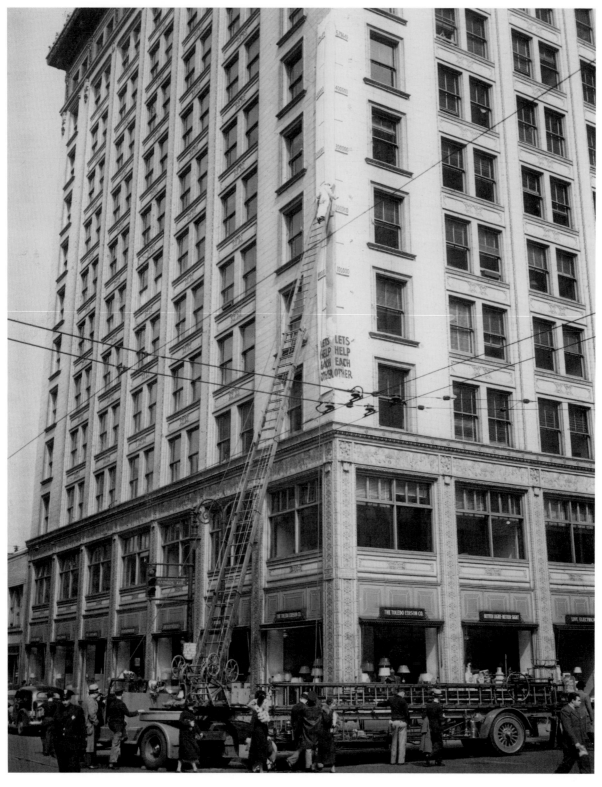

The fire fighter at the top of the ladder is not fighting a fire, but is only updating the running total of the 1950 Red Feather campaign, the predecessor of the United Way Campaign familiar to most today. This is the Ohio Building, located at the corner of Madison Avenue and Superior Street.

The Fishing Rodeo was popular with children in the 1950s. These events were held at the pond at Pierson Metropark, with prizes for the children who caught the biggest fish.

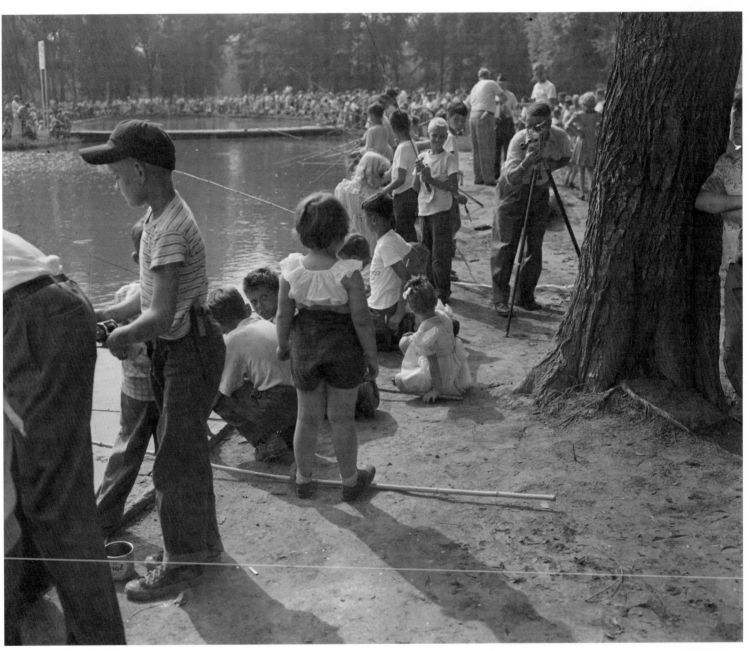

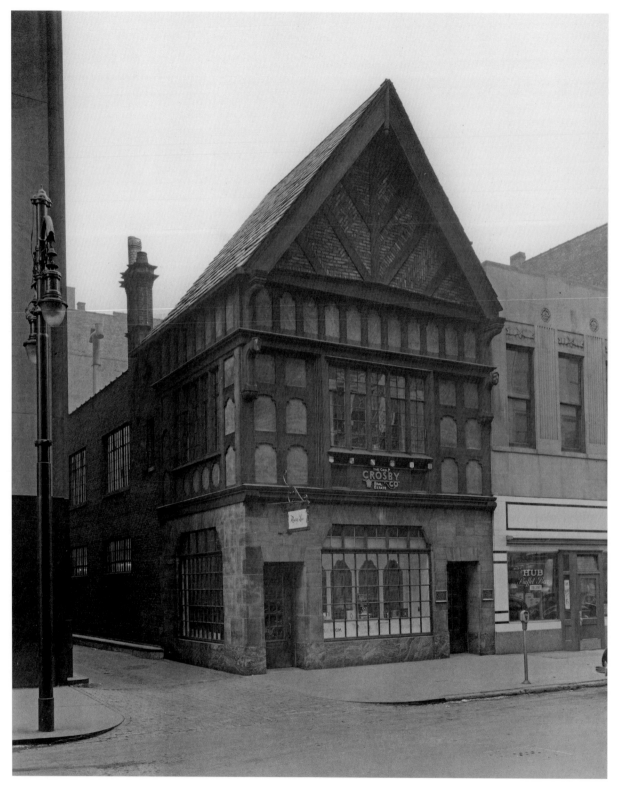

The George Crosby Real Estate Company was located in this little bit of tyrolean architecture in the early 1950s. Before parking lots became profit makers, Toledo boasted a wide variety of architectural styles. With the need to park cars, however, and increased competition from suburban shopping centers, parking lots began replacing buildings like this one.

General George Marshall comes to Toledo in February 1950 during his service as president of the American Red Cross. He was to give a speech in the Peristyle of the Toledo Museum of Art, where this photograph was taken.

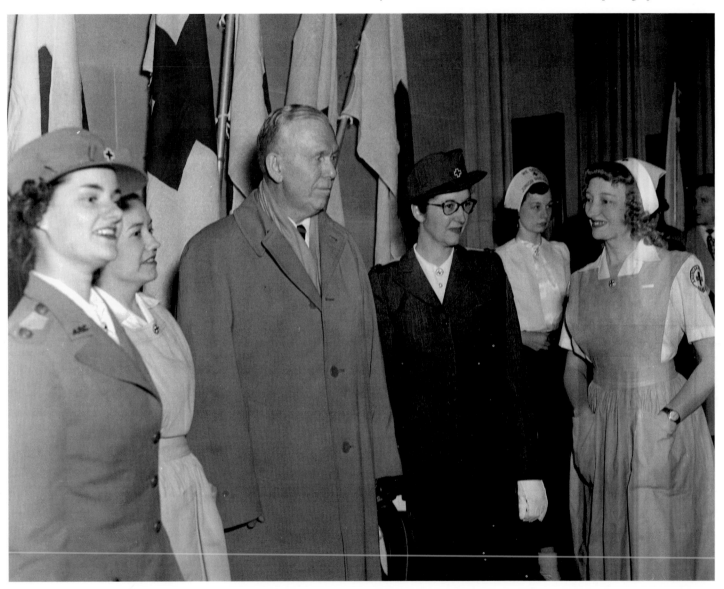

The staff of the Stewart Pharmacy, ca. 1950. Ella P. Stewart and her husband, William "Doc" Stewart, opened their pharmacy at the corner of City Park Avenue and Indiana Avenue in 1922. They quickly established themselves as leaders of their community. Doc became manager for local jazz pianist Art Tatum, and Mrs. Stewart became active in community affairs and civic groups.

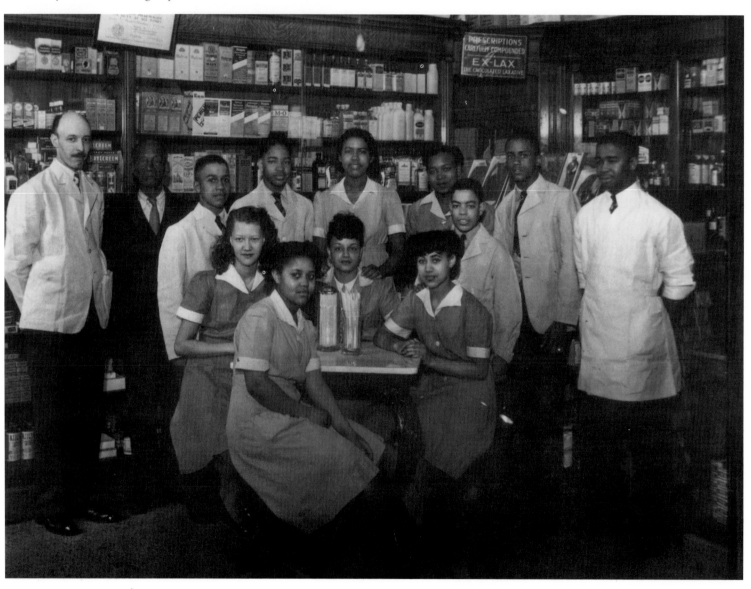

The Ashland Avenue Baptist Church building was designed by Toledo architect David L. Stine, based on the "Akron Plan." In the early part of the century, churches had little problem filling their pews. As people moved to the suburbs, however, filling these great spaces became more of a challenge.

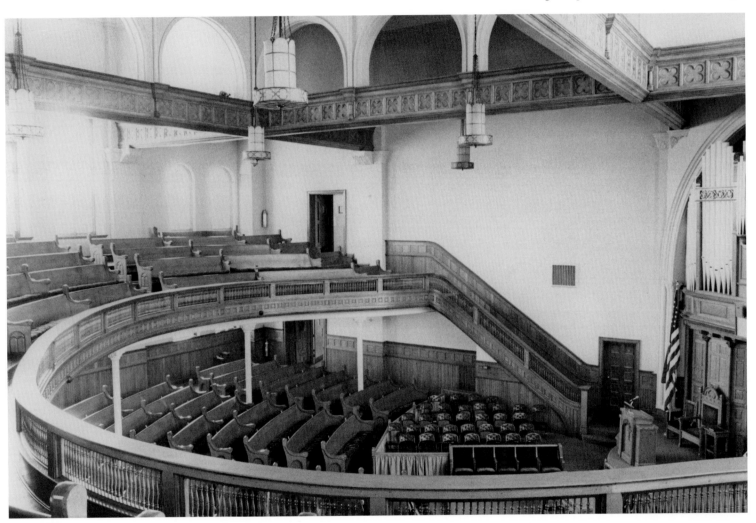

The Toledo Fire Department underwent a reorganization in the 1950s, owing to the new suburbs. Several new fire stations were built, like the new Number 1 Station here at the corner of Huron and Orange streets (which also served as headquarters for the department). Other stations were closed.

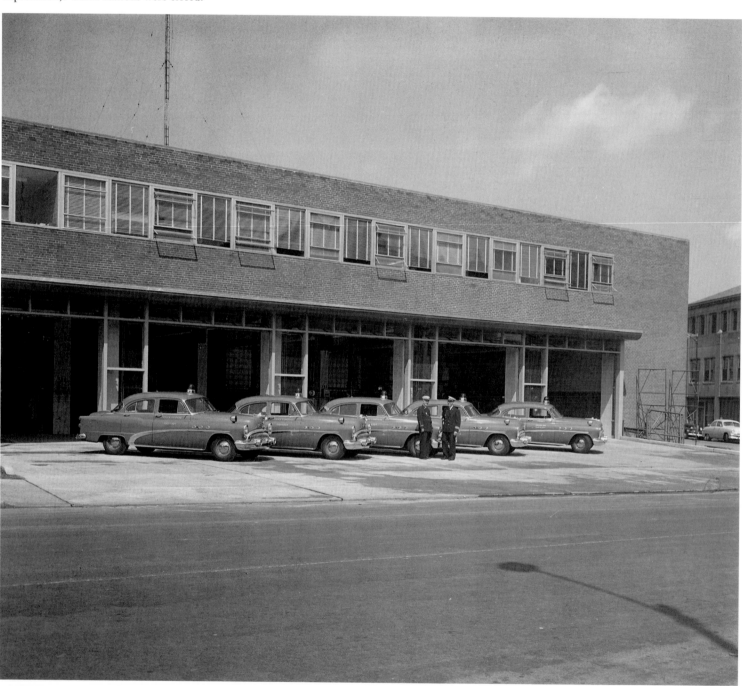

In the 1950s, the widespread enjoyment of the automobile led to more businesses that catered to Americans in their automobiles. Open for business here in 1955, this drive-in was located on Detroit Avenue, and Toledo enjoyed many more like it. Only the Sundance Kid Drive-in shows outdoor movies today.

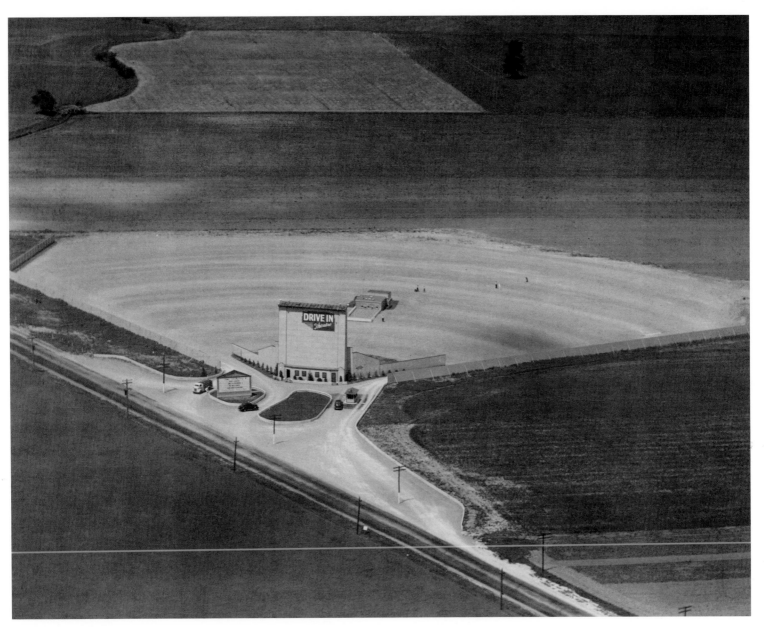

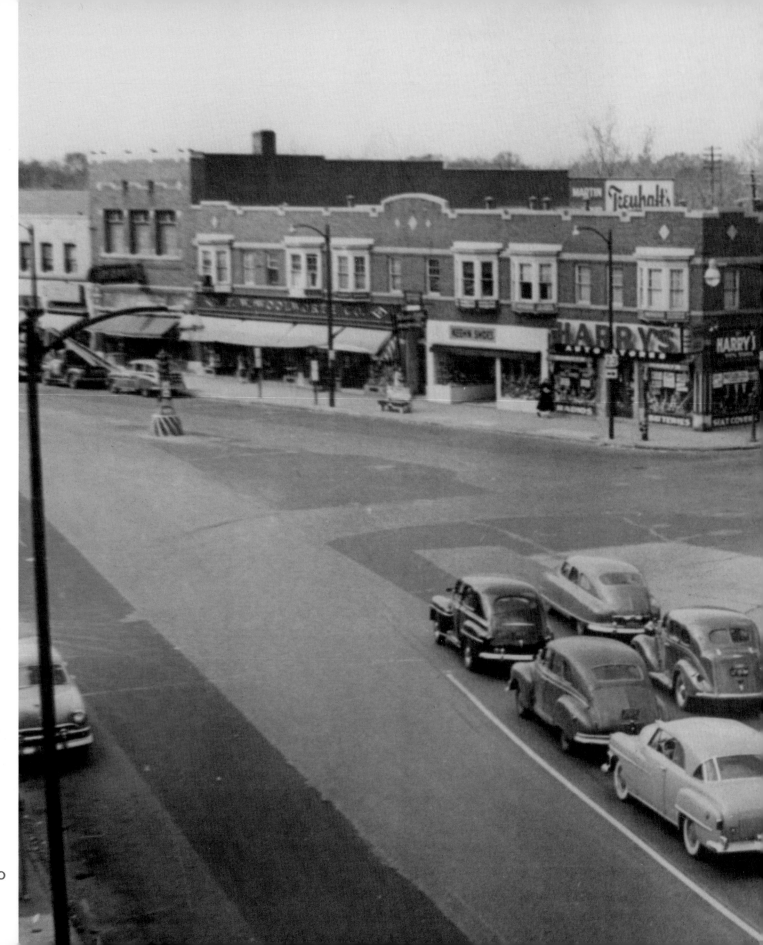

180

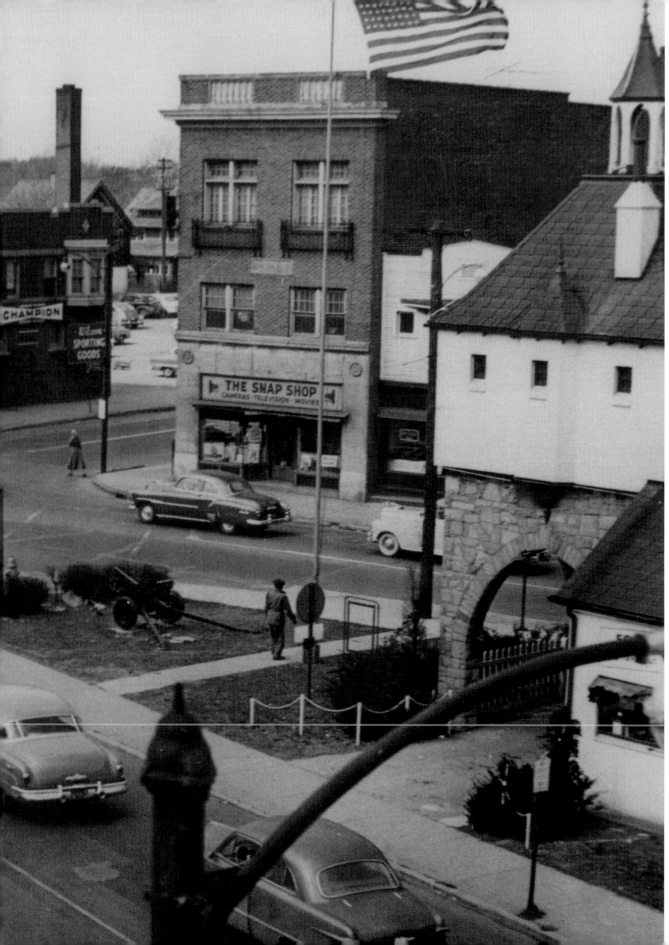

Five Points in West Toledo, where Phillips Avenue, Lewis Avenue, Sylvania Avenue, and Martha Street intersect. This photo was probably taken as part of a study in the early 1950s to improve traffic flow in the area, before the construction of the interstate highway system. Lewis Avenue at this time was a route to Ann Arbor.

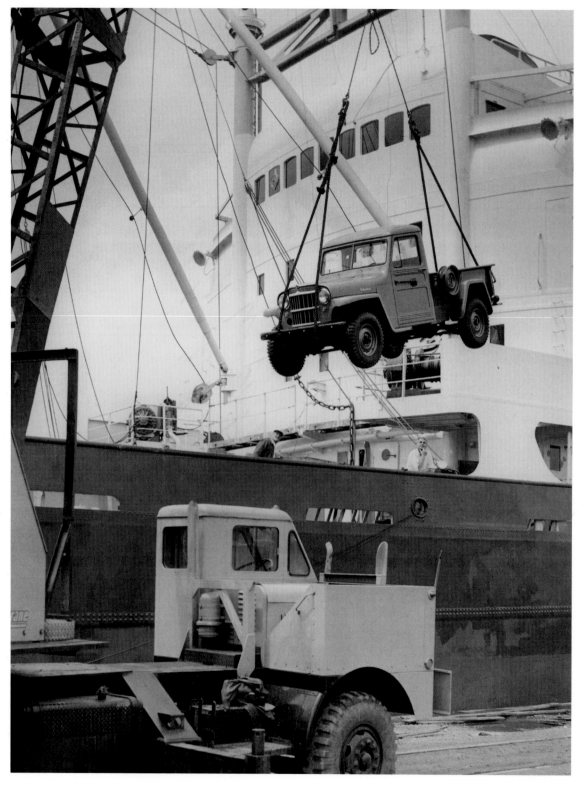

Willys-Overland took advantage of Toledo's location as a seaport to ship a large number of Jeep automobiles overseas in the mid 1950s. The company also set up branch production in countries like Australia and Brazil.

As shoppers headed to the suburbs, downtown retailers quickly noticed, pressing city officials to attempt to create a "mall" downtown. Both Adams Street and Madison Avenue were closed to traffic between St. Clair Street and Huron Street, and entertainment, gardens, and playground equipment were moved into the streets to create the Pedestrian Mall in 1958 and 1959. The organist here is entertaining listeners on Madison Avenue.

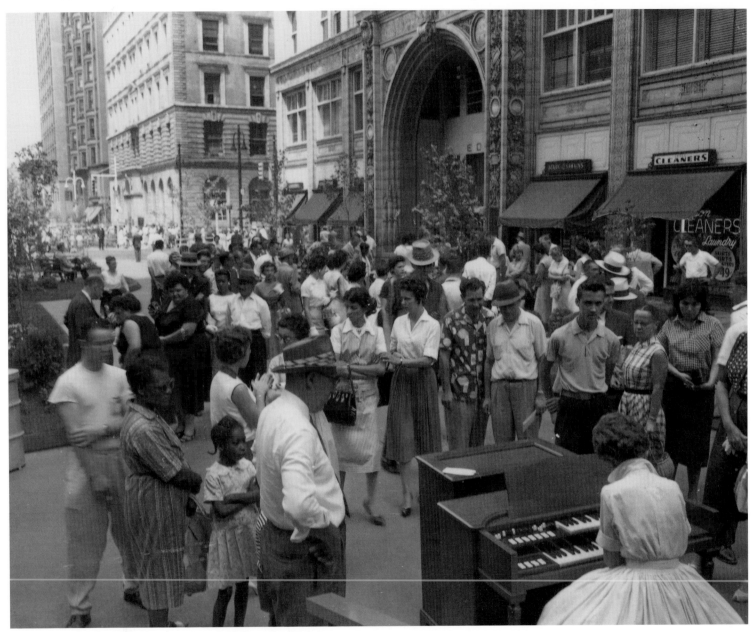

Following Spread: These men are testing the new deep-fording kit for the military jeep, probably around 1955. This test is probably taking place in Maumee Bay, near Point Place. The Jeep has been closely identified with Toledo since World War II.

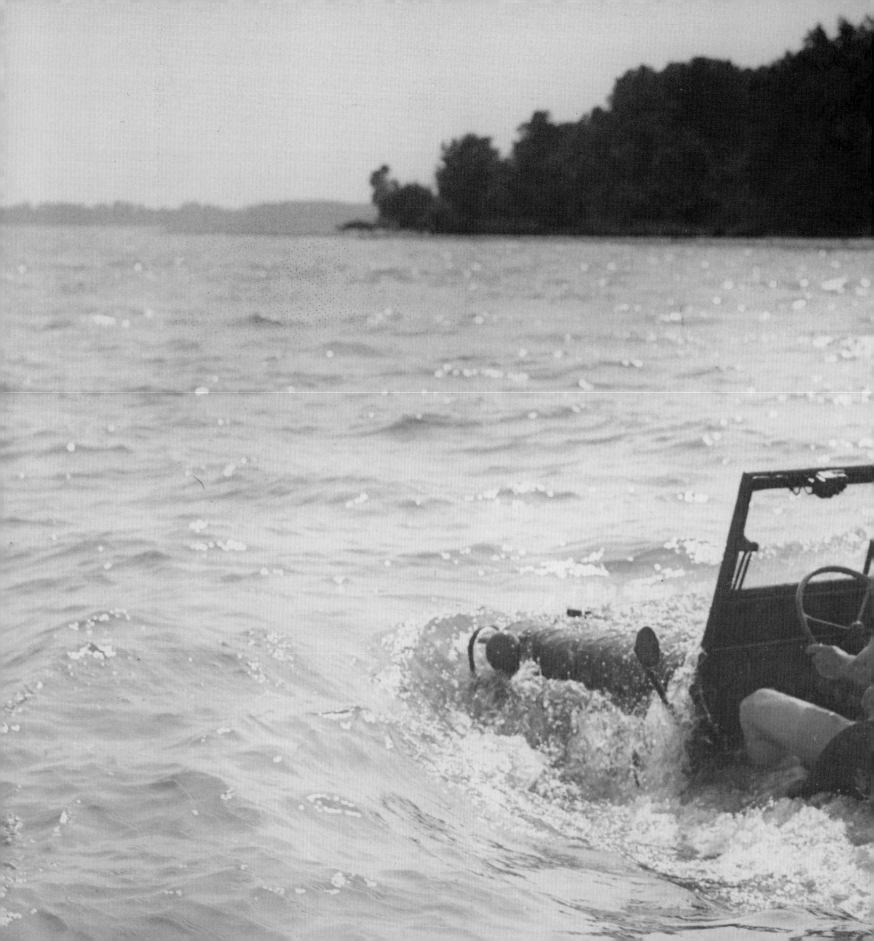

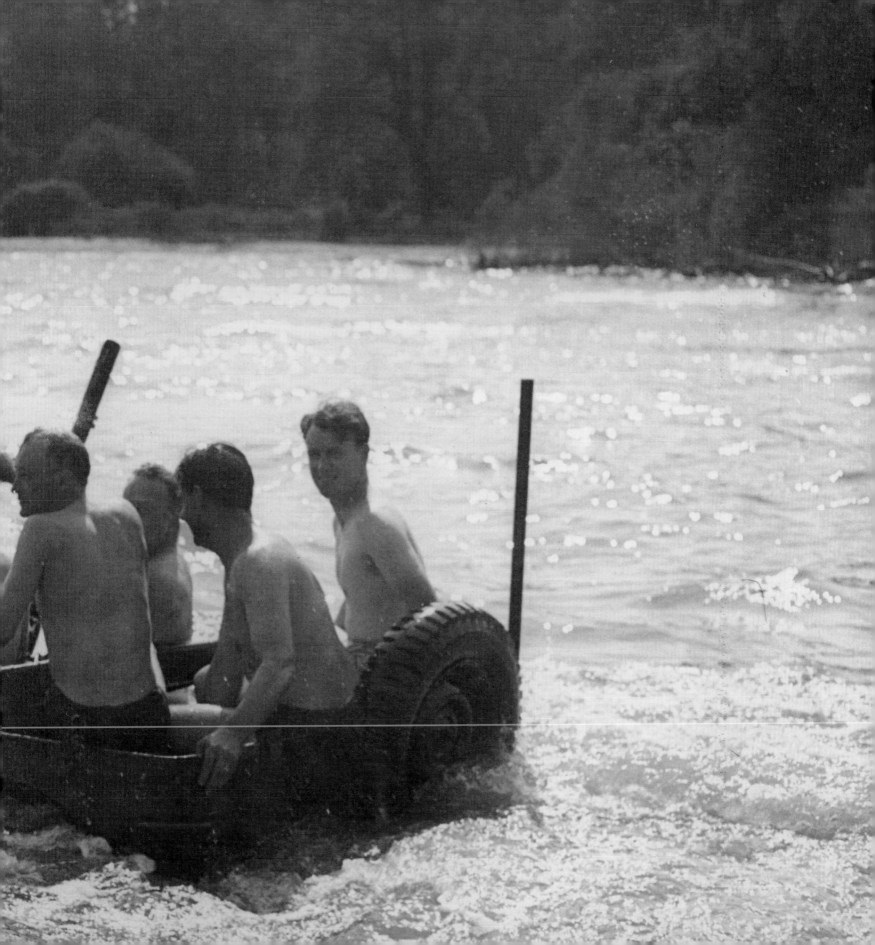

Holy Toledo! Danny Thomas returns to Toledo in 1957 for ceremonies
held to rename a city park in his honor.

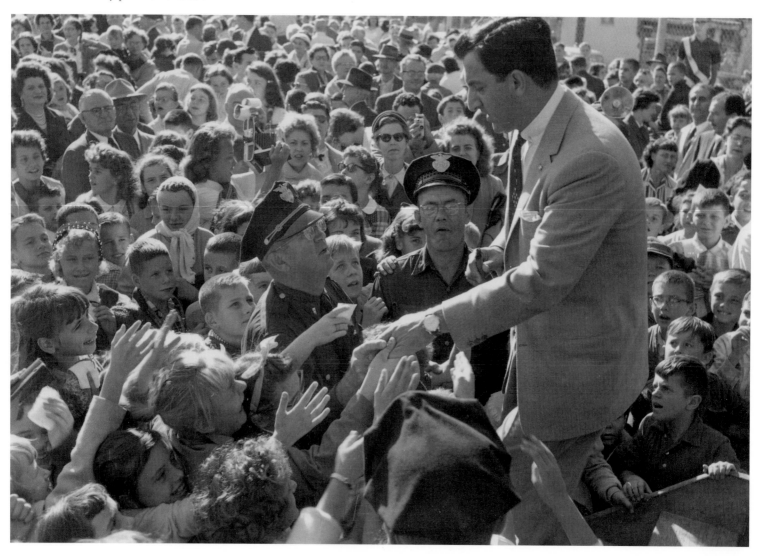

In an attempt to lure shoppers back downtown from suburban shopping centers, Tiedtke's updated the look of their downtown store, including vanquishing sawdust-laden floors, installing floor tile, and updating the display cases.

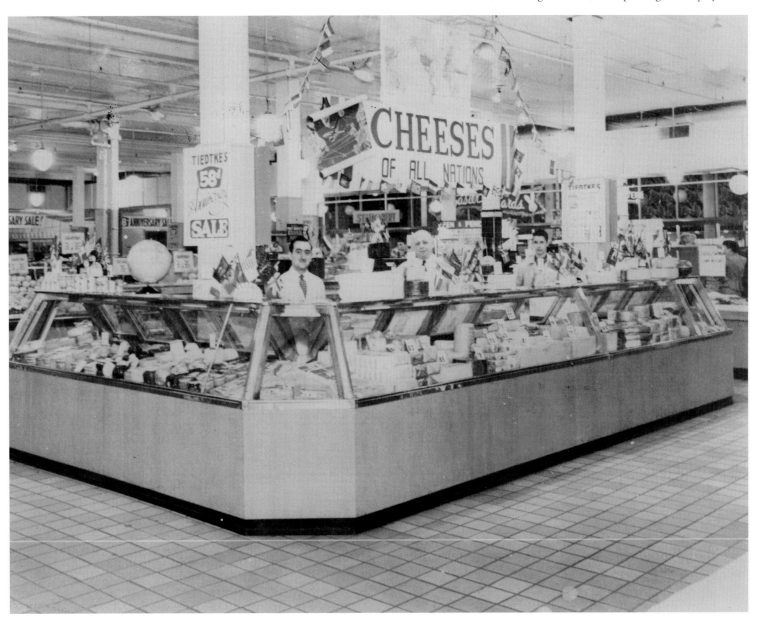

In 1953, the Kaiser Motors Corporation bought Willys-Overland
Motors, and concentrated on producing only utility vehicles. By 1955,
the company was producing only the Jeep and Forward Control trucks
like the one in view here. This photograph was taken at the newly opened
Toledo Express Airport around 1955.

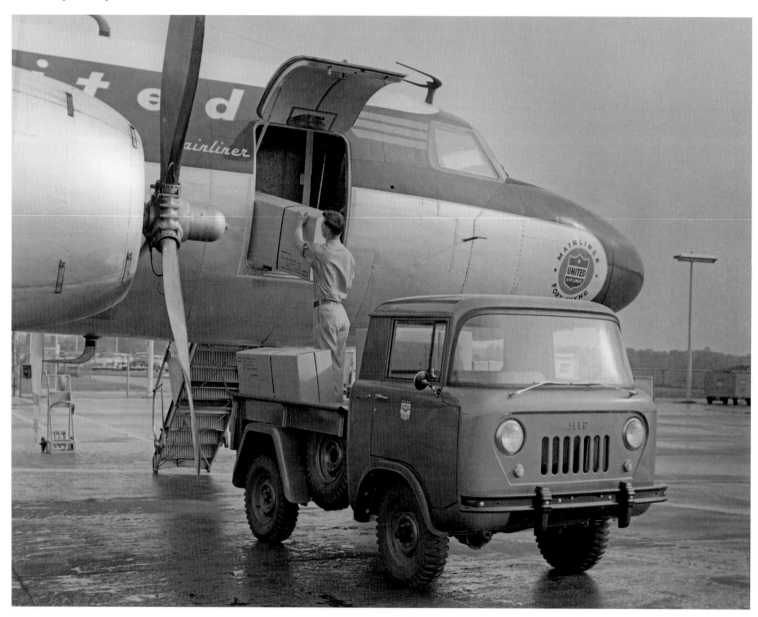

This 1955 bird's-eye view offers a glimpse of the growth Toledo enjoyed during the first fifty or so years of the twentieth century.

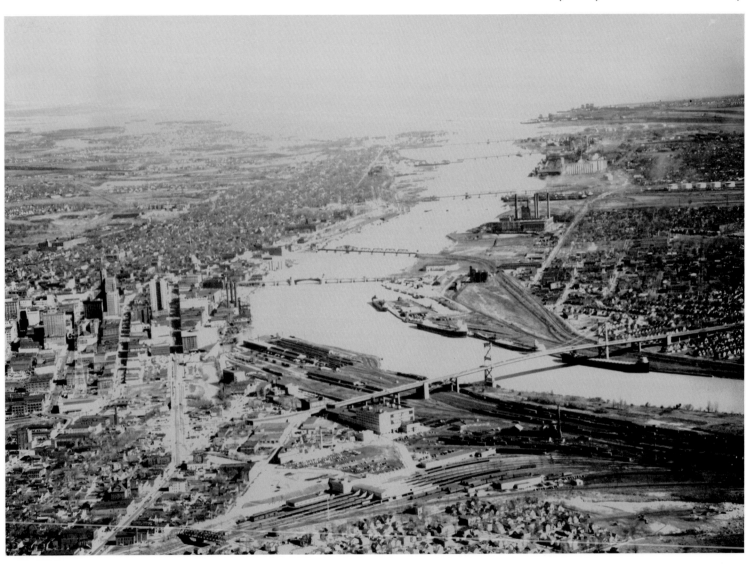

The Toledo Museum of Art has provided countless schoolchildren in the Toledo area with a greater appreciation for art. This school group is visiting the museum in 1962.

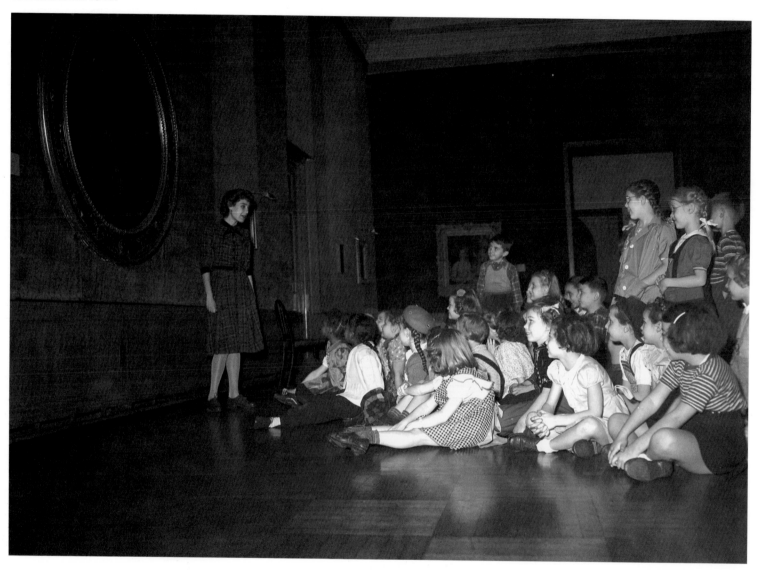

These smokestacks are located at the Libbey-Owens-Ford plant in suburban Rossford (ca. 1960).

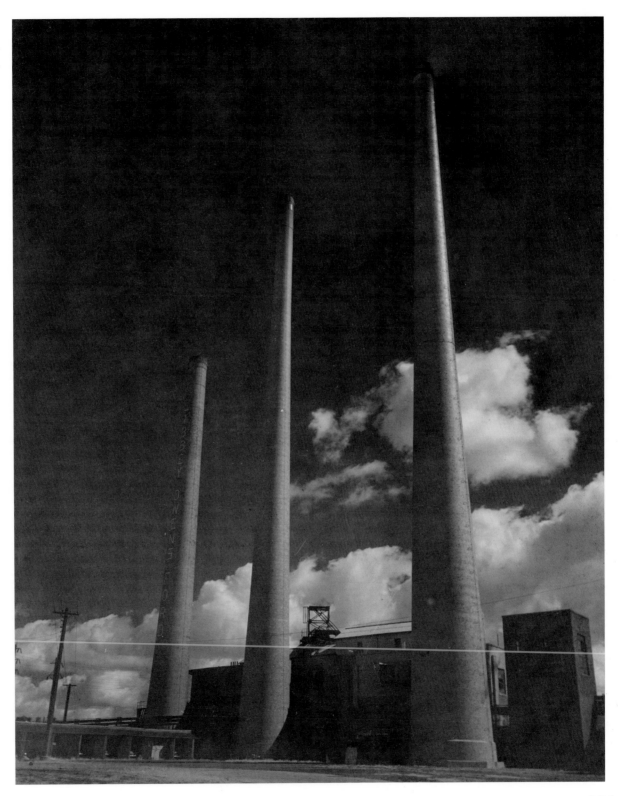

At the Libbey-Owens-Ford plant in Rossford, this woman is attaching electrical components to a windshield to be installed in a jet airplane. LOF also supplied a number of automobile companies with glass components (ca. 1965).

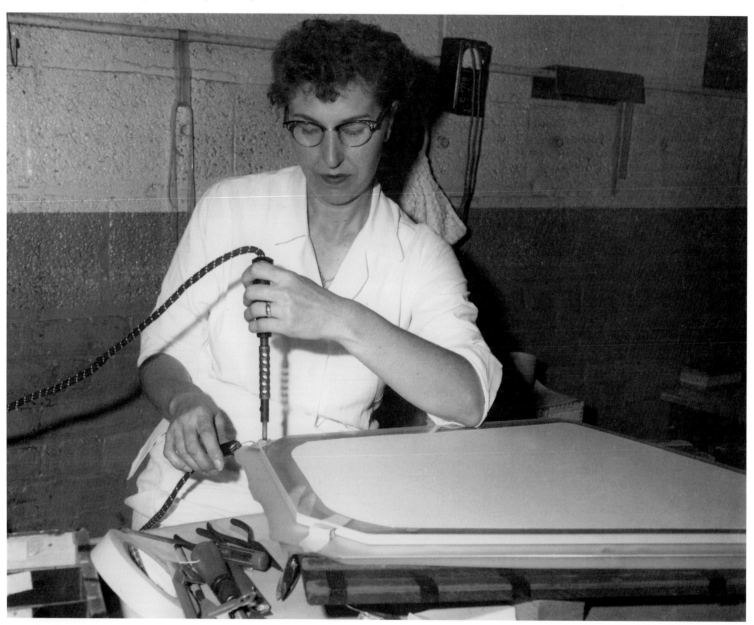

The Columbia Gas Company had this building constructed at the corner of Erie Street and Jefferson Avenue. The building is reminiscent of the work of German architect Ludwig Mies van der Rohe, of "less is more" fame.

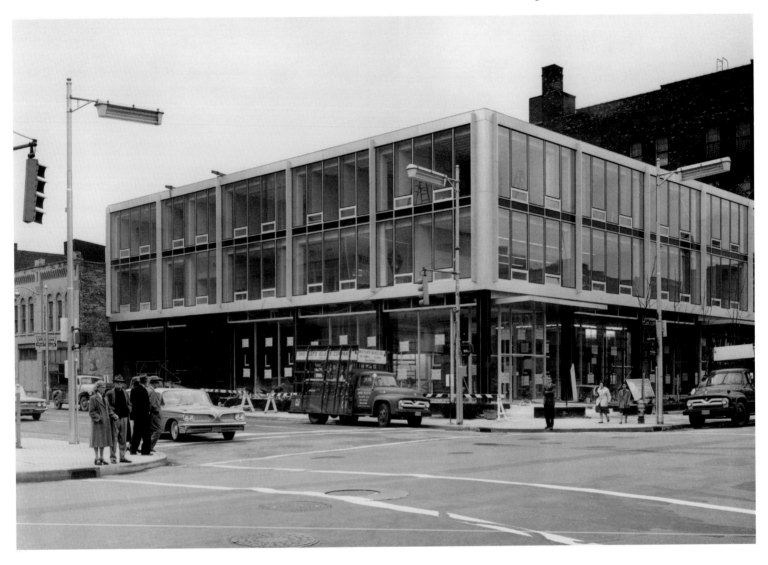

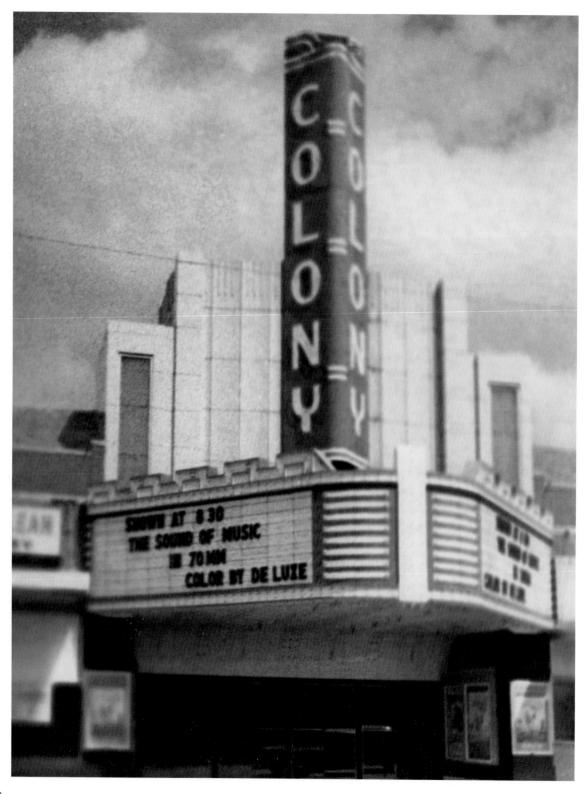

The Colony Theater was one of the earliest of the new breed of suburban movie theaters. Rather than having to wait for new films, Colony audiences were able to see first-run movies, like *The Sound of Music* showing here in 1965. Downtown theaters, meanwhile, were being reduced to showing second-run movies.

Holy Trinity Greek Orthodox Cathedral, ca. 1975. Holy Trinity has been an anchor for the near northside of Toledo since its opening. Every large city has a neighborhood that new immigrants move into; North Toledo has served as an entrepot for Germans, Jews, Greeks, Lebanese, Syrians, and others.

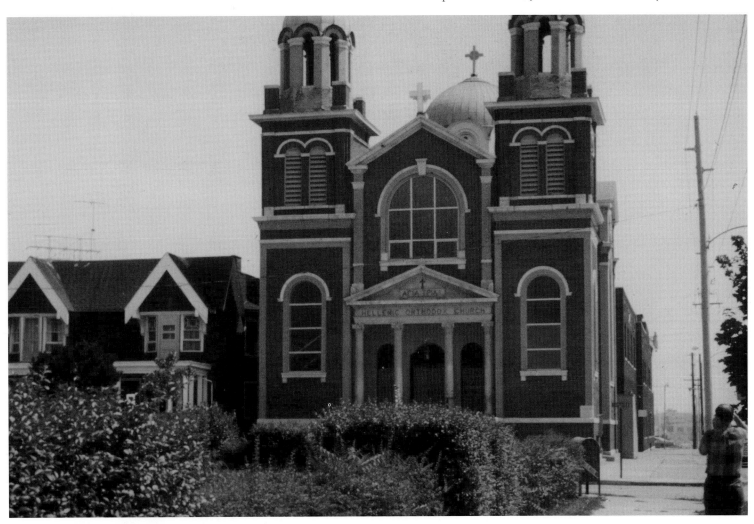

Toledo Scale holds an open house for its employees and their families in the spring of 1964. The Toledo scale was another widely known Toledo product. The slogan "No Springs—Honest Weight" called attention to both their design innovation (no springs) and the claim that this innovation prevented cheating (honest weight). The company placed scales in areas where passersby could weigh themselves, which built trust in the product.

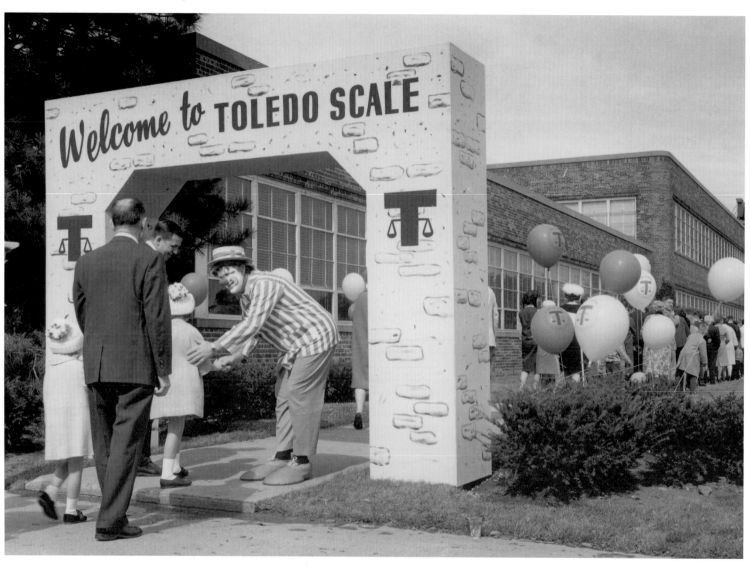

From the mid 1960s to the 1980s, the city was being reshaped. One of the anchor projects of this effort was the construction of the new headquarters for Owens-Corning, Fiberglass Tower, named for their most popular product.

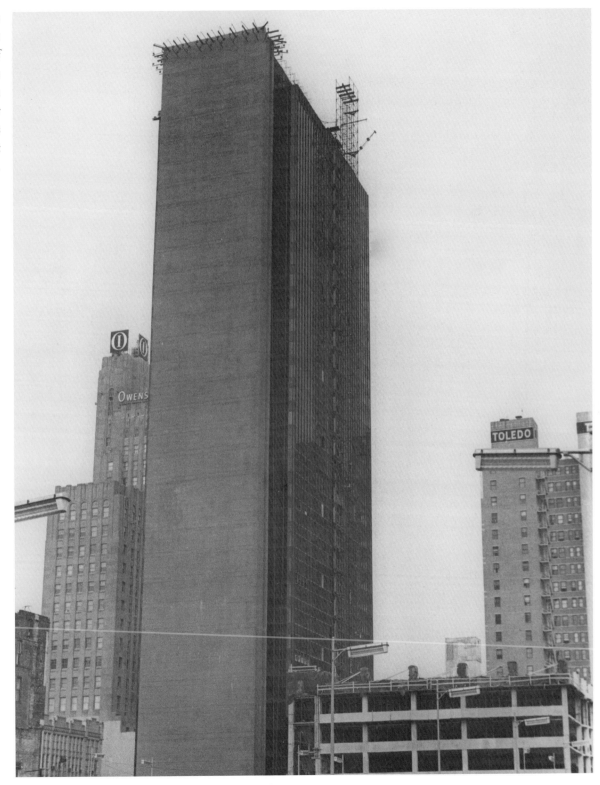

The urban renewal projects of the mid 1960s and 1970s greatly changed the appearance of the city. One of the casualties was the Town Hall Burlesque Theater. Rose LaRose, proprietor of the Town Hall, was able to move her business to the Esquire Theater.

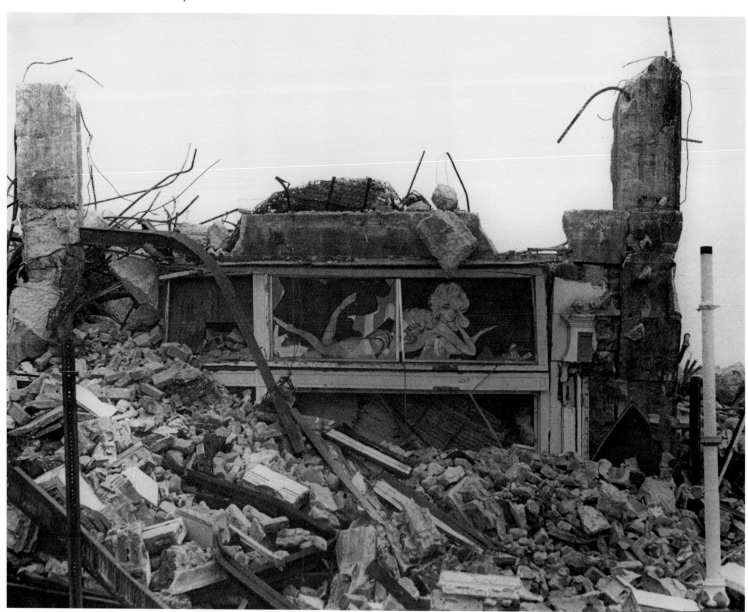

Toledoans today mainly look at the Great Lakes as a recreation spot, forgetting that many still make their living on the lakes. In the late fall of 1975, nature reminded those living in the area of just how unforgiving those waters can be. When "the gales of November" claimed the *Edmund Fitzgerald,* they also claimed the lives of seven Northwest Ohio residents—including the captain of the ship, Ernest M. McSorely.

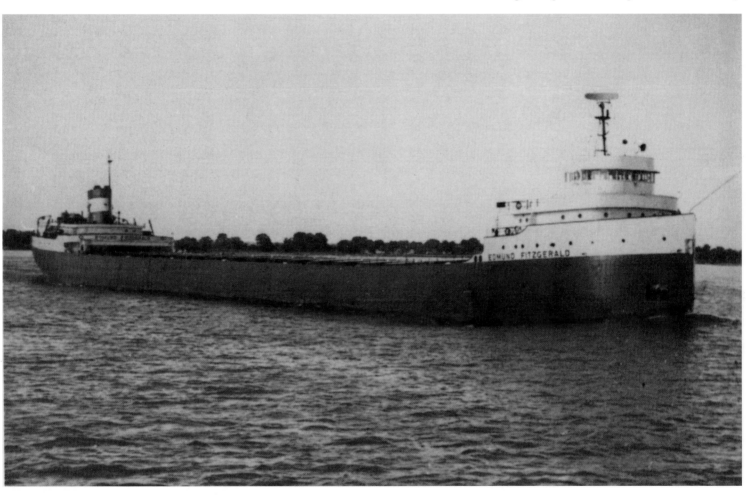

NOTES ON THE PHOTOGRAPHS

These notes, listed by page number, attempt to include all aspects known of the photographs. Each of the photographs is identified by the page number, photograph's title or description, photographer and collection, archive, and call or box number when applicable. Although every attempt was made to collect all available data, in some cases complete data was unavailable due to the age and condition of some of the photographs and records.

101 **BALSA WOOD PLANES**
Toledo-Lucas County Public
Library
a_907_transcontinental_air

102 **SAFETY BUILDING**
Toledo-Lucas County Public
Library
a_18285_safety_building

103 **GROUNDBREAKING**
Toledo-Lucas County Public
Library
a_16642_lamson_groundbreak

104 **ST. PATRICKS**
Toledo-Lucas County Public
Library
a_st_patricks

105 **WOOLWORTH**
Toledo-Lucas County Public
Library
a_8815_woolworth

106 **LINDBERGH**
Toledo-Lucas County Public
Library
a_2990_lindy_bono

107 **TOLEDO BLADE**
Toledo-Lucas County Public
Library
a_blade_building

108 **LAMSONS**
Toledo-Lucas County Public
Library
a_5423_lamsons_opening

110 **SUMMIT STREET**
Toledo-Lucas County Public
Library
a_summit_cherry

111 **VALENTINE THEATER**
Toledo-Lucas County Public
Library
a_12938_valentine

112 **POLICE BUILDING**
Toledo-Lucas County Public
Library
a_police_fire_alarm_build

113 **NASBY BUILDING**
Toledo-Lucas County Public
Library
a_6100_madison_ave_1933

114 **RIVER ROAD HOME**
Toledo-Lucas County Public
Library
a_16556_stranahan_backyard

115 **HOOVERVILLE**
Toledo-Lucas County Public
Library
a_6046_hooverville

116 **ANNIVERSARY**
Toledo-Lucas County Public
Library
a_9992_tiedtkes

117 **WOMEN PICKETING**
Toledo-Lucas County Public
Library
auto_lite_female_pickets

118 **PORTS FOR COAL**
Toledo-Lucas County Public
Library
a_nyc_hulett_loader

120 **PICKETERS FIGHT BACK**
Toledo-Lucas County Public
Library
auto_lite_gas_bomb

121 **CHESTNUT HILL BATTLE**
Toledo-Lucas County Public
Library
auto_lite_album_soldier

122 **MAUMEE PORTS**
Toledo-Lucas County Public
Library
a_nyc_coal_dock

123 **WORKING POTS**
Toledo-Lucas County Public
Library
a_lof_glass_pot

124 **FLOP HOUSE**
Toledo-Lucas County Public
Library
a_depression_flophouse

125 **SCOUT TREEHOUSES**
Toledo-Lucas County Public
Library
a_12941_miakonda_treehouse

126 **MICHIGAN STREET**
Toledo-Lucas County Public
Library
a_main_library_construction

128 **AMUSEMENT PARK**
Toledo-Lucas County Public
Library
a_walbridge_amusement_ride

129 **FIRST NATIONAL BANK**
Toledo-Lucas County Public
Library
a_18470_toledotrust.tif

130 **STREETCAR 801**
Toledo-Lucas County Public
Library
a_10460_streetcar_east

131 **PARKING GARAGE**
Toledo-Lucas County Public
Library
a_APPCO_parking

132 **LOCOMOTIVE**
Toledo-Lucas County Public
Library
a_train_story

133 **THE PALACE**
Toledo-Lucas County Public
Library
a_9860_palace_theater

134 **PASSENGER STATION**
Toledo-Lucas County Public
Library
a_wheeling_station

135 **INTERLAKE IRON CO.**
Toledo-Lucas County Public
Library
a_interlake_iron

136 **TOLEDO STEEL PRODUCTS**
Toledo-Lucas County Public
Library
a_13779_steel_products

137 **WALDORF HOTEL**
Toledo-Lucas County Public
Library
a_14443_waldorf_hotel

138 **FDR SPEECH**
Toledo-Lucas County Public
Library
a_roosevelt_train

139 **BOYS AT SPEECH**
Toledo-Lucas County Public
Library
a_roosevelt_train_boys